IMAGES
of America

DARBY BOROUGH

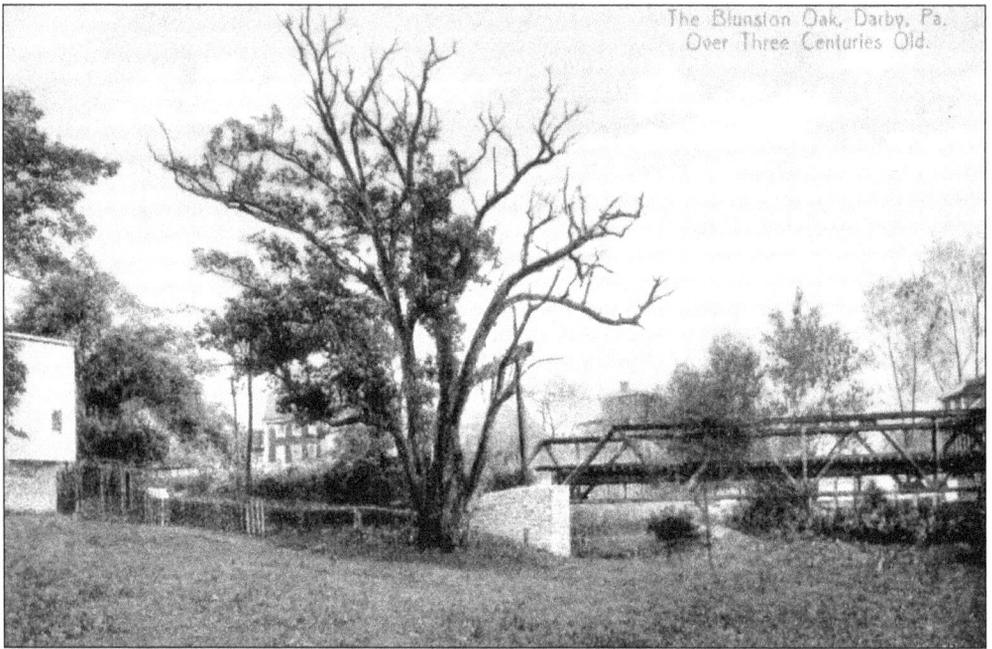

The Blunston tree represents the beginning of Darby. The area of Darby Creek where it was located was John Blunston's starting point to build his town. The old iron bridge, which is the third bridge to be built over the creek, will soon be gone. It is scheduled for demolition because of flooding. During Darby's early years, the people had no need for a bridge, as there was an excellent ford at the head of the tide near the site of the MacDade Boulevard bridge.

ABOUT THE PHOTOGRAPHS

The photographs on these pages are just a glimpse of the 320 years of Darby Borough's history. The collection we have assembled here was possible because of the immense pride and interest that Darby residents have in their community. The images shared of their lifetimes, accomplishments, and families, and those of the mills and the creek, warmed our hearts.

Gathering these pictures was a rewarding experience. As the collection grew, so did the realization that one book of photographs could never encompass the range of personal achievements and events that took place in our early American town. We do hope, however, that as you view those we have selected that you will want to see and read more about the history of Darby. Credits are listed with each photograph. All others are from the Darby Borough Historical and Preservation Society (DBHPS) photograph collection.

Christopher Morley wrote about Darby in his book *Philadelphia* concerning a visit to the beautiful old town after many years absence. He wrote, "Down a steep winding hill, and we came upon the historic spot with delightful suddenness, Our heart was uplifted. There it was unchanged, the old gray building standing among trees with the clank and grind of the water-wheels, the yellow dapple of level sun upon the western wall. We both agreed that the old mill, dozing in the sunlight with the pale and tremulous shimmer of the blue light in the porch where Mr. Flounders was working, was a fit subject for some artist's brush." We of the Darby Borough Historical and Preservation Society hope that these pictures have captured the spirit of the our community.

IMAGES
of America

DARBY BOROUGH

Darby Borough Historical and Preservation Society
Lindy Constance Wardell, Editor

ARCADIA
PUBLISHING

Copyright © 2003 by Darby Borough Historical and Preservation Society
ISBN 978-1-5316-0788-3

Published by Arcadia Publishing
Charleston, South Carolina

Library of Congress Catalog Card Number: 2003101671

For all general information contact Arcadia Publishing at:
Telephone 843-853-2070
Fax 843-853-0044
E-mail sales@arcadiapublishing.com
For customer service and orders:
Toll-Free 1-888-313-2665

Visit us on the Internet at www.arcadiapublishing.com

This book of photographs is dedicated to the citizens of Darby.

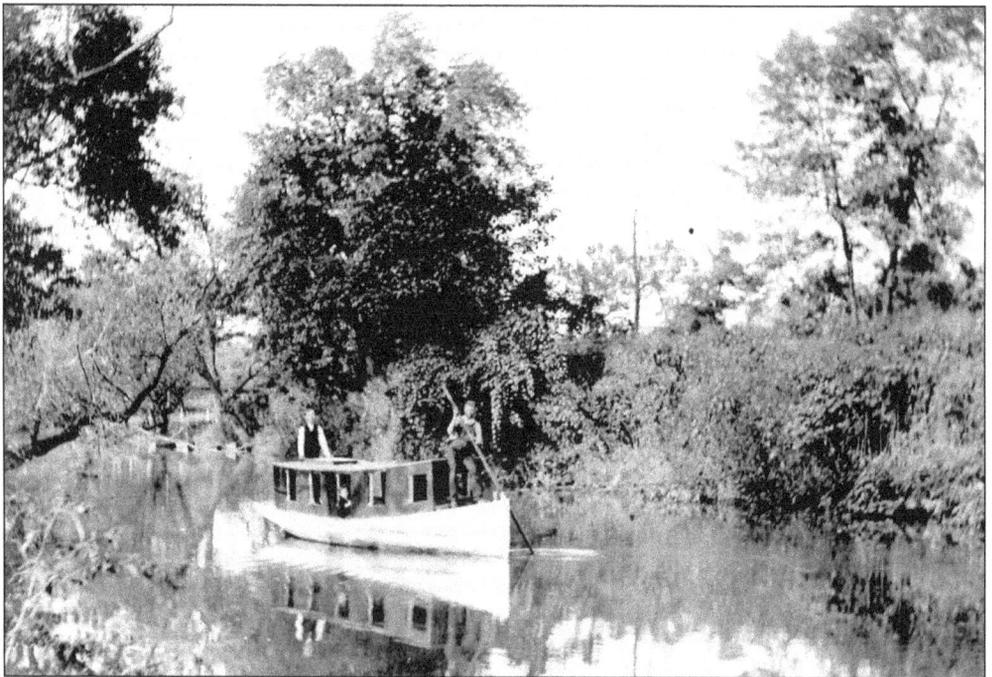

Seen is Darby Creek in 1887. The creek was the center of early Darby. The mills used it for power, and because it was navigable, barges and sailboats used it for bringing goods up the Delaware River to Darby.

CONTENTS

ACKNOWLEDGMENTS

The members of the Darby Borough Historical and Preservation Society have dedicated the last six years to saving the history of the community. This book would not have been possible without the help of each member. Longtime Darby residents Evelyn Cain, Beatrice Harris, Marshall Ladd, Ruth Niles, and Frederick Trent helped with documentation. Many residents and former residents offered bits of history and words of encouragement. This book is one more way that they have benefited their community. The historical society also thanks every person and group that contributed photographs. This is also their book.

The Darby Religious Society of Friends Meeting has supported the historical society's efforts to preserve, document, and educate concerning Darby Borough history. Thanks go to the Society of Friends for allowing the historical society to meet in the historic Darby Friends Meeting House and for providing information on the history of the early Quakers.

Special thanks go to Roy Wilson Lewis Jr. for his professional advice and last-minute assistance and to Richard Clark for his technical assistance. Thanks also go to Donald Parker Verlenden for sharing his family's history and the history of the Verlenden mills. Special and heartfelt thanks go to Thomas J. DiFilippo, author of *The History of Darby Borough*. His work not only made this book easier but also encouraged further research.

Thanks also go to Darby Borough Council members Doris Grosso, Janice Davis, and Helen Thomas for their support and assistance in documenting the community's history.

Many thanks go to the society membership and to board members: Wanda Barrett, Beatrice Child, John Child, Glen Gilman, Nancy Hack, Margaret Petty, Marion Pugh, Charles F. Sanders, Barbara Saunders, Frederick S. Saunders, Frank Wardell, and Gladys Wetzel. They ran errands, researched archives for information, took photographs, and always worked as a team. They gave time, expertise, and advice that made this collection possible, and they made my job as editor much easier and a pleasure.

—Lindy Constance Wardell, President
Darby Borough Historical and Preservation Society

INTRODUCTION

William Penn gave the responsibility of establishing a town on Darby Creek to his friend John Blunston 321 years ago. Blunston became a member of the first Pennsylvania legislature and helped Penn get his rules of privileges passed, which became the first law of Pennsylvania. The first eight Quaker families that arrived here, in 1682, took contiguous land grants that allowed them to create a community where they could support each other and plan the town. Others that followed benefited from a close-knit community even though the estates and farms were large.

Only a year after their arrival, the Quakers had built homes and a mill and held their first town meeting. By 1687, they had built their first meetinghouse, established a school for their children, built more mills and homes, and provided for a burial ground. John Bartram, John Blunston, and most of the early settlers are buried there. As the mills flourished and new settlers arrived, the United States was expanding and Darby mills provided the goods and services that the settlers needed to move west. Blacksmiths, mills that ground grain, tool-making operations, and cotton, wool, and silk mills were established. Sawmills and tanning mills were also established and provided services and goods to new settlers as well as to the inhabitants of Darby. New businesses opened, and the town grew. Despite the fact that the mills seemed to dominate the industrial growth, Darby was not a one-company town. A variety of industries and services brought their businesses to Darby.

Churches of every denomination were soon built. People of diverse religious beliefs and nationalities combined with the tolerant Quaker community to create a family town that was proud of all of its inhabitants. By 1775, residents had organized Fire Company No. 1, which has provided volunteer services to the community since before the United States was a nation. Beautiful homes were built, and the Home Protection Society was formed to give security to the residents. Many fraternal and religious lodges and societies were organized. These societies made arrangements to care for the sick and the poor. Mount Zion Methodist Meeting built its church in 1808, and its burial ground is the resting place of early settlers and many military veterans. Mount Zion African Methodist Episcopal Church was established in 1875. It was the first black church of Darby.

In 1743, the Quakers established a library that was carried in a case from house to house and kept in several places until the present library building was erected in 1862. They built schools and educated Darby children until c. 1900. The Philadelphia Roman Catholic archdiocese, c. 1913, built the Blessed Virgin Mary Church and an elementary school that at one time had more than 1,500 students.

The creek flooded frequently, and lives were lost, property was damaged, and bridges were washed away. After the flood in 1843, the block of houses on Fuller Street was built for mill workers.

After the separation from what was originally Darby Township, the area was renamed Lower Darby until its incorporation in 1853 as Darby Borough. It is still called Darby, named for the English town of Derby, where the first settlers came from. Much building and new development took place just before and after 1900. Neighborhoods of row houses were built, and a golf course, Lansdowne Country Club, was added. Fitzgerald Mercy Hospital and St. Francis

Country House initiated the beginning of the present healthcare complex. This progress soon changed the landscape from beautiful old estates and farms to a busy town that was a center for business and finance and became important as a transportation hub. Businesses thrived, and Mrs. Finigan opened a doll hospital above her store to compensate for the lack of imported dolls during World War I.

Physicians, lawyers, dentists, architects, and pharmacists chose Darby as the place to establish their practice. Morgan Bunting and Frank Furness, both well-known architects, designed several buildings in Darby. Family-owned businesses such as Roberts Filter Manufacturing Company and others became international corporations. The business section of Darby once attracted more than 1,000 cars to Main Street on Saturday nights. Residents were involved in the community as volunteers, and the schools offered their children a good education. The trolleys brought people to Darby from Philadelphia year-round to shop and in the summer to vacation.

Darby has experienced the effects of war many times, and each time, Darby citizens have responded to the call of duty. Darby was ravaged by the British during the Revolutionary War, and the people suffered through a winter of great hardship. The Civil War took a great toll on the community, and World Wars I and II left their mark on the community's spirit. Darby people were very active in the abolitionist movement, and the town has several well-known Underground Railroad sites.

The Depression brought hardship to many people in Darby, and banks failed, but the community recovered and was soon a thriving town again. Since 1990, Darby has suffered economic depression and financial difficulties brought about by changes in urban communities that affect manufacturing and other aspects of urban living. Darby Borough residents face new challenges—the most important one being to preserve 320 years of history and use it as a catalyst for progress and renewal by incorporating the old with the new through innovative planning. With care, the Darby Borough pioneer spirit that helped build a new country will survive in the hearts of today's residents.

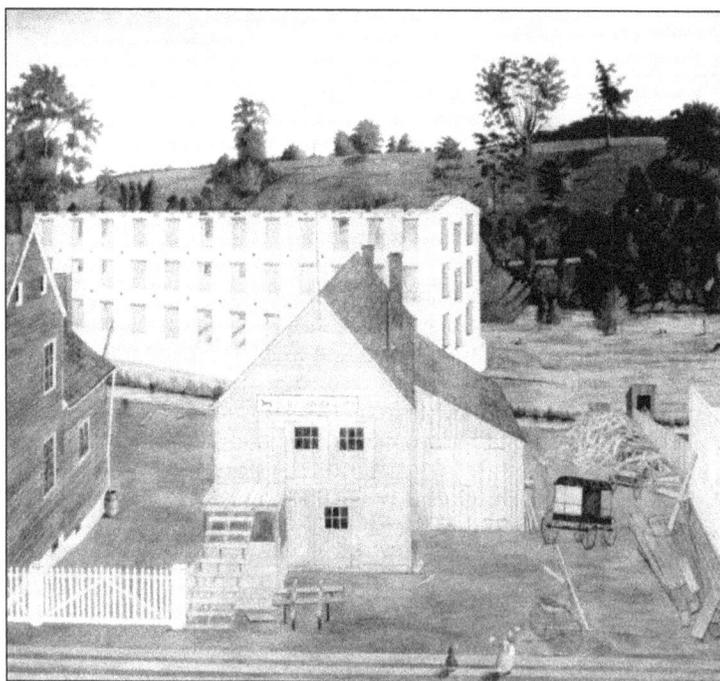

View of Darby after the Burning of Lord's Mill, is an oil on canvas painted by Darby artist Jesse D. Bunting c. 1860. It shows the millrace, the creek, and the G. Flounders millwright business. The original painting is in the M. and M. Karolik Collection at the Museum of Fine Arts in Boston. Tax records of 1861 indicate that another mill was added to the Darby Mills facility when Simeon Lord purchased part of the facility. (Courtesy the Museum of Fine Arts, Boston.)

One

DARBY CREEK AND THE MILLS, TROLLEYS, TRAINS, AND TAVERNS

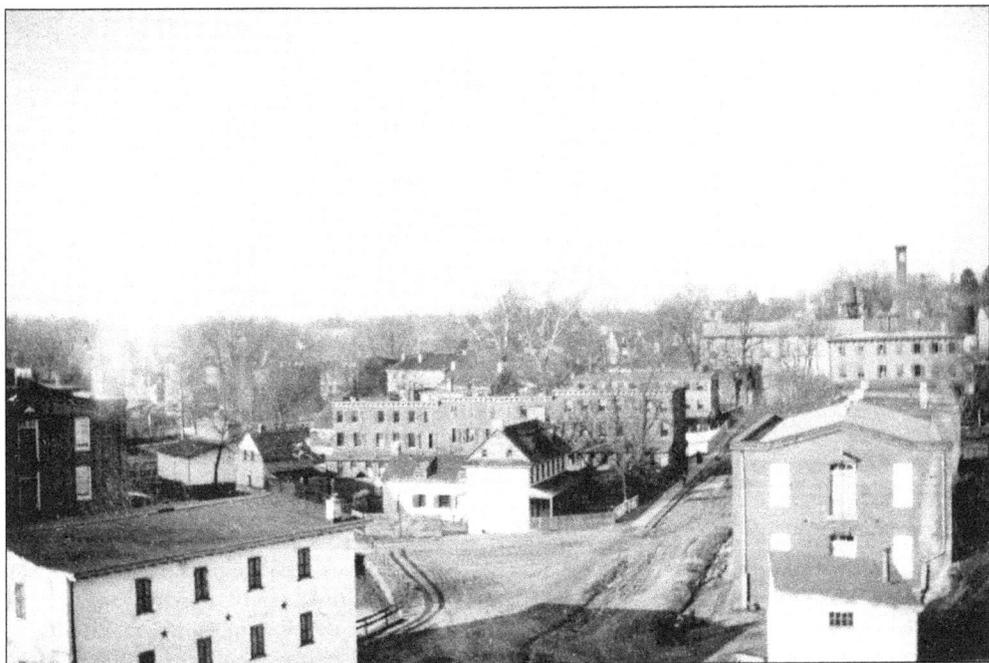

This view of Tommy Steele's house and the mills was taken from the Baltimore and Ohio bridge before 1899. (DBHPS, Harold S. Finigan Collection.)

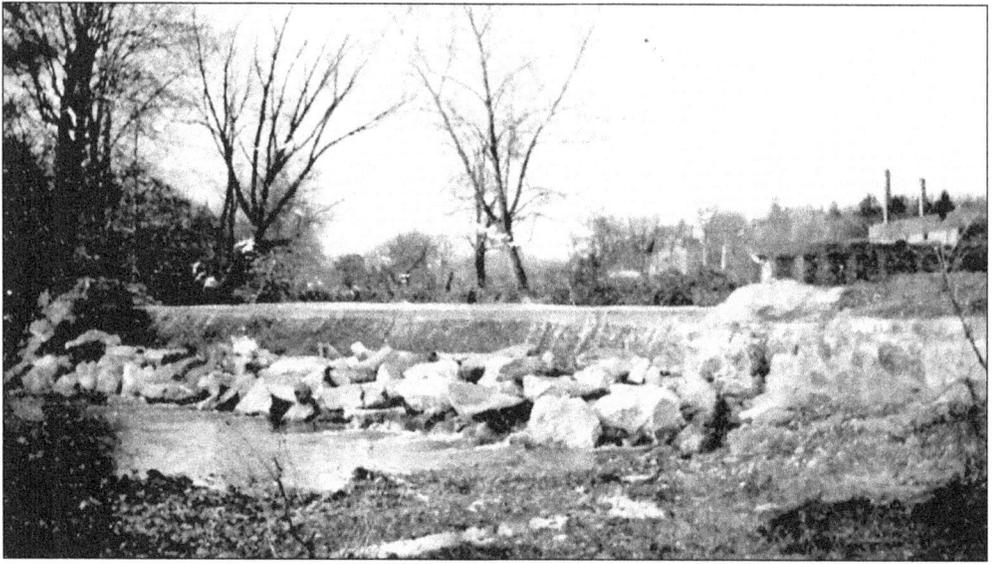

In 1887, the smokestacks of a mill could be seen from the dam.

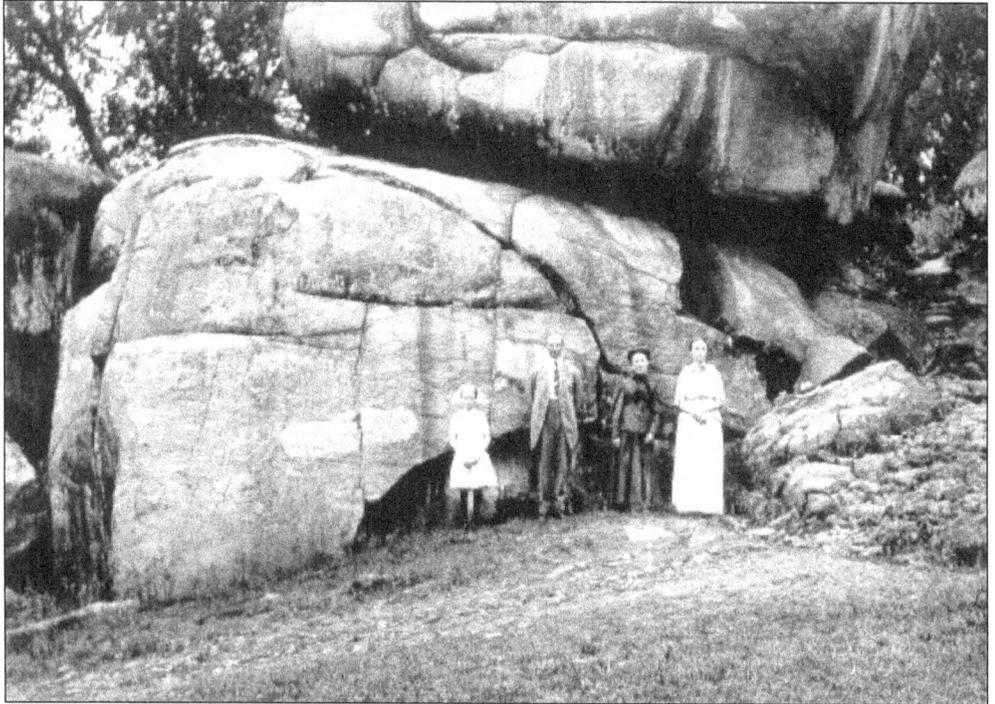

Members of the Tribbet family pose c. 1900 in front of Anne's Rock, which was located on their farm. The farm was part of Darby before it became Colwyn. This is a memorable site to many Darby natives, especially children who experienced its mysterious Ice Age presence on the local landscape. Local folklore includes stories of lovers' trysts, Lenni Lenape Indians, explosions, whispered chronicles of the Underground Railroad and slaves coming up the creek, children's adventure trips, picnics, a known hiding place, and of bits of writing that area people left for posterity. The rock—like the old trees, Indian lore, and scenes along Darby Creek—gives the community its unique character and personality. (DBHPS Lynne Murray Collection.)

10

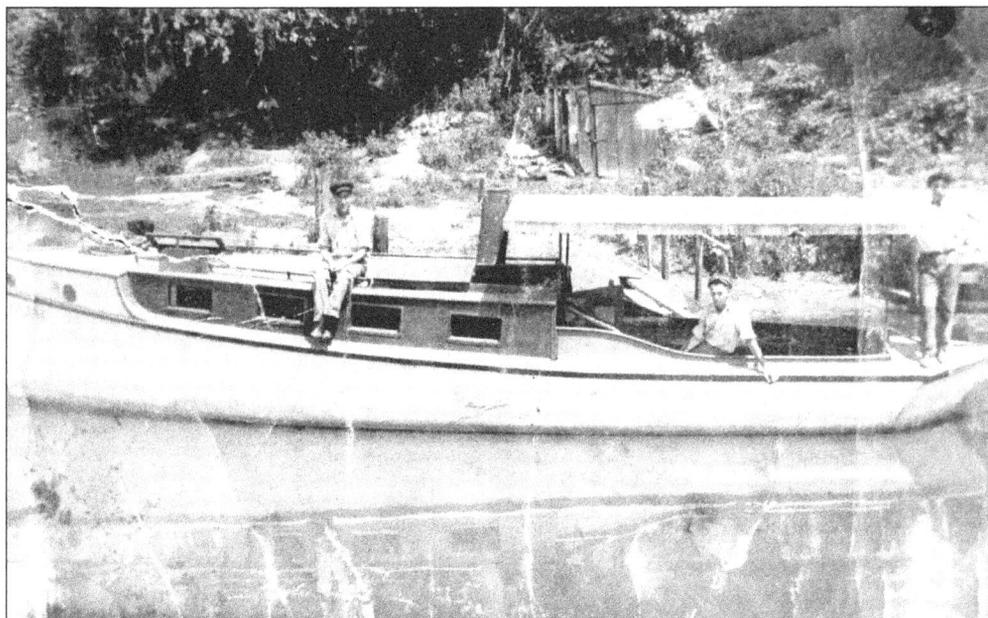

Al Woolford, John Kerr, and Dick Patterson are seen aboard the *Mary May* on Darby Creek c. 1915. (Courtesy Thomas R. Smith, Sellers Memorial Free Library.)

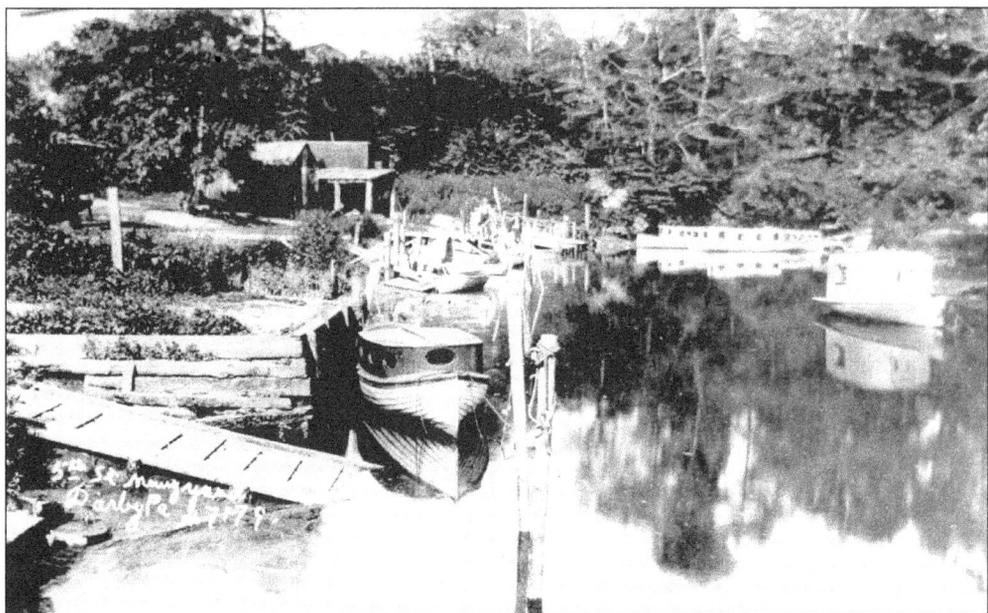

Jokingly referred to as the Darby Navy Yard was the creek at 5th Street, where boats owned by local residents were moored. At one time, Darby Creek was navigable and large barges and sailboats brought supplies, including livestock, for use by the mills, factories, stores, and farms. (Courtesy Thomas R. Smith, Sellers Memorial Free Library.)

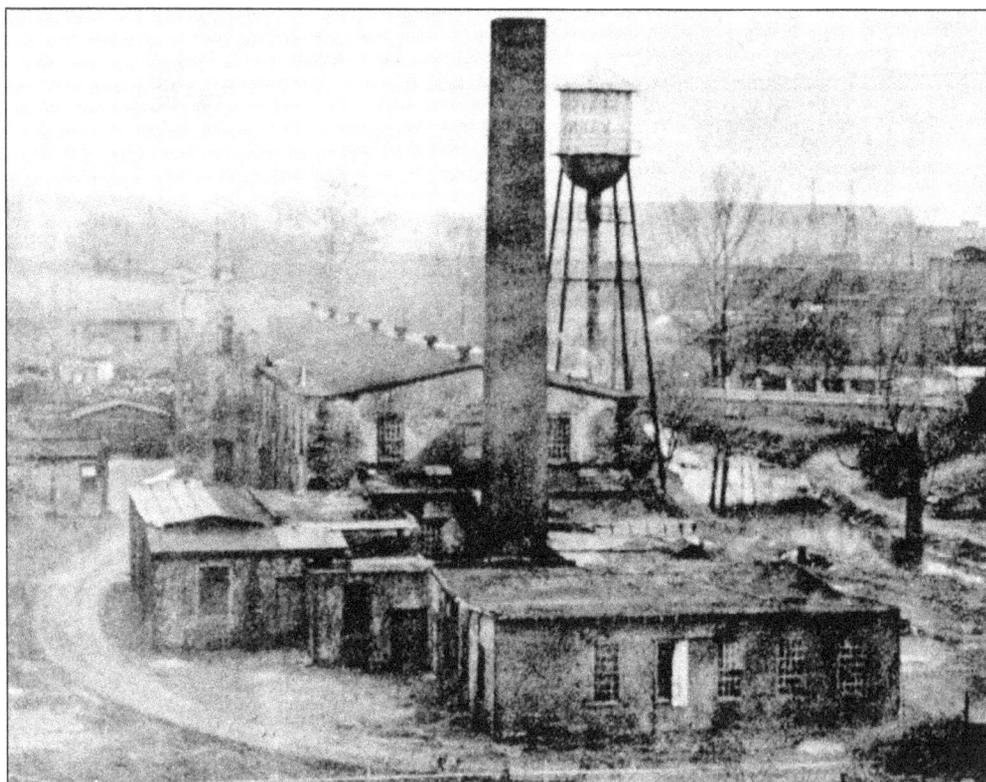

The former Grayson mill on Mill Street is now owned by Sentry Paint Technologies. Sentry survived Hurricane Floyd's devastating flood in September 1999. Benjamin S. Breskman is the president and chief executive officer of the international corporation. The reuse of the historic mill has been a step forward in the renewal of the borough. The photograph was taken c. 1915. (Courtesy Mary Ann Burnside.)

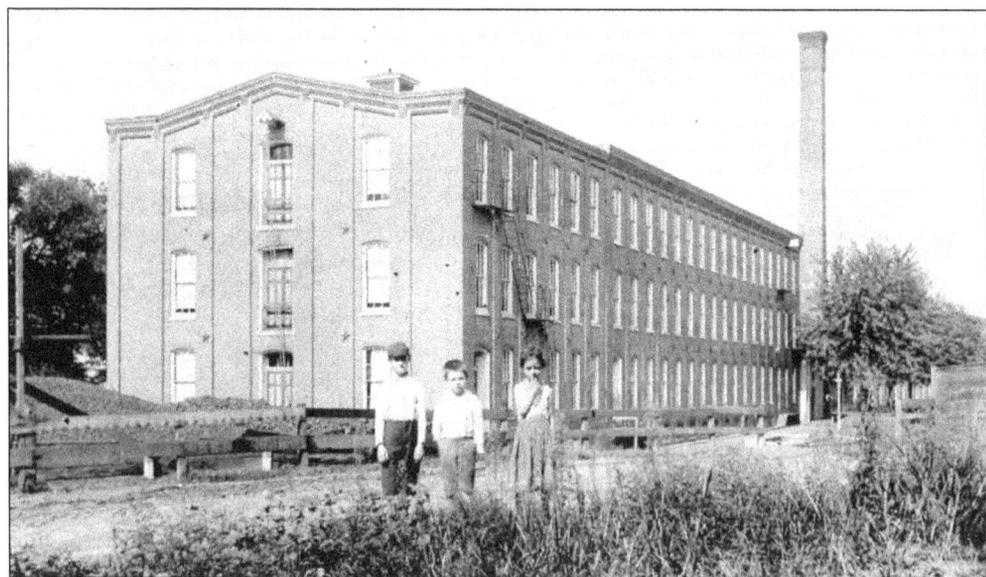

The Griswold mill is seen in this 1900 view. (Courtesy the Library Company of Philadelphia.)

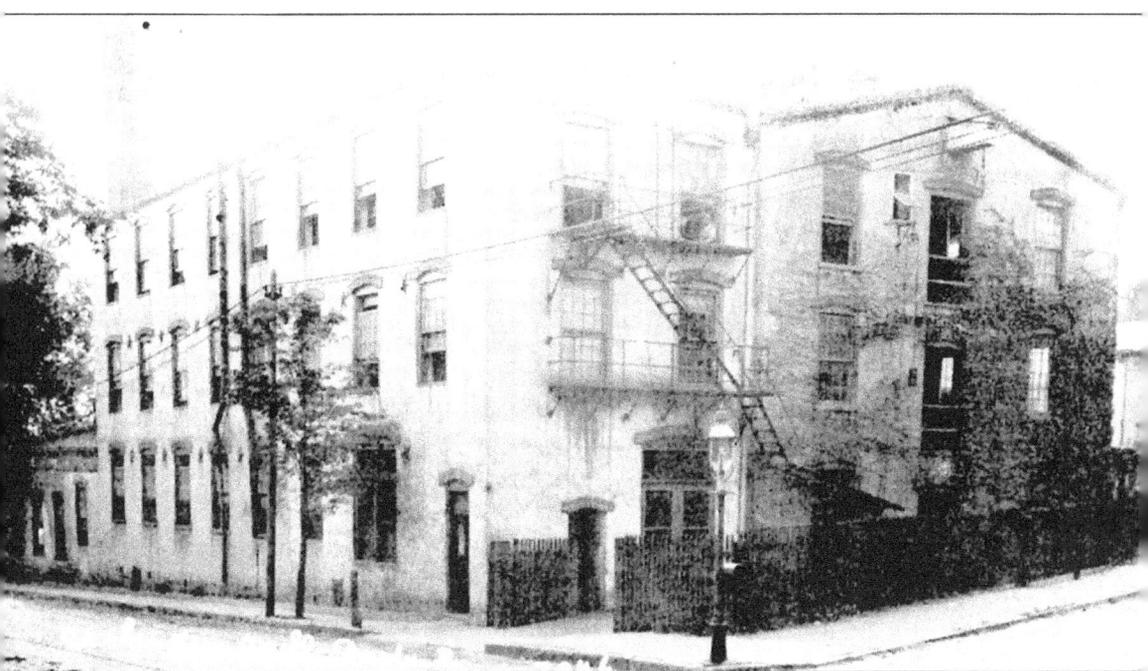

In 1851, John Verlenden took over the fulling mill previously owned by Thomas Steele and, before him, Isaac Oakford. The mill burned c. 1859, and Verlenden built a new mill near the northwest corner of Main Street and Ridge Avenue. Enos Verlenden and W. Lane partnered with George Smith, the son of Dr. George Smith, and called the mills Verlenden & Smith. In 1867, the mills were leased to Richard Thatcher & Sons, which added them to the Darby Mills. Partly destroyed by fire in 1880, the mill buildings were then enlarged to manufacture both cotton and woolen materials. In 1892, they were renamed the Imperial Woolen Mills. The mills closed in 1928. (Courtesy Donald Parker Verlenden.)

13

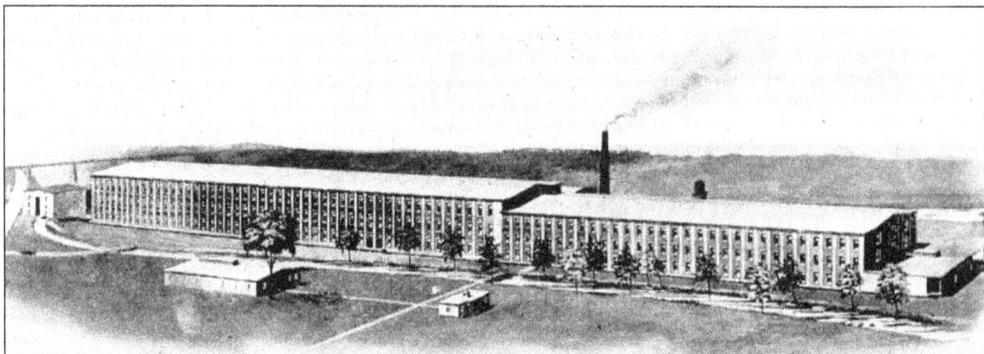

In 1915, the Salts Manufacturing Company owned the Darby Mills. The company made high-fashion coats from wool and other materials. It also had a plant in Paris, France. Sometimes, artificial fur was used in the designs. Darby Borough Historical and Preservation Society has one of the company's advertising brochures illustrating its women's coats of 1915.

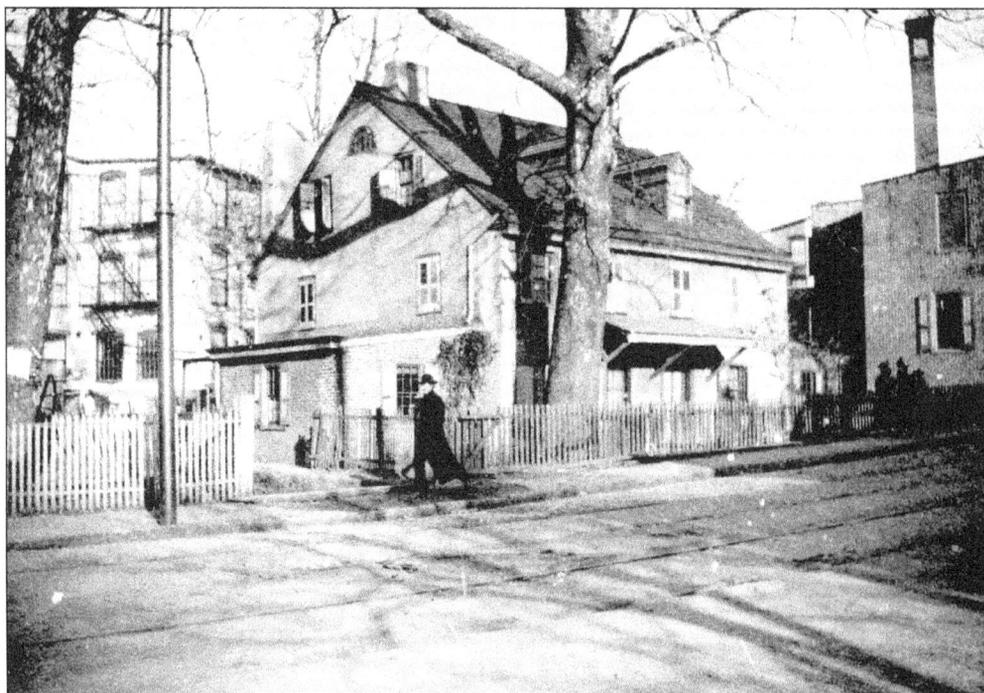

Hannum's Tavern was located at the corner of Powell and Main Streets, near where the post office is today. It was originally named the Ship. In 1812, the sign with the British flag was destroyed by Darby youths and was quietly replaced with one showing an American frigate with a U.S. ensign. According to one of the tavern's proprietors, Sydney Smith, George Washington stopped there several times. Norman Hanna bought the tavern in 1840, and it was renamed the Darby Village Inn. In 1847, Sarah B. Hanna received her license as owner. Edward Ingram made the inn the point of arrival and departure for his horse-drawn stages to and from Philadelphia. In 1856, the inn was torn down, and the Philadelphia Hotel was built in its place. (DBHPS, Harold S. Finigan Collection.)

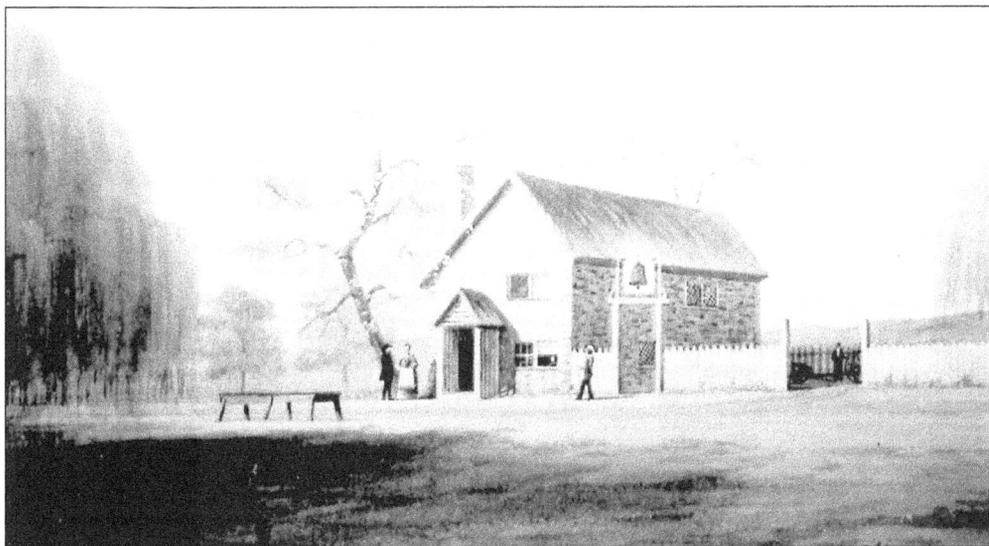

The Blue Bell Inn on Cobbs Creek was built in 1766 at the site of the first mill owned by William Wood. It is connected to many of Darby's early families. Located on what was the King's Highway, it was the stopping place for George Washington and Gen. Anthony Wayne and the site of a November 1777 skirmish during the campaign for Fort Mifflin. Built by Henry Paschall in 1766 and owned by the Lloyd family during the 19th century, it was the gathering place of important families of the area. It was used as a recruiting station during the Civil War. The Blue Bell also has Underground Railroad connections. It was the scene of Washington's first welcome to Philadelphia as president and his last farewell to the city. This is a photograph of the 1766 Evans painting of the tavern. (Courtesy the Library Company of Philadelphia.)

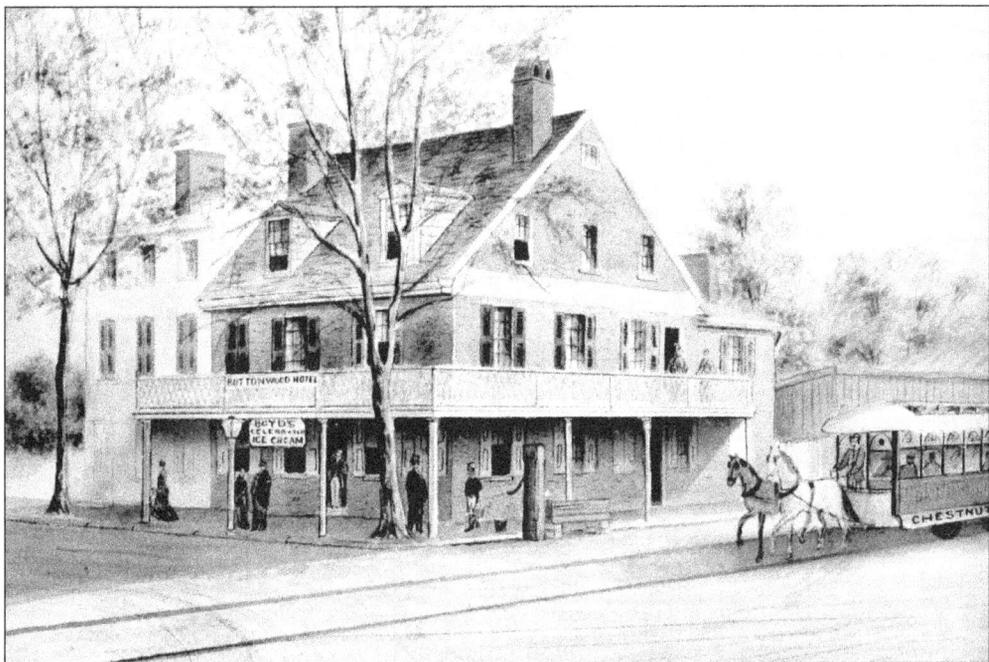

The Buttonwood Hotel was painted by Evans in 1886, showing the horse-drawn trolley that traveled between Philadelphia and Darby. (Courtesy the Library Company of Philadelphia.)

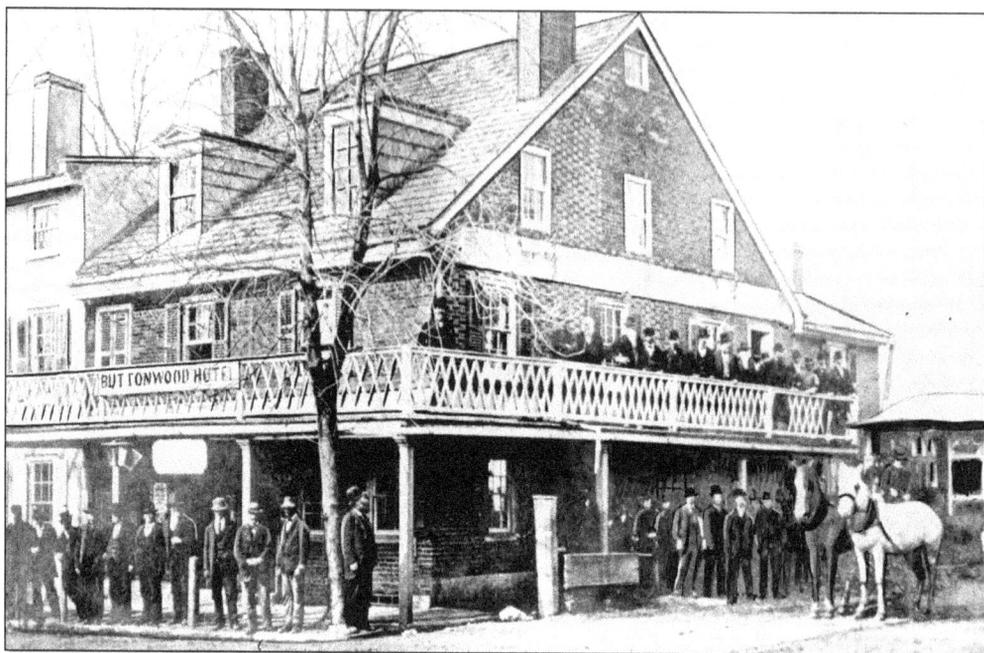

At one time, there were 39 taverns, hotels, and boardinghouses in Darby. The Buttonwood is probably the most famous because of its location at 9th and Main Streets and its history of political activities when owned by Andrew McClure and, later, his children. George Washington stayed there and, according to townspeople of that time, he was presented with a beautiful white horse by Darby people. General Howe, Caesar Rodney, Daniel Boone, John Bartram, and other well-known and famous travelers stopped there. Humorist W.C. Fields was born there. Built in 1739 by George Wood, it was first named the Mariner's Compass. Its name was changed to the Drove, and in 1866, it was renamed the Buttonwood. It was replaced with a more modern hotel in 1879, and in 1982, it was demolished. (Courtesy the Temple University Urban Archives.)

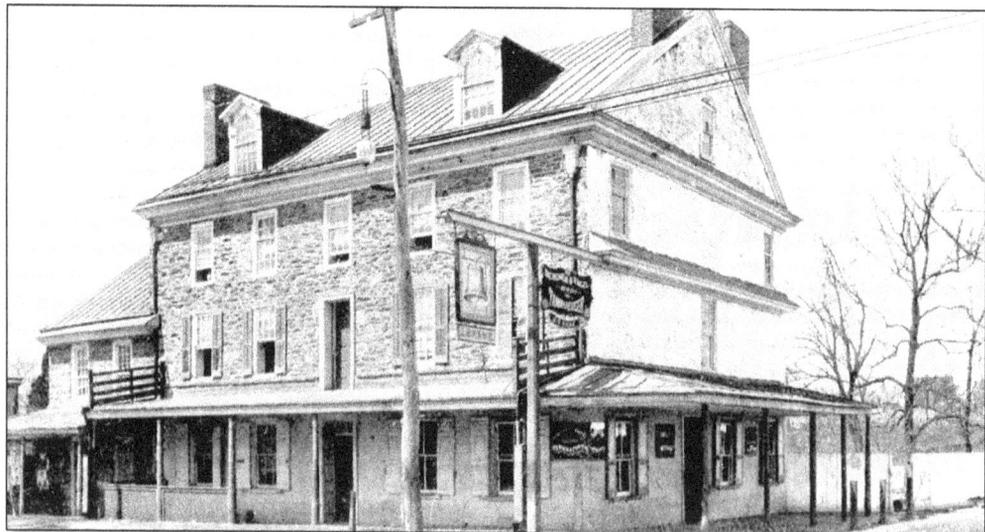

Changes were made at the Blue Bell Inn. This photograph shows the large additions that had been made by 1880. (Courtesy the Library Company of Philadelphia.)

This photograph is of a c. 1801 painting by Evans of the Blue Bell Inn at Cobbs Creek. (Courtesy the Library Company of Philadelphia.)

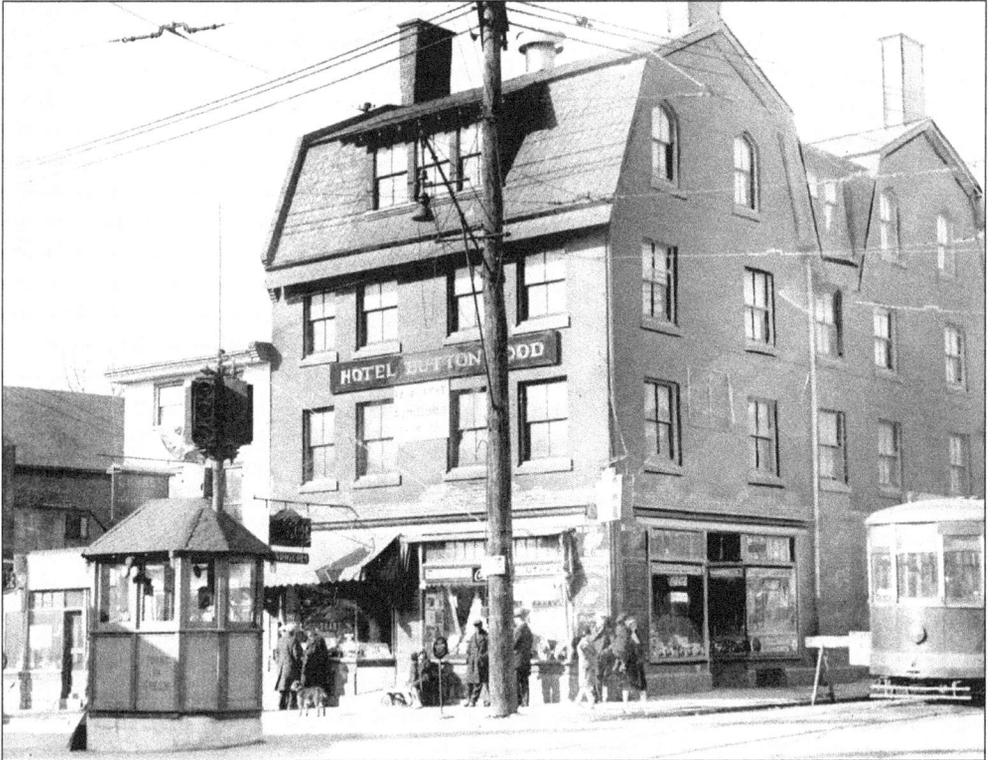

Shown is the Buttonwood Hotel in 1940. (Courtesy the Temple University Urban Archives.)

17

In 1910, Chester Pike still had its tollbooth. Early on in the area, tolls were a way to acquire funds to maintain roads—just as they are today.

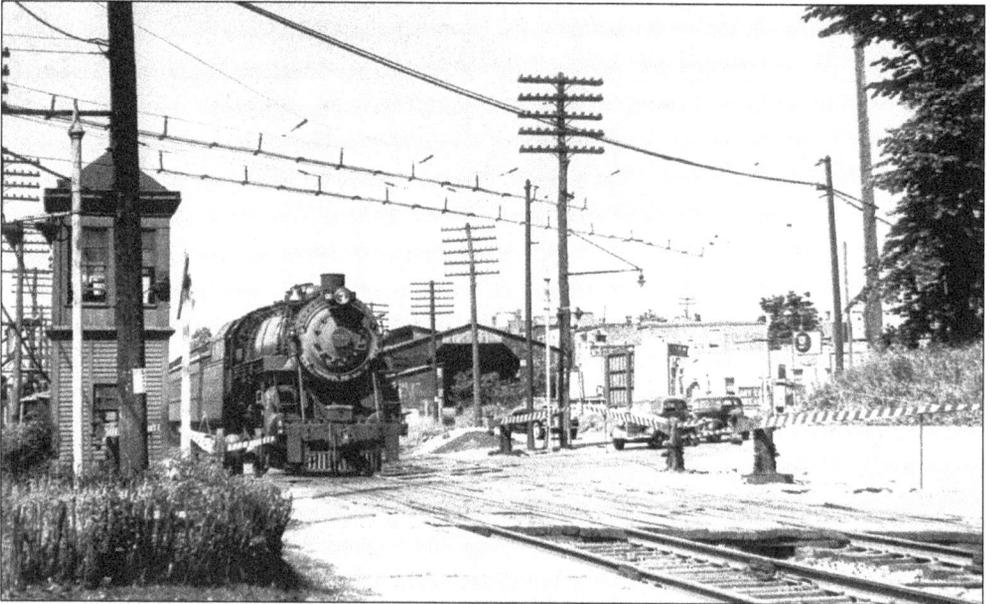

The old Baltimore and Ohio station at 6th and Main Streets was built in 1887 and changed Darby from an agricultural area to a transportation and shopping hub. Suburban homes were built near the railroad for commuters' convenience. Philadelphians came to the suburbs for summer vacations to get away from the city heat. Railroads considered Darby important, and it became a place that three railroads serviced. The Philadelphia, Wilmington and Baltimore was laid out in 1870. The Philadelphia and Reading and the Baltimore and Ohio came later. The tower shown here was used by the signalmen, and the railroad employees collected fares on the first floor. Rail cars were kept in this area, and the employees lived in houses across the tracks to the right of the station. (DBHPS, Lynn Murray Collection.)

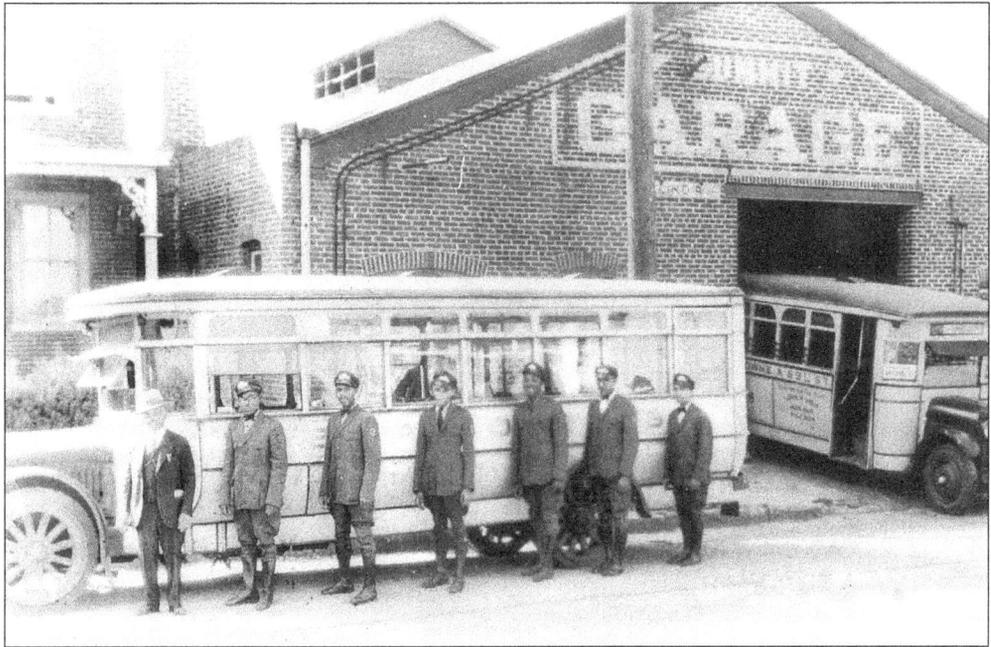

In this photograph, John Mott Drew is shown with some of his drivers in front of his garage on Summit Street. He started his bus company c. 1930 and was very successful. He later purchased part of the Baird estate above Summit Street (part of this property was in Yeadon) to use for the Hilldale baseball stadium that he helped finance. (Courtesy Thomas R. Smith, Sellers Memorial Free Library.)

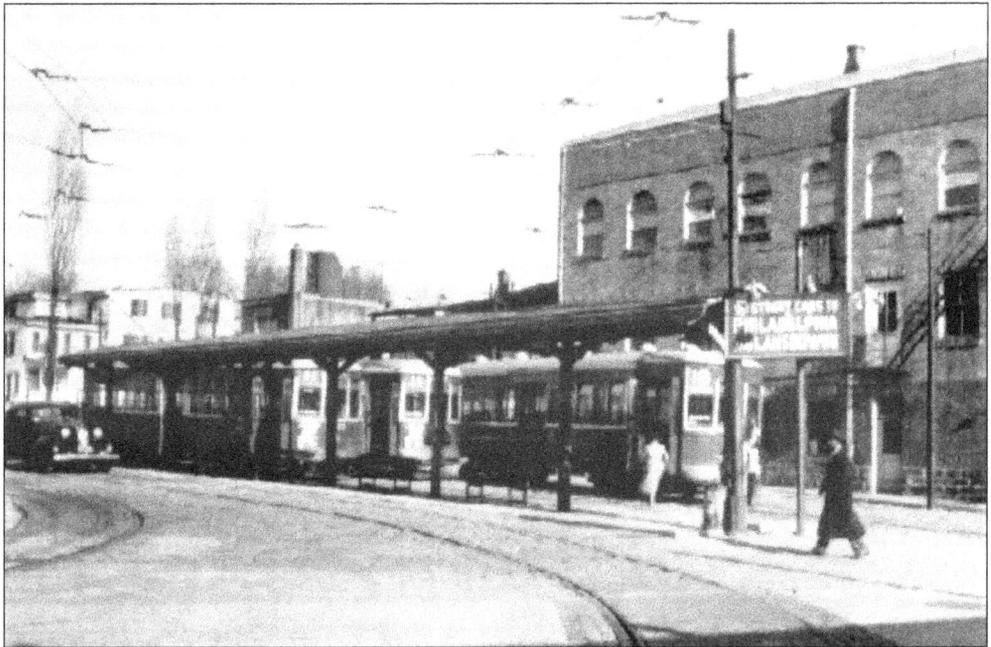

In 1953, Darby's trolley loop was used even more than earlier because new housing developments were in progress or finished and commuters found the trolley and buses an easy solution for travel to their jobs. (Courtesy the Temple University Urban Archives.)

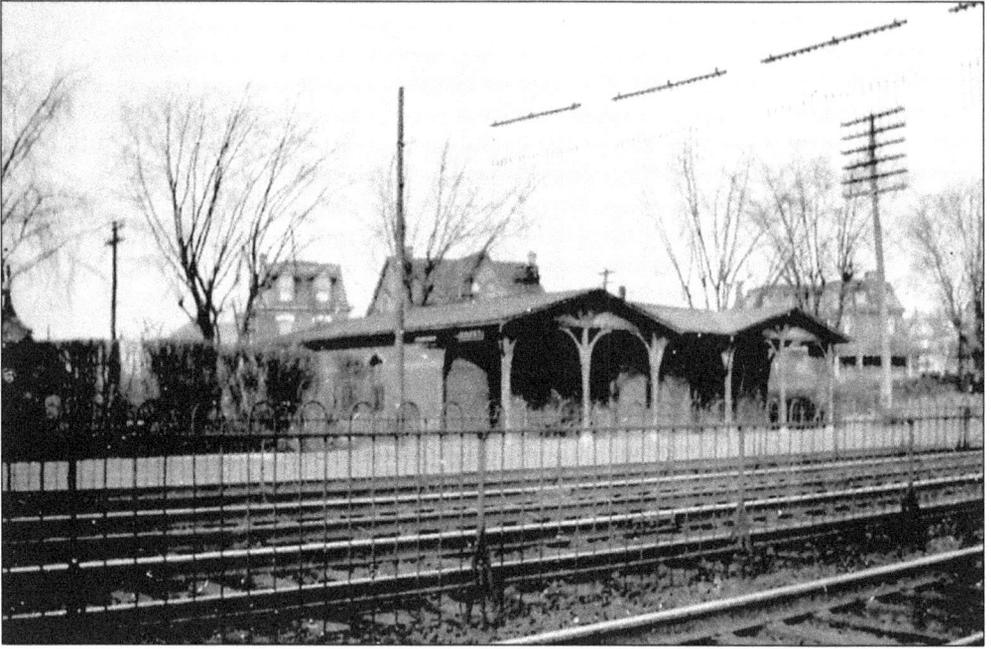

The Pennsylvania Railroad station was at 7th and Pine Streets. This picture was taken in 1925. Amtrak trains stop here on their way to and from New York City and Washington, D.C. Only a small shedlike building welcomes travelers.

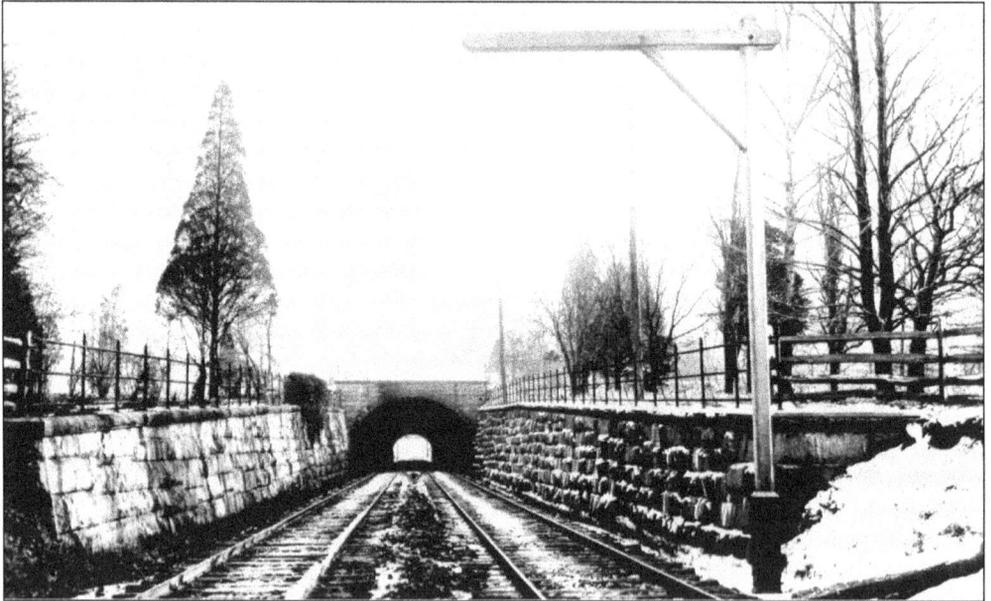

Boone's tunnel, which goes under Pine Street, made it possible for trains to get in and out of Darby more directly. It is eligible for the National Register of Historic Places because of unique engineering features that make it representative of its time. Crashes involving cars and trains have occurred at the tunnel over the years. The tunnel is pictured in 1931, soon after it was built. (Courtesy the Library Company of Philadelphia.)

Two

CHURCHES

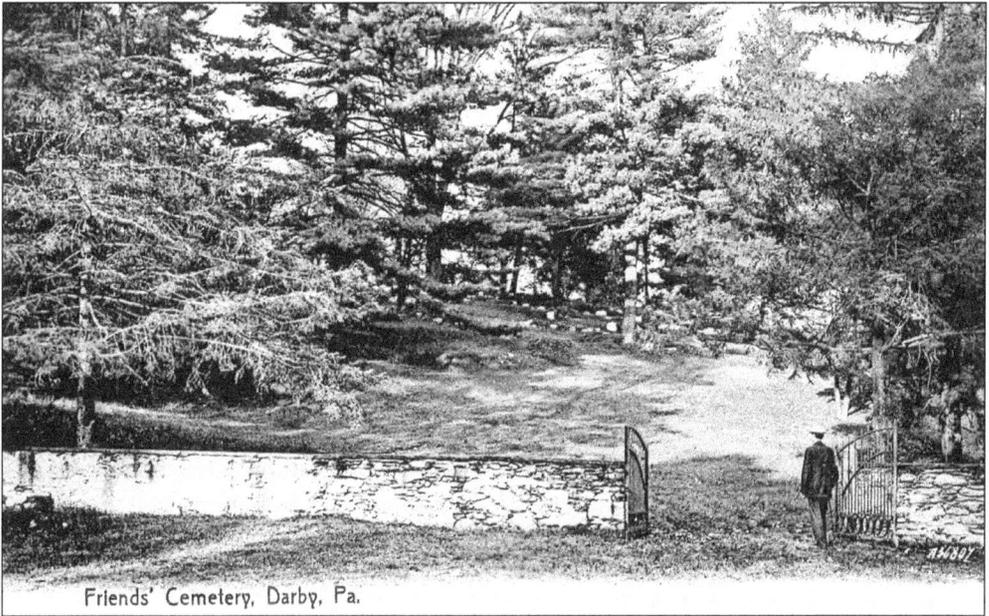

Friends' Cemetery, Darby, Pa.

The Darby Friends Burial Ground was established in 1687, when John Blunston donated the property for the building of a meetinghouse and a burial ground. John Blunston, William and John Bartram, Samuel Bunting, and almost all of the first families that came to Darby in 1682 and many of their descendants are buried in this cemetery. It is shown here when the gate was still on the old wall. This is the site of the first meetinghouse built in Darby by the Quakers. Today, Darby children are often seen playing ball on the level area facing Main Street. (Courtesy Donald Parker Verlenden.)

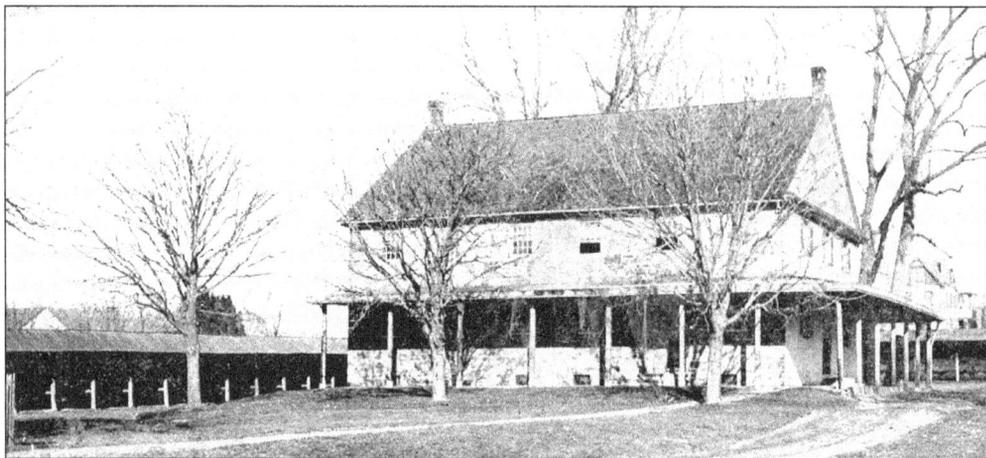

The Darby Religious Order of Friends Meeting was organized in 1682 by eight Quaker families. Worship meetings were first held in the home of John Blunston, the founder of Darby. A log meetinghouse that also served as a school and township building was built in 1687. William Penn's daughter, Letitia, attended a wedding there. Another meetinghouse was built in 1701 and was used until the present one, shown here, was built in 1805 at 1017 Main Street. During the War of 1812, this meetinghouse was used by the army as a field hospital. First members of the Darby Friends Meeting include the following: Blunston and his Serrill and Bunting descendants; John and William Bartram, the naturalists; Bonsall; Garrett; Garrigues; Hallowell; Heacock; Hunt; Kirk; Lloyd; Newlin; Ogden; Paschall; Pearson; Powell; Schofield; Sellers; Smith; and Swayne. John Woolman, the first crusader for abolition in England and America, visited this meetinghouse in 1772. (Courtesy Darby Friends Meeting.)

The Mount Zion Methodist meetinghouse was built in 1808. One of the first temperance meetings in Pennsylvania was held on June 6, 1818, in the c. 1735 school that was part of the Mount Zion property. The Home Protection Society was organized soon after by residents to give protection to Darby citizens. The church was one of the area's first four institutions. In 1739, George Whitfield, a famous preacher and friend of John Wesley, preached in an orchard here to hundreds of people after being escorted from Chester by more than 100 horsemen. He stayed at a local boardinghouse, and the thief that he had saved from execution in Chester that day followed him to Darby and stole his money during the night. The congregation built a new church, the Mount Zion Methodist Episcopal Church, on Main Street in Darby in 1881. (Courtesy Mount Zion United Methodist Church.)

22

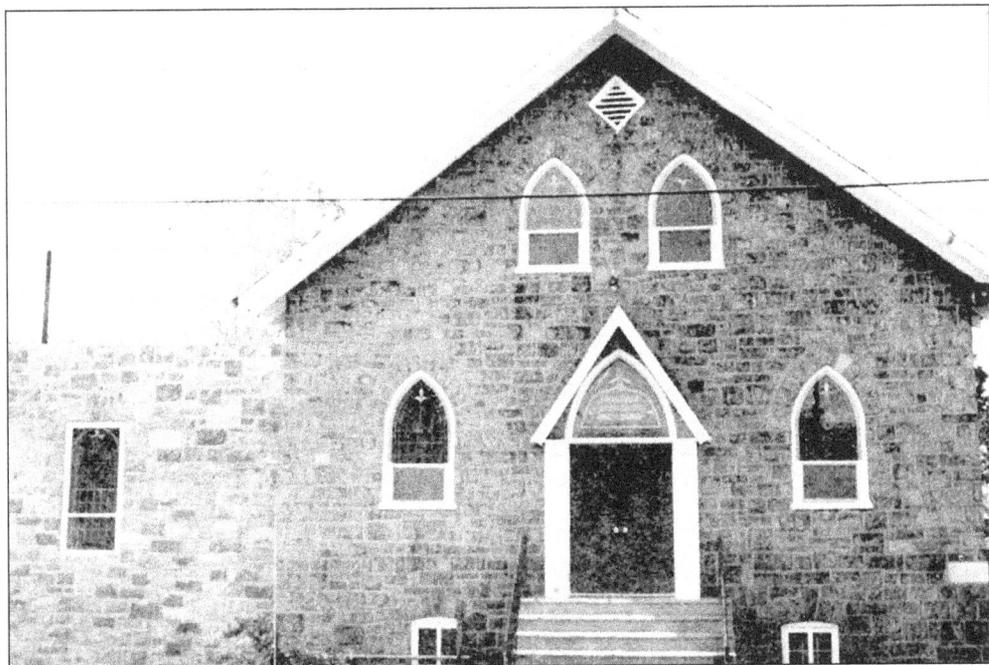

This is the fourth home of the First Baptist Church of Darby, established in 1900 by Rev. George W. Porter. The congregation first met in a hall on 10th Street and then in a home on Forrester Avenue and, in 1913, in what was known as the Tabernacle on Marks Avenue. The church shown here was purchased in 1917, and an addition was constructed in 1940. Today, the congregation is looking forward to building a new church.

The mission of All Saints' Episcopal Church was established on October 20, 1911. As early as 1789, Darby Anglicans were served by the Parish of St. James of Kingsessing. In 1872, the laity of St. James established a Sunday school in the Darby library hall. In 1910, a permanent Sunday school was established from Trinity Church in Collingdale. It met in the Darby reading room at 846 Main Street. Ground was broken for the church and parish house on July 17, 1911, and the cornerstone was laid on September 29, 1912, for All Saints' Episcopal Church. The first services were held in the church at Main and Summit Streets on December 22, 1912.

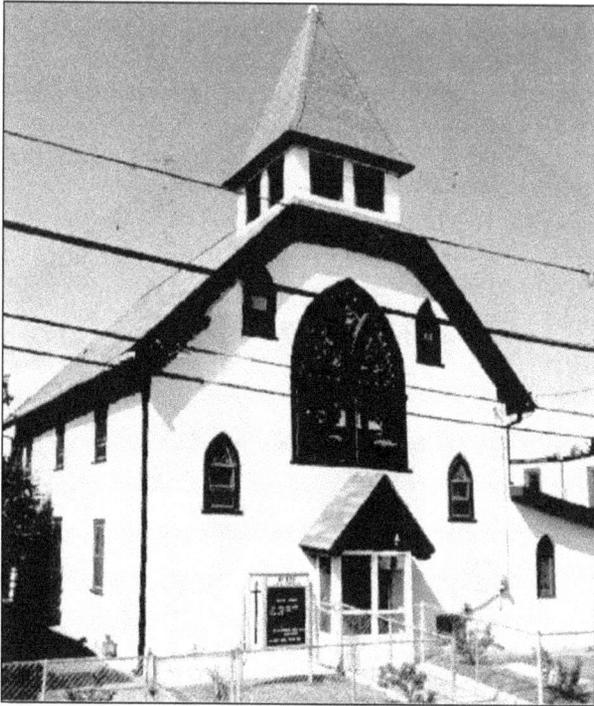

In 1875, the founders of Mount Zion African Methodist Episcopal Church met in Penn Hall on 10th Street, then called Serrill Street, to organize a Sunday school and Bible study class. It was the first black church in Darby. Today, there are fifth- and sixth-generation family members who still attend. In 1877, the lot was purchased for the church and Rev. Richard Barney, the first pastor, was assigned. Since its acceptance as an African Methodist Episcopal church, 43 pastors have served Mount Zion. In 1916, the upper story was added for the sanctuary. In the stained-glass window are the names of many of the church's early members. The annex was added in 1976. The congregation calls its church "a light set upon a hill."

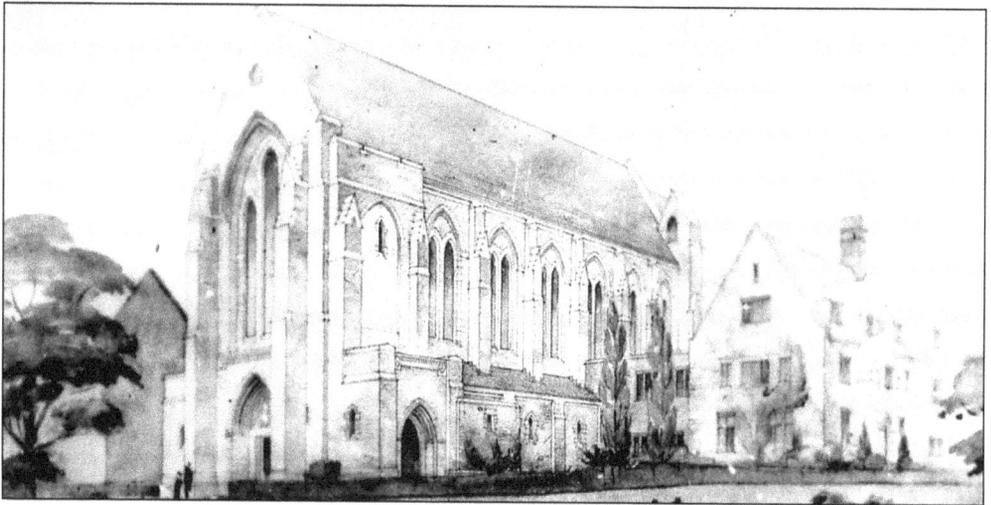

The Blessed Virgin Mary Roman Catholic Church began on April 2, 1913, when Fr. William A. FitzGerald was appointed founder and rector of the new parish. This English Gothic building, dedicated in 1914, is the only Roman Catholic church bearing the single name of the Blessed Virgin Mary. Built at Main Street and 11th Street (now MacDade Boulevard), it occupies the site where the Bunting mansion (built before 1699) was located. Early on, the mansion was used to hold Mass and for school classes, and later, it served as a convent for the nuns. Mass was also held in the Darby Theater while the church was being built. The first sacrament of matrimony was held in the theater on August 5, 1913. The deed to the property, executed on April 22, 1913, conveyed the property from George M. and Caroline K. Bunting and Morgan and Anna Miller Bunting to the Archdiocese of Philadelphia. (Courtesy the Blessed Virgin Mary Church.)

The Union Memorial Methodist Church was known as St. Matthew's Methodist Episcopal Church when it was organized on July 19, 1921, at the home of Rev. William R. Pearce at 108 Mulberry Street by Dr. J.W. Scott, the district superintendent of the South Philadelphia, Delaware Conference. The church rented Penn Hall on 10th Street, and Rev. J.M. Whitington was the minister. Building fund rallies were held until a church was built in 1923. In 1950, the "little church" was replaced with a new building and renamed Union Memorial Methodist Church. Additional property was purchased for future expansion. Shown is the interior of the church after more recent remodeling. (Courtesy Union Memorial Methodist Church.)

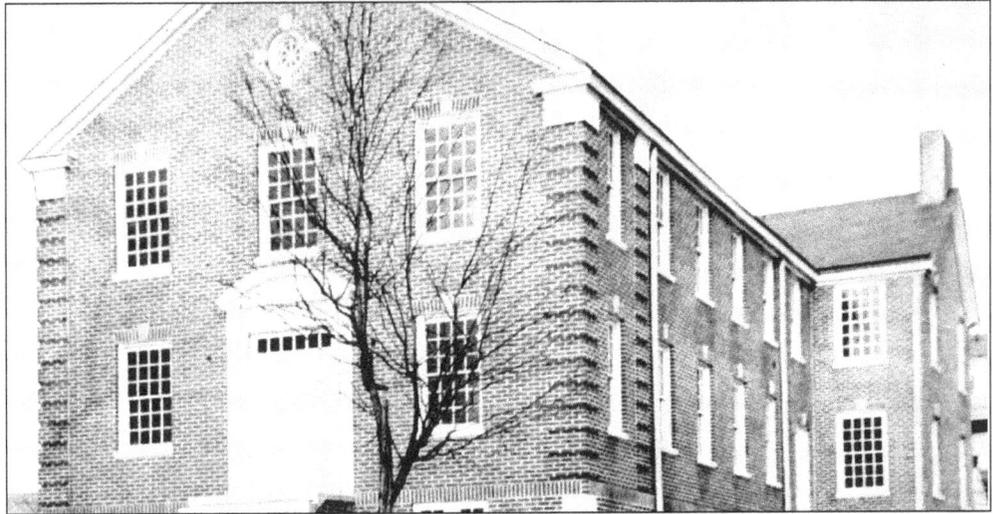

Maran Atha Tabernacle was founded in 1916 when several families in Norwood and Colwyn began home Bible studies with emphasis on the study of prophecy concerning the Second Coming. As the classes grew, they were combined and held in the reading room at 846 Main Street until 1922, when a church was organized. Bible teachers from the Bible Institute of Philadelphia (now Philadelphia College of Bible) were asked to serve as ministers. In April 1922, the church was chartered as Maran Atha Tabernacle, an Independent Fundamental Church of America. A church, an education building, and missionary apartments were built on Ridge Avenue. This building was destroyed by fire in 1982, and a new church was built. Maran Atha was known for its Christian day school and vacation Bible school. In 1960, the church had more than 100 missionaries doing full-time worldwide Christian work. (Courtesy the Temple University Urban Archives.)

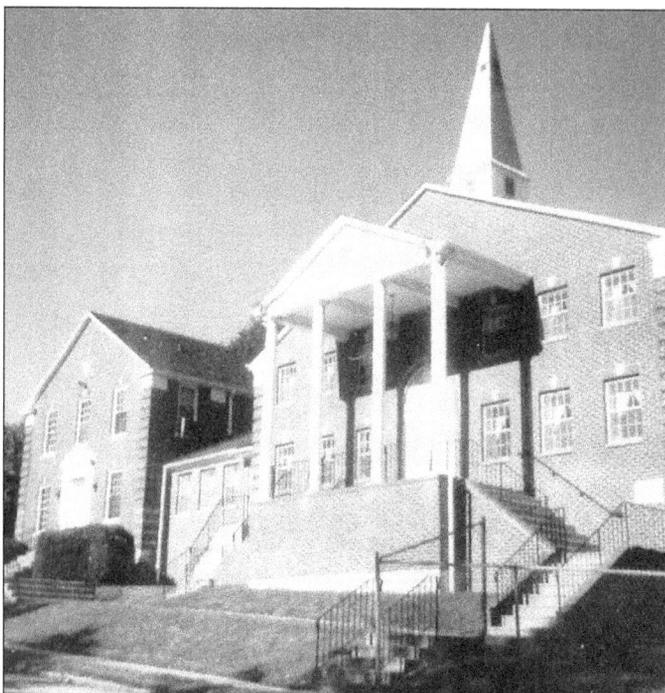

Maran Atha Tabernacle's new church was erected at 121 Ridge Avenue after fire had destroyed the first church in 1982. The building contains a gymnasium for the church's Christian day school, classrooms, a beautiful sanctuary, meeting rooms, and a large dining room with modern kitchen facilities. The church also has a Christian bookstore. (Courtesy the Temple University Urban Archives.)

The Ogudath Israel Synagogue was established at the northwest corner of 6th and Main Streets when the congregation bought the building in 1925. It was then the only synagogue between the Philadelphia border and Chester. It had a Hebrew school for the children and sponsored a football team called the Sons of David. Shown here in a photograph taken c. 1950, the synagogue served the Darby area Jewish community for many years until members started to move to other areas. After the membership diminished, the building was sold. Today, it is used as a restaurant.

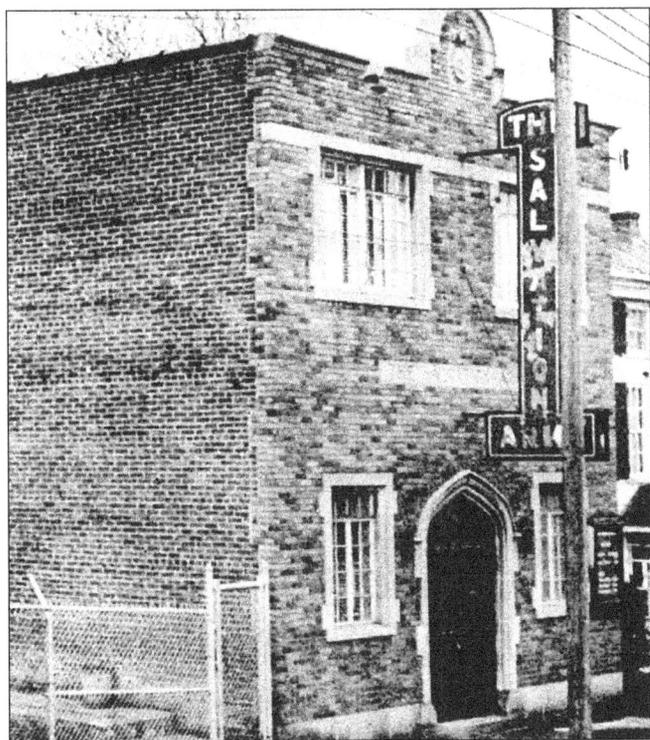

On September 18, 1895, the Salvation Army Darby Corps came to Darby. By 1915, the organization had moved to 248 Mill Street, and by the following year, it had acquired property at 29 North 10th Street. From there, the corps served the community until 1922, when it moved to 805 Main Street. In 1927, the corps purchased quarters at 22 North Ninth Street, where it remains today. The Salvation Army's purpose has always been to lead men and women into a proper relationship with God. In the early years of the mission, the corps' music attracted residents and shoppers on Main Street and involved them in singing Christmas carols and hymns.

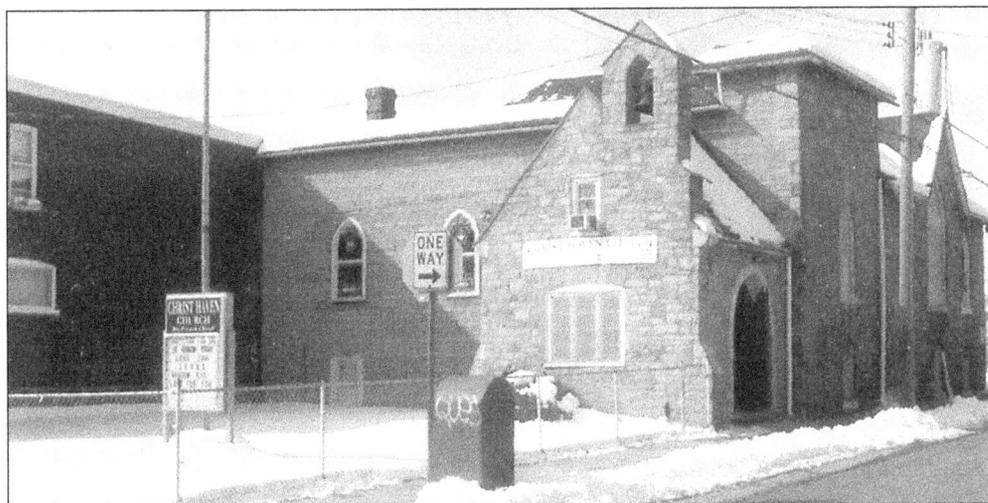

The Trinity Evangelical Lutheran Church was formed on December 2, 1900, when 23 people met in a storeroom at 5th and Pine Streets, now known as Gotshall's apartments. Rev. W.H. Harding became the first pastor. A lot was purchased at 5th and Walnut Streets, and in the spring of 1902, building began with the aid of the Lutheran Board for Home Missions. The cornerstone of the church was laid in July 1902. The building was completed and dedicated in May 1903 with a membership of 71. A Sunday school, formed a month before the church was formed, had 200 students. The parsonage was built in 1914. At one time, the Sunday school membership was 333. One of the subsequent pastors, Rev. Charles S. Jones (who served from1923 to 1948), wrote A Walk to Darby, documenting some of Darby's history. The church is now the home of Christ Haven Church. (Courtesy Frederick S. Saunders.)

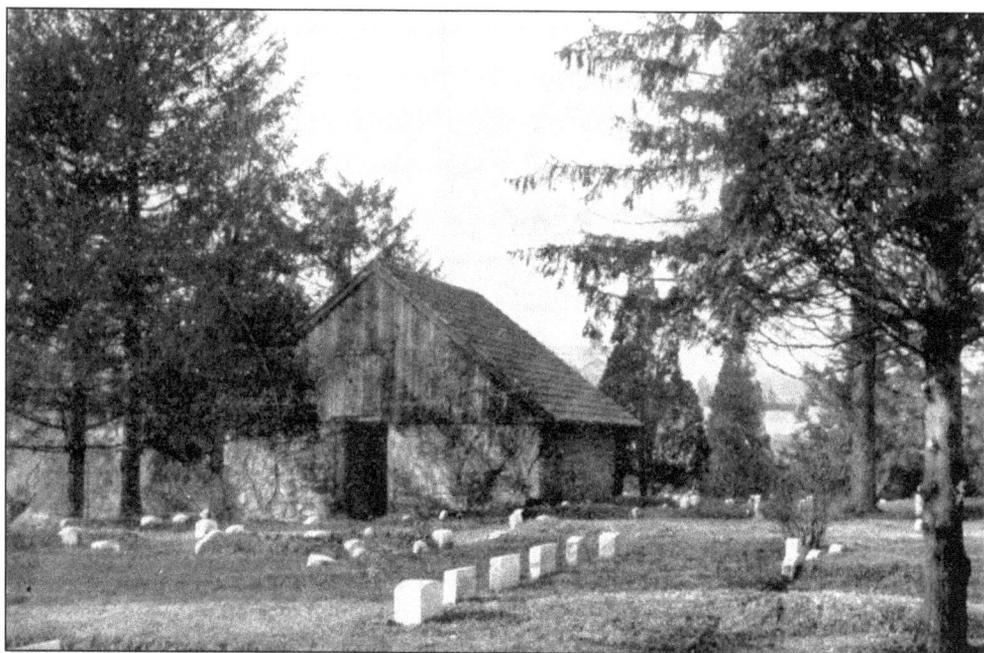

This view of the Darby Friends Meeting Burial Ground was taken before 1900, when the stable was still there. This was the site of the original meetinghouse, and the stable was for the horses of members who had to come from a distance for worship. The first meetinghouse, a log cabin, was replaced by what is believed to be a brick building that was used by Revolutionary War soldiers when they were in Darby.

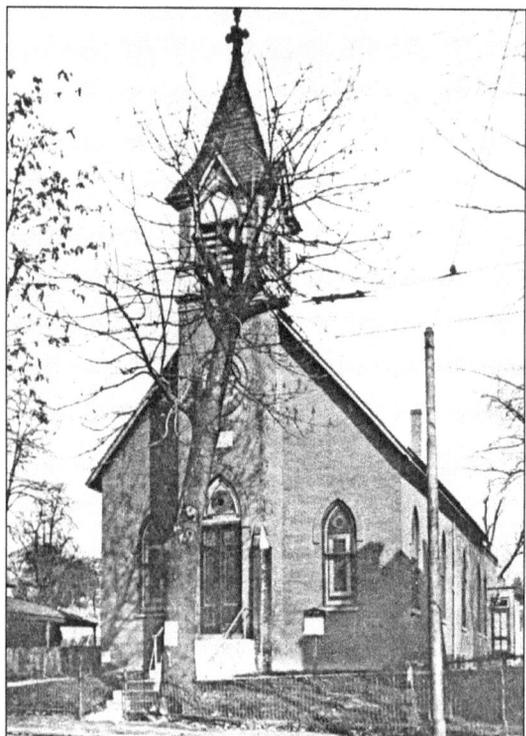

Mount Zion United Methodist Church was founded in 1807, when 20 men and women residing in the Darby area formed a Methodist class meeting, which became Mount Zion Methodist Meeting. Among these people were William Palmer, David Dunbar, Charles and Samuel Levis, Enos Williams, Hannah Shaw (Mrs. Oswold Patchell), Charles Grant, and Phoebe Hoofstechler (Mrs. George Lincoln). In 1808, Dr. Phineas Price purchased property on Springfield Road from Joseph Wood and built a church 45 feet square. As Methodism grew, so did Mount Zion Methodist Meeting, and by 1882, a new church was built at 921 Main Street. This view of the new church is from 1913. The cornerstone was laid by Bishop Matthew Simpson on February 2, 1882. By 1930, the church had been remodeled and a large education building and a parsonage had been built. At one time, the church had 750 members. (Courtesy Mount Zion United Methodist Church.)

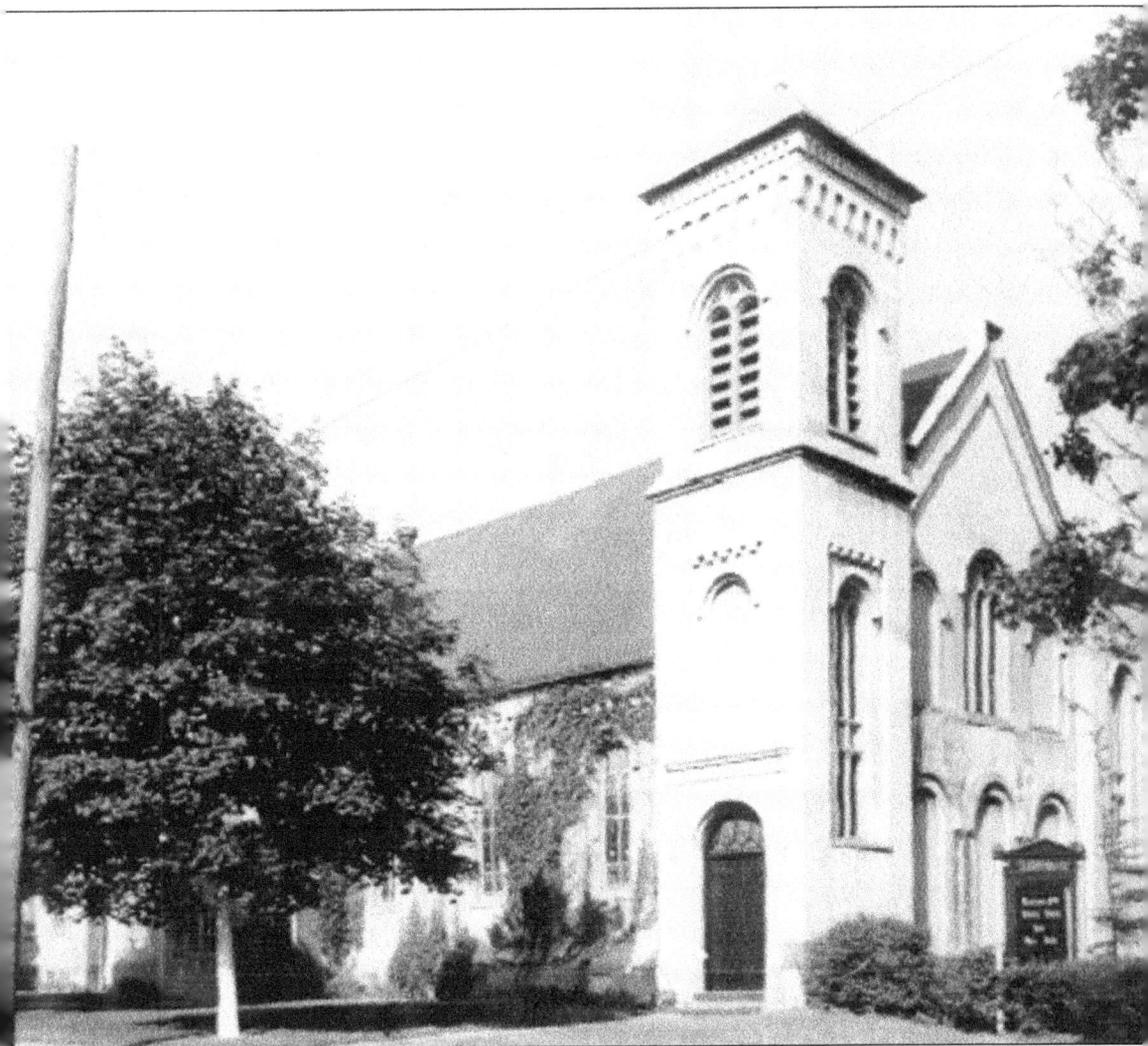

The First Presbyterian Church of Darby, at 4th and Main Streets, had its origin in 1852–1853, when preaching services by the Rev. J. Addison Whitaker were held. Official organization followed on October 1, 1854. Designed by architect John Nottman of Philadelphia, the church was first occupied in 1857. Although there have been alterations, the building survives as one of Nottman's earliest examples of the Romanesque Revival style, of which the round arch is most characteristic.

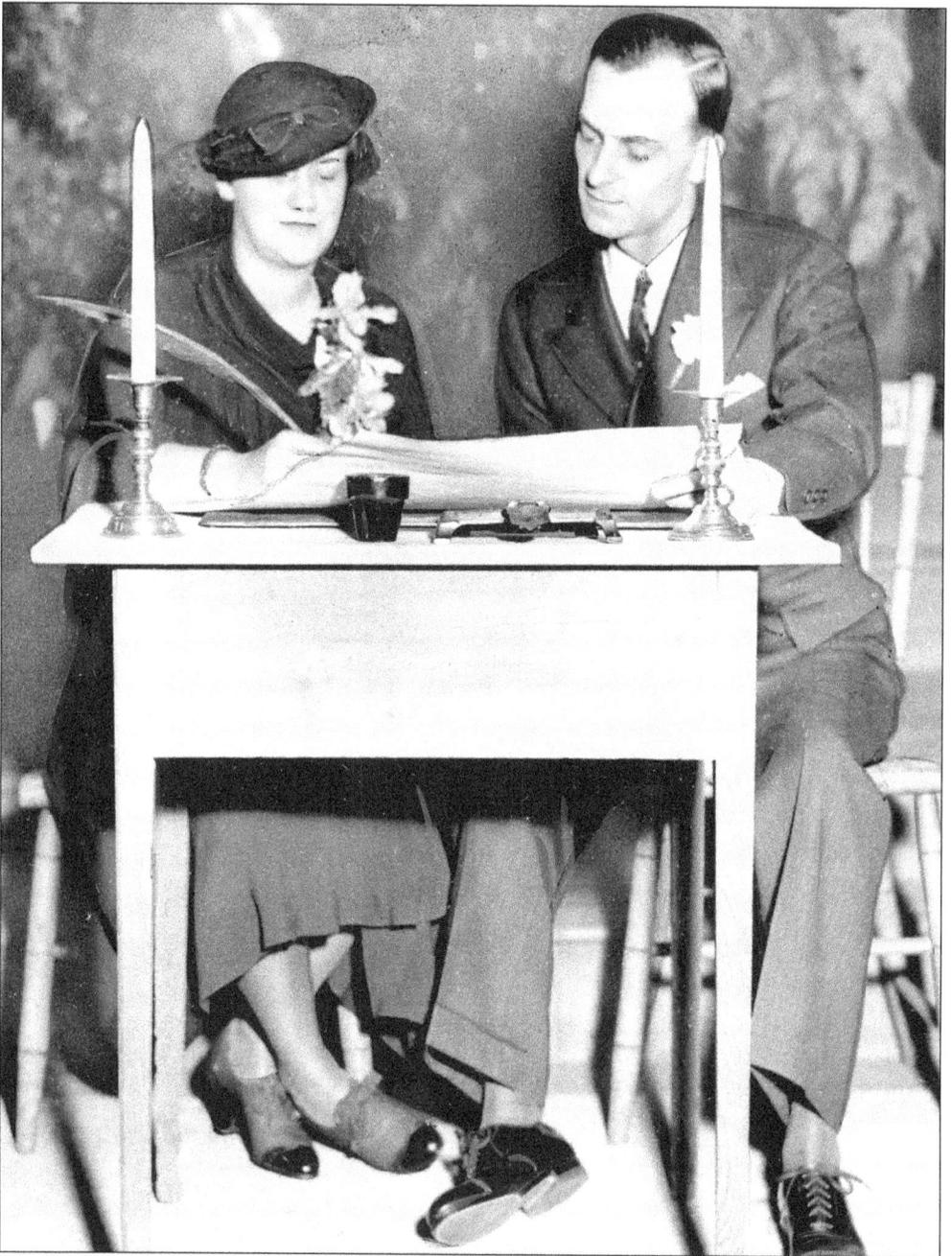

On October 29, 1935, Hilda Gaul and William H. Brown were married at the Darby Friends Meeting House. It was the first marriage held there in 25 years. At the time of the marriage, the marriage table was more than 200 years old. The old quill pen and marriage chairs from the meeting were used for the Browns' marriage ceremony. Some of the benches from 1697 are still used in the meetinghouse. (Courtesy the Temple University Urban Archives.)

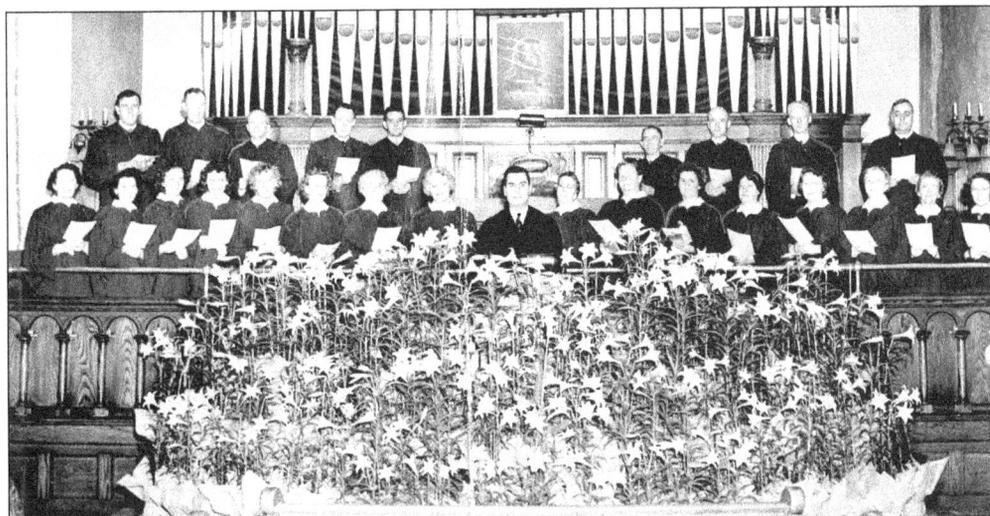

The choir from First Presbyterian Church of Darby was featured in the *Evening Bulletin* on Easter Sunday, April 10, 1944. (Courtesy the Temple University Urban Archives.)

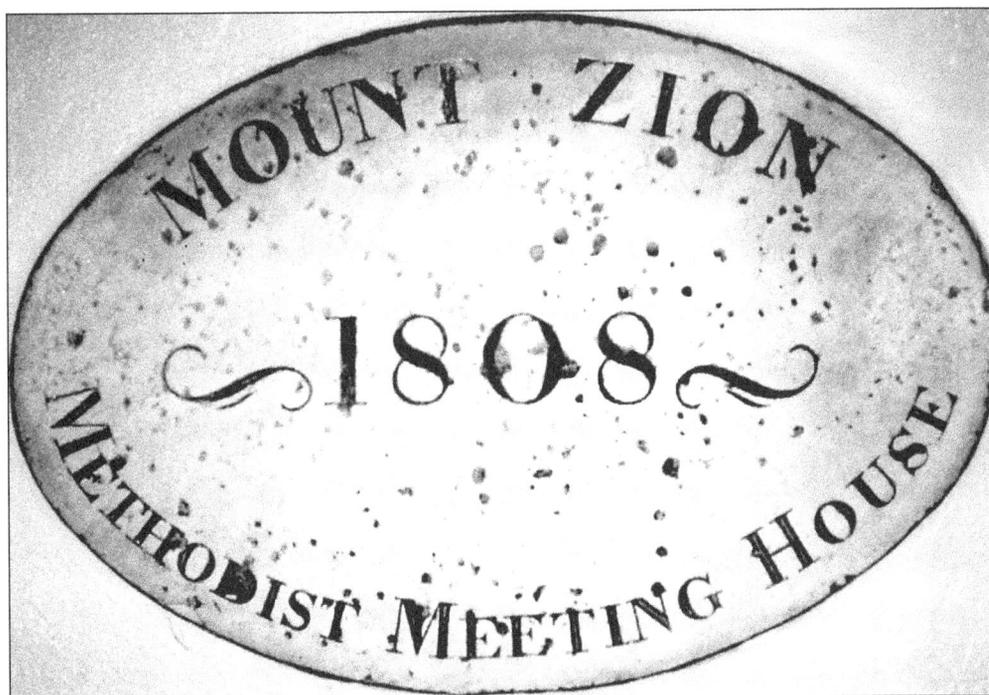

This marble cornerstone from the old Mount Zion Meeting House, built in 1808, has been placed in the education building of Mount Zion United Methodist Church, at 921 Main Street. (Courtesy Lindy Wardell.)

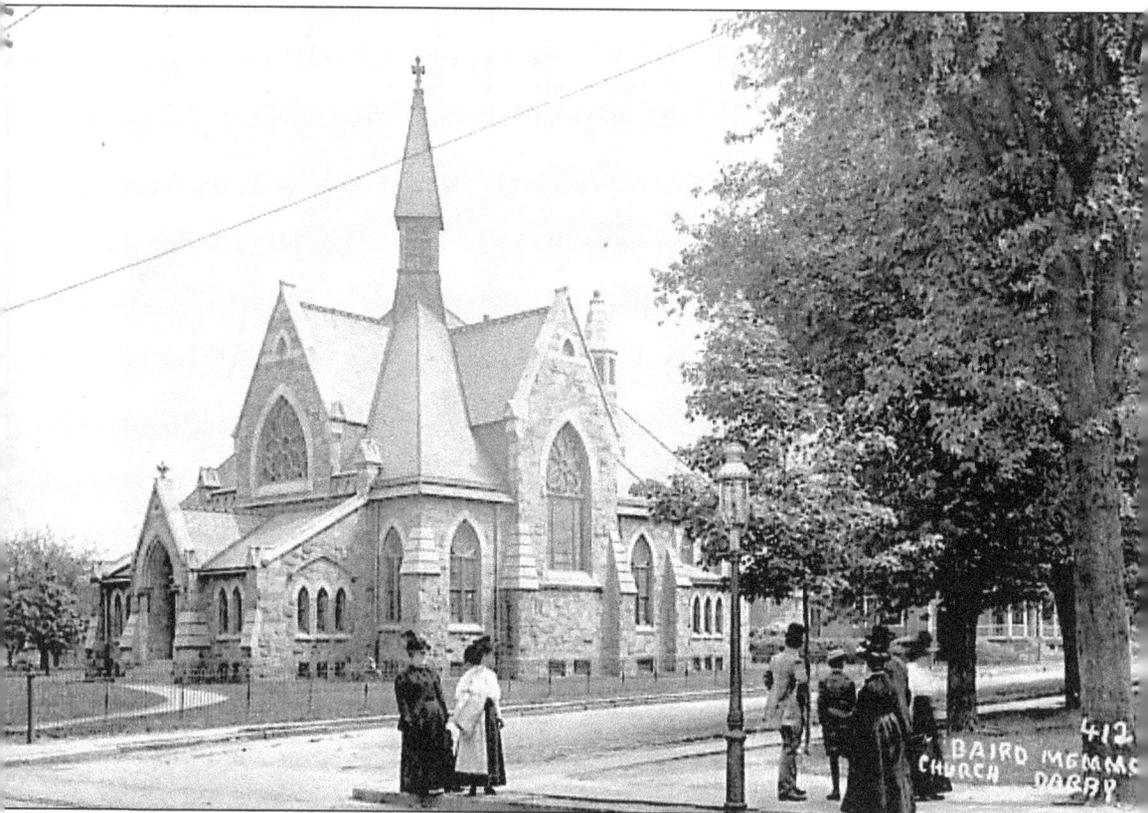

Baird Memorial Chapel at Darby Presbyterian Church is directly across from the church on 4th Street. It was built with funds and property donated by the Baird family who owned Baldwin Locomotive Works. This photograph was taken c. 1900.

Three

HOMES AND
NEIGHBORHOODS

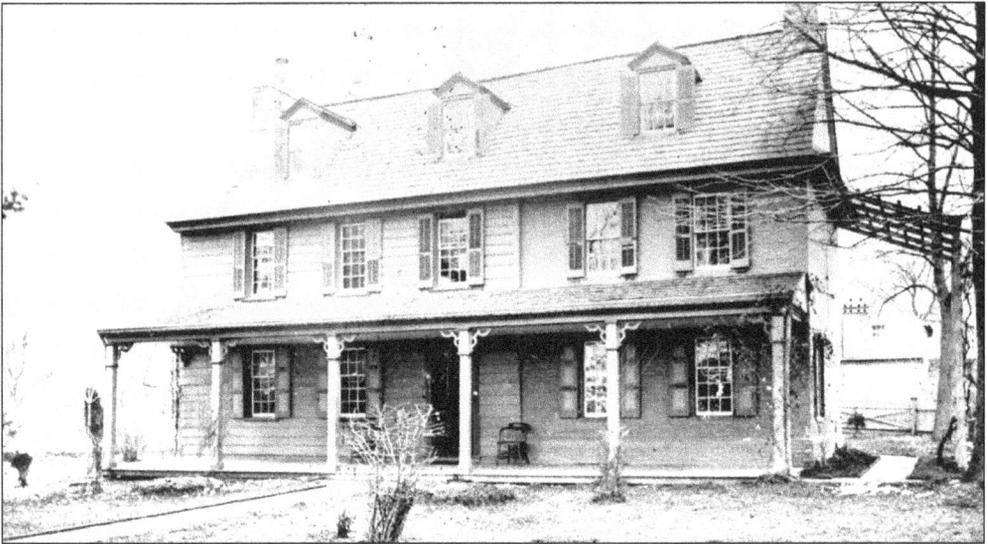

This house has traditionally been referred to as the Bunting mansion. It was built *c*. 1700 and belonged to the Bunting family. It was included in the land transferred to the Blessed Virgin Mary Church by Caroline K. and Morgan Bunting on April 13, 1913. Used by the church for several different purposes, it was moved to accommodate building plans and was later destroyed by fire. (Courtesy the Library Company of Philadelphia.)

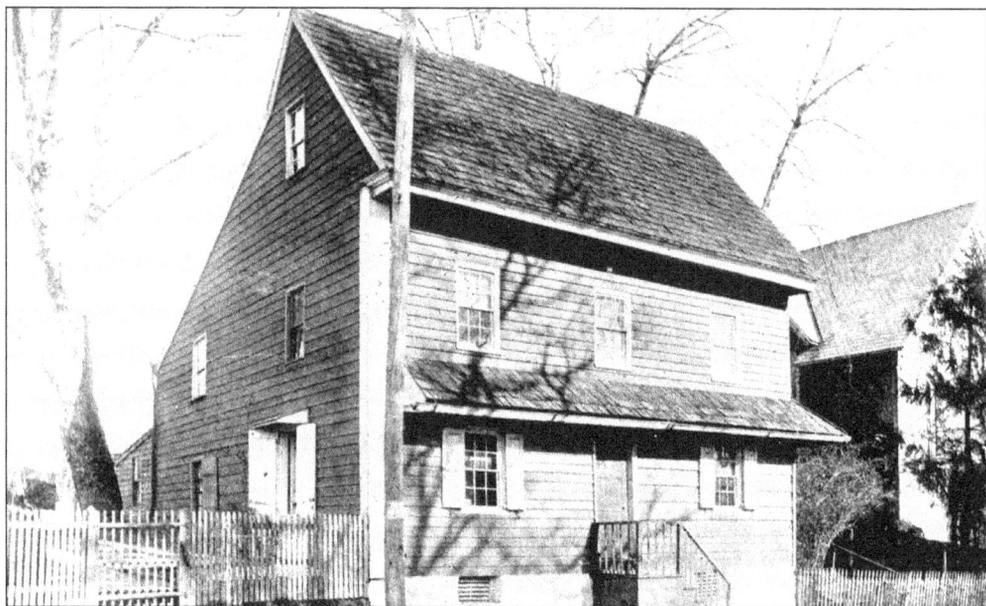

The Blunston Bake House building, built before 1699, was an original John Blunston property located between the tenant house in front of the meetinghouse and the library on Main Street. Later tenants used the house as a home. It was mentioned in advertisements and letters as an example of a permanent Pennsylvania settlement to attract new settlers.

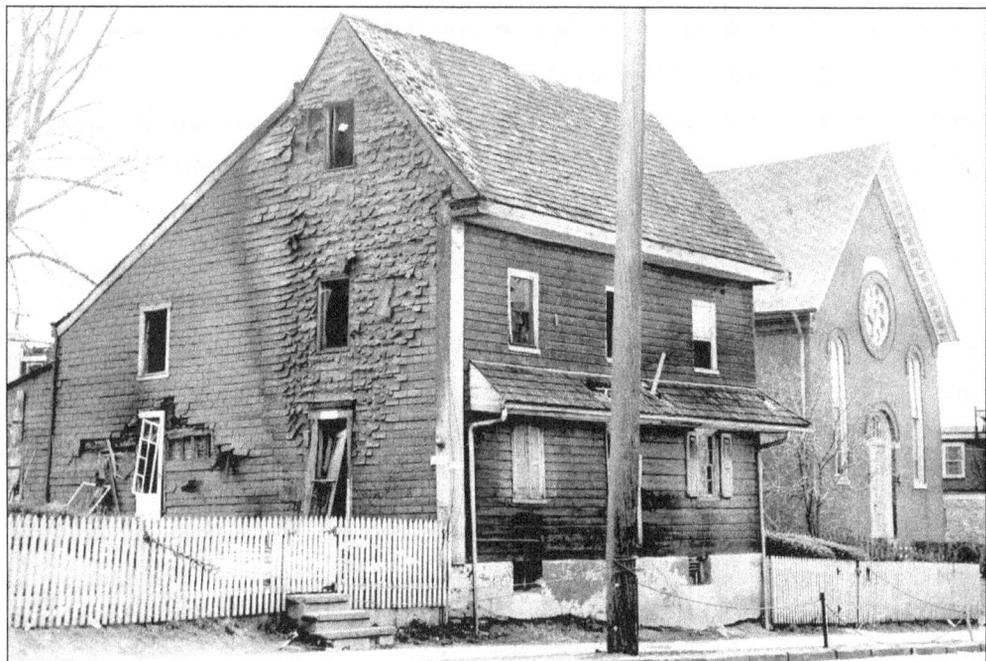

On May 23, 1951, the Blunston Bake House was badly damaged by fire. The Darby Friends Meeting was forced to demolish it. The home had been inhabited by family and tenants over the years and was the first bakery for the new settlement. When coming to Philadelphia, John Blunston listed his occupation as a biscuit maker. (Courtesy the Temple University Urban Archives.)

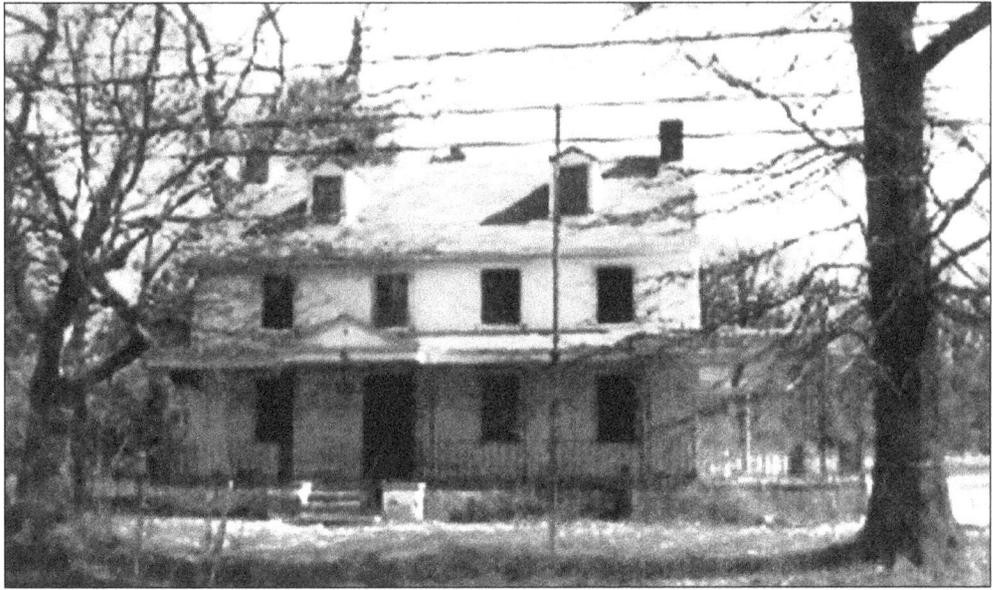

The Bunting Friendship Freedom House, at 1205 Main Street, is an original John Blunston property. The middle part of the rear portion dates from 1699. The house has 14 rooms and 12 fireplaces. Members of the Bunting family lived in this house until the 1950s. During the Civil War, the Bunting family was known to have helped slaves to freedom. The house is an Underground Railroad site and is considered to be the heart of Darby because of its involvement in every era of Darby history. The Friendship Freedom Foundation used the house as its headquarters for interracial programs, education classes, and senior programs. This photograph was taken c. 1955.

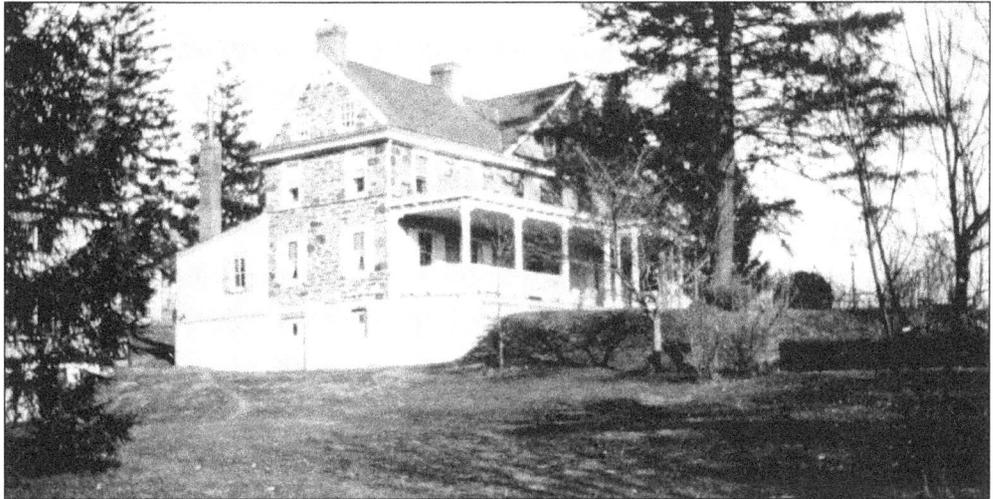

Woodmount is also known as the Whitely house. The structure was built at 715 Darby Terrace c. 1750 and was owned in 1882 by members of the Whitely family, mill owners in Upper Darby and Darby. Samuel Mackey bought it from Joseph B. Conover, who obtained it from Stillwell S. Bishop, a Philadelphia merchant, in 1864. Prior to that, Abraham F. Hunt had obtained it from Charles Longstreth, a wallpaper manufacturer. Between 1791 and 1845, the property and parts of this house belonged to James McIllvain and his wife, Rebecca. (DBHPS, Harold S. Finigan Collection.)

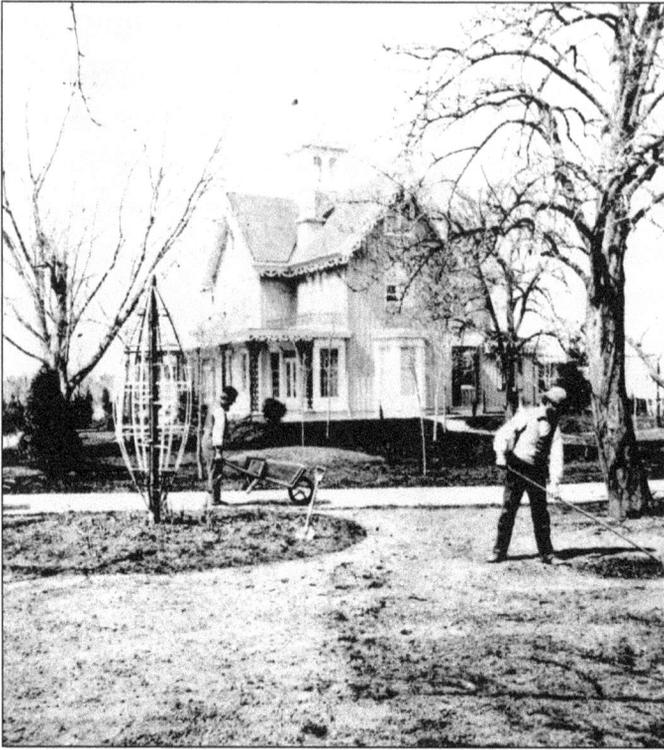

This photograph of the Baird house on Summit Street shows gardeners working in the yard. The Baird family owned the Baldwin Locomotive Company. They owned a large estate bordering on Summit Street that extended into Yeadon. (Courtesy the Temple University Urban Archives.)

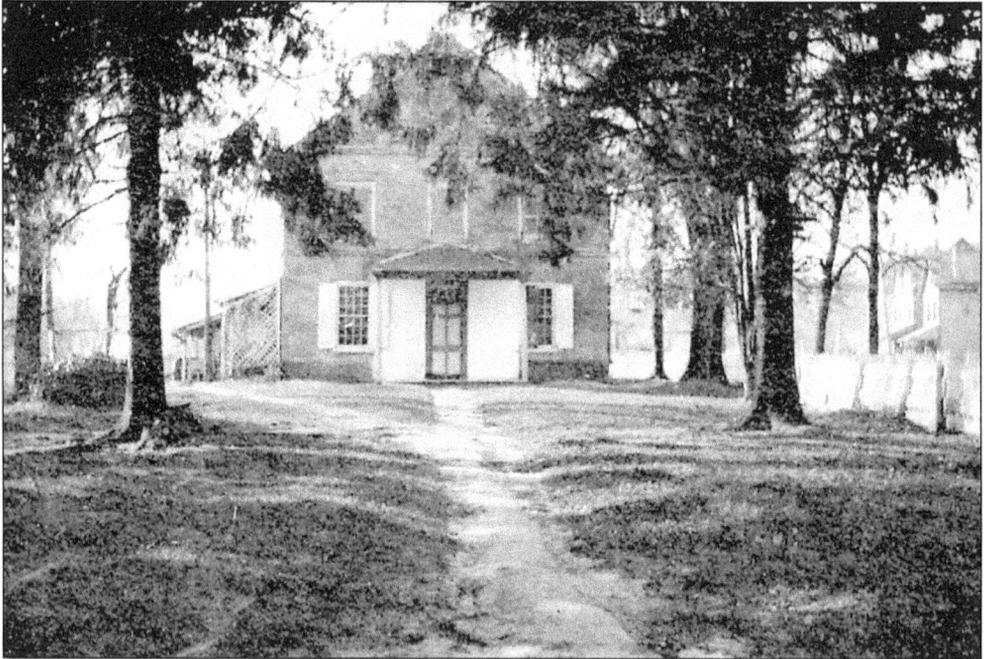

The Pusey house, formerly on Moose Field on Summit Street, was used by the Order of the Moose for its headquarters. The house was destroyed by fire, and the Order of the Moose built a new brick building. This building was sold to Darby Borough and is now used as the municipal building. The property was part of the Baird estate. (DBHPS, Harold S. Finigan Collection.)

The building at 1006 Main Street is a gracious example of Georgian architecture. It was built on a one-acre tract extending from Main Street to the millrace *c.* 1734 for Sarah Fearne Bunting, granddaughter of John Blunston and sister of Martha Fearne. Many well-known people visited this house, whose owners were known for their hospitality. Several generations of Blunston and Bunting descendants have lived here. It has been known as an Underground Railroad site since the Civil War. It has been sold several times in the last 50 years.

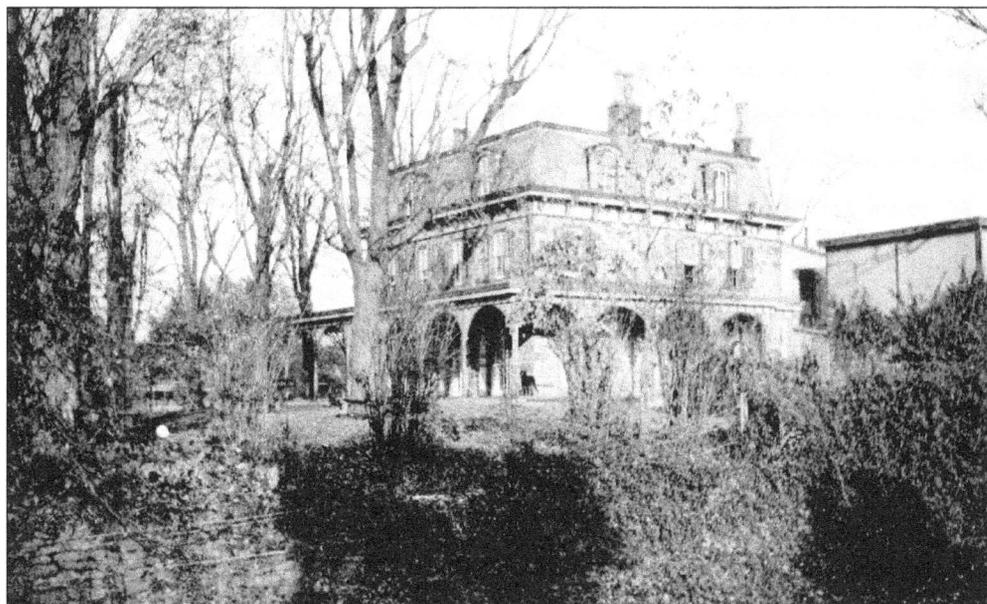

The Cochran house is located at 2nd and Main Streets. Henry S. Cochran was the head weighter at the Philadelphia Mint. Built *c.* 1880–1885, this house and several others of similar architecture were constructed on the hill on the east end of Main Street. (DBHPS, Harold S. Finigan Collection.)

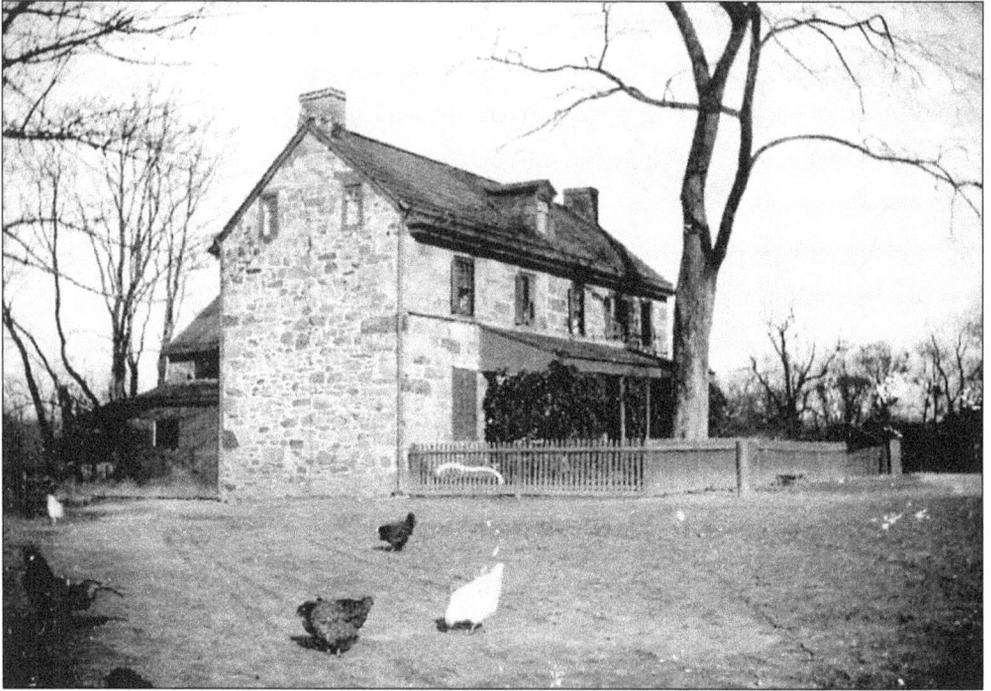

The old house on the Scott estate is shown c. 1899. (DBHPS, Harold S. Finigan Collection.)

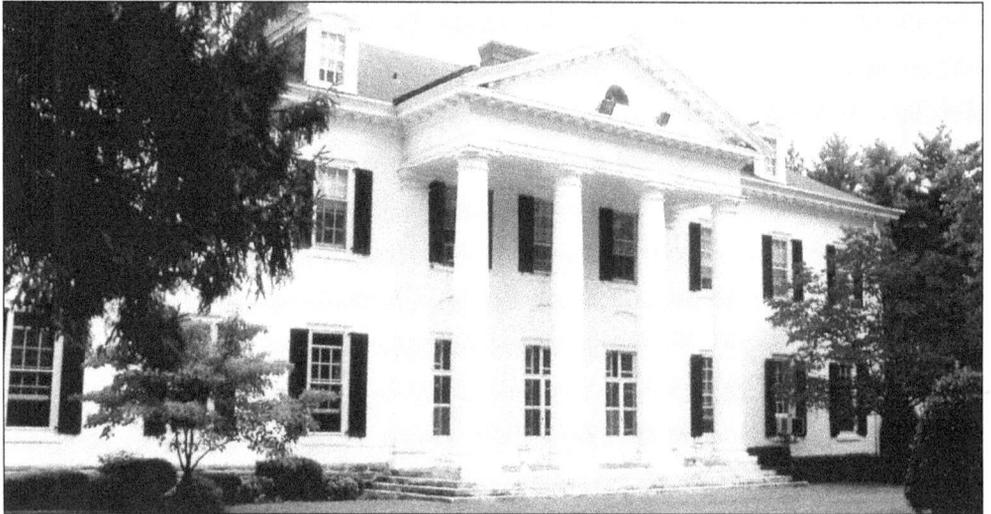

Woodburne was the estate of Thomas Scott, vice president of the Pennsylvania Railroad. Located on Springfield Road, the property had several houses, some of which had been Bartram residences. The mansion, designed by Horace Trumbauer, was built by Edgar Scott. Thomas Scott was Pres. Abraham Lincoln's assistant secretary of war and was in charge of the transportation department. In 1861, Scott is said to have saved Lincoln's life from an assassination attempt by rerouting his train to Baltimore. The property is eligible for the National Register of Historic Places. The house was left vacant for several years after the Scotts moved and was later purchased by the Sisters of the Divine Redeemer and used as an orphanage for girls. The mansion was renamed St. Teresa's Villa and is now used for the care of elderly women. (Courtesy Frederick S. Saunders.)

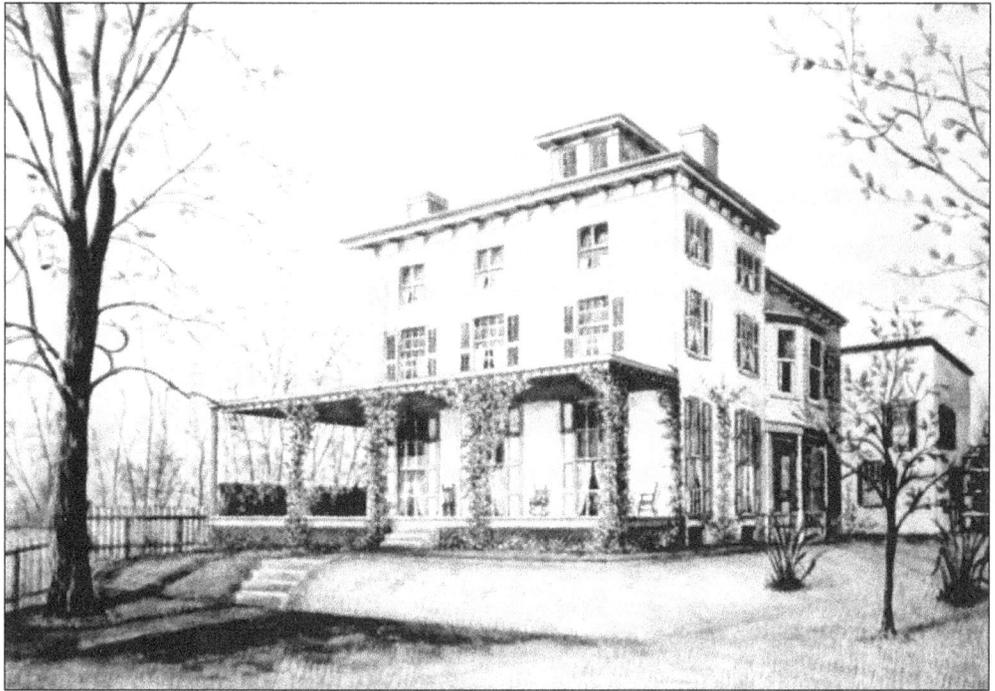

The house at 15 Ridge Avenue was one of the Verlenden homes. It was built on the mill property and was close to the corner of Ridge Avenue and Main Street. (Courtesy Donald Parker Verlenden.)

This view of the Baird estate on Summit Street is from a collection of photographs on an 1899 handmade calendar. (DBHPS, Harold S. Finigan Collection.)

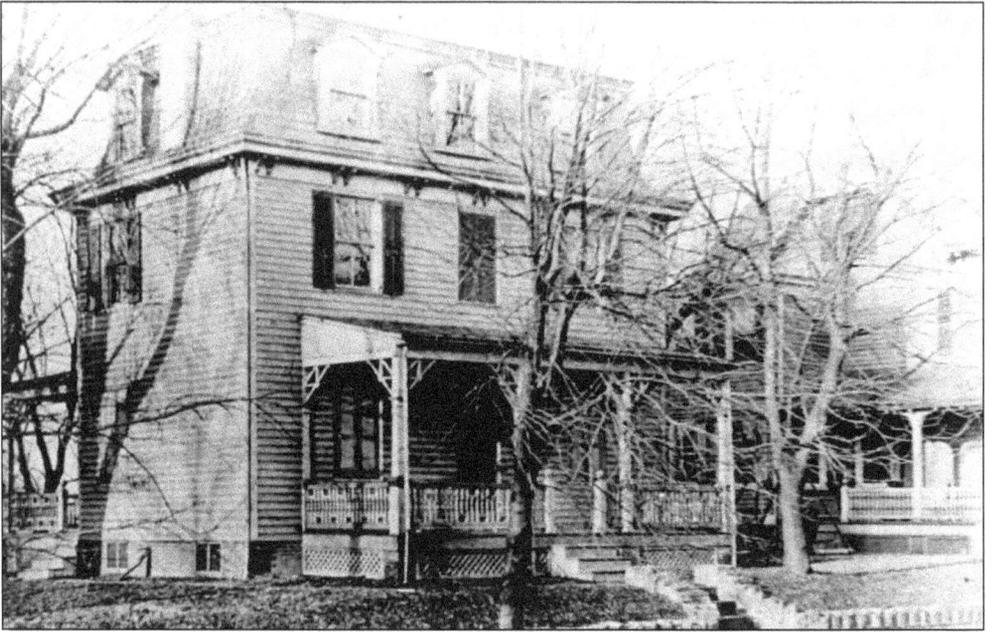

This house, located at 12 Ridge Avenue, was a Verlenden family home. The Verlendens were owners of the Verlenden Imperial Mills and lived close to the mills that made wool-worsted yarns. The home was built by Charles Verlenden, the uncle of W. Lane Verlenden II. The house and childhood of W. Lane Verlenden II is described in the book *The Verlenden Family 1800–1988*. (Courtesy Donald Parker Verlenden.)

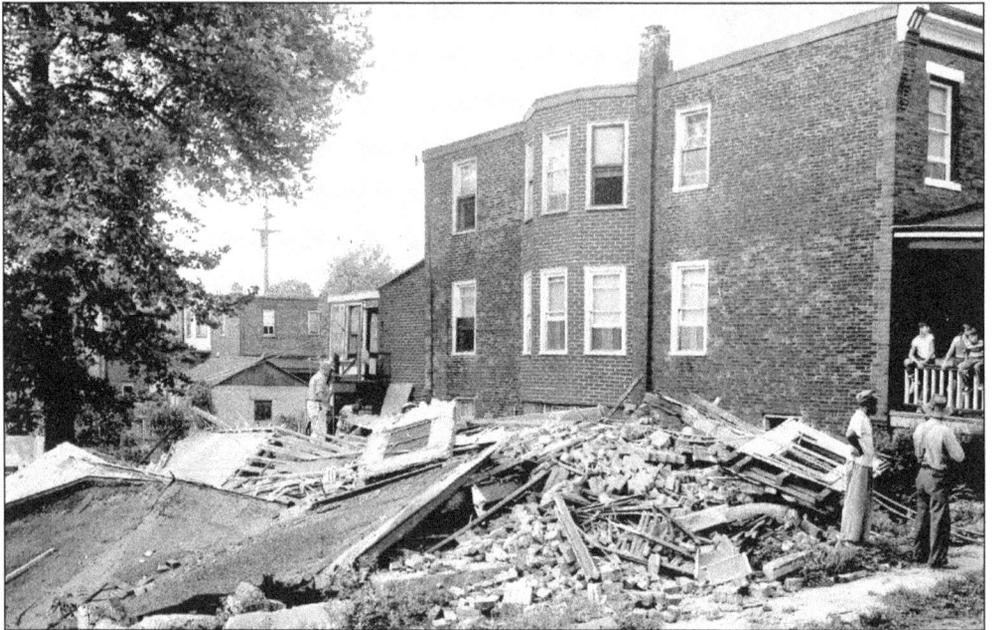

The house at 4 Greenway Avenue collapsed in the 1950s, minutes after Victor Murray led his family to safety. Murray noticed structural damage and warned his wife, Elizabeth, and his children to leave the house. Minutes later, he and his family watched as the house collapsed. (DBHPS, Lynn Murray Collection.)

The Painter house at 1016 Main Street was built in 1870 on nine acres of land owned by the Sellers family. Dr. William Painter and his wife called the property Painter's Gardens, and he had his medical practice there until his death in 1919. The house, a fine example of Queen Anne architecture, has been partially restored.

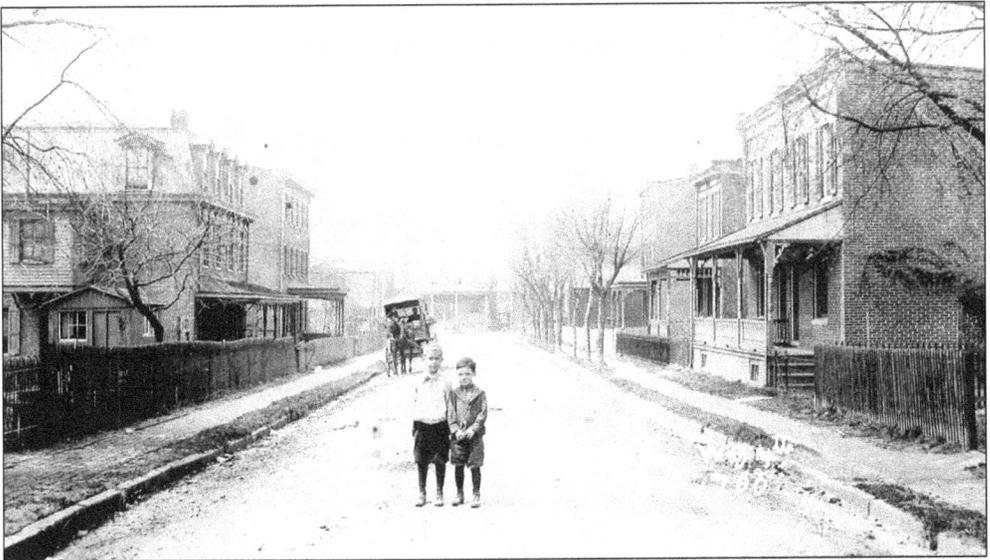

This photo postcard shows Franklin Street in 1900. Most of the homes in this area were built between 1880 and 1900. (DBHPS, Lois Burchill Collection.)

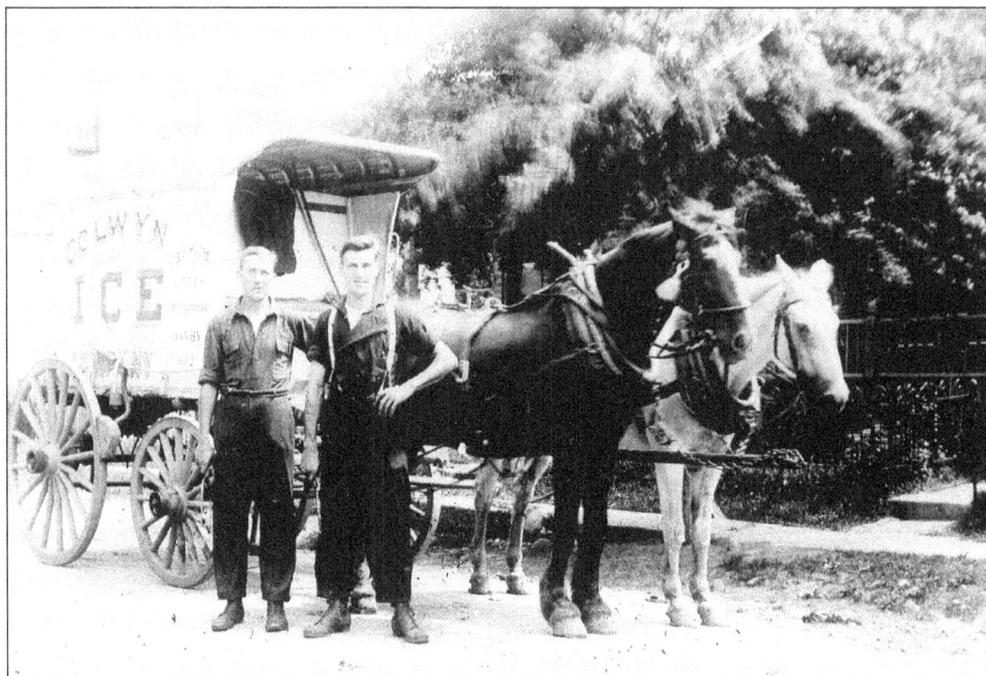

Ice wagons and horses were familiar in the close-knit neighborhoods of Darby. Vendors and delivery people were trusted members of the community. Horses knew their routes well and would move ahead to the next house or corner while the deliverymen took ice, milk, bread, and other products up to the previous house. (Courtesy Ruth Niles and Dorothy Crane.)

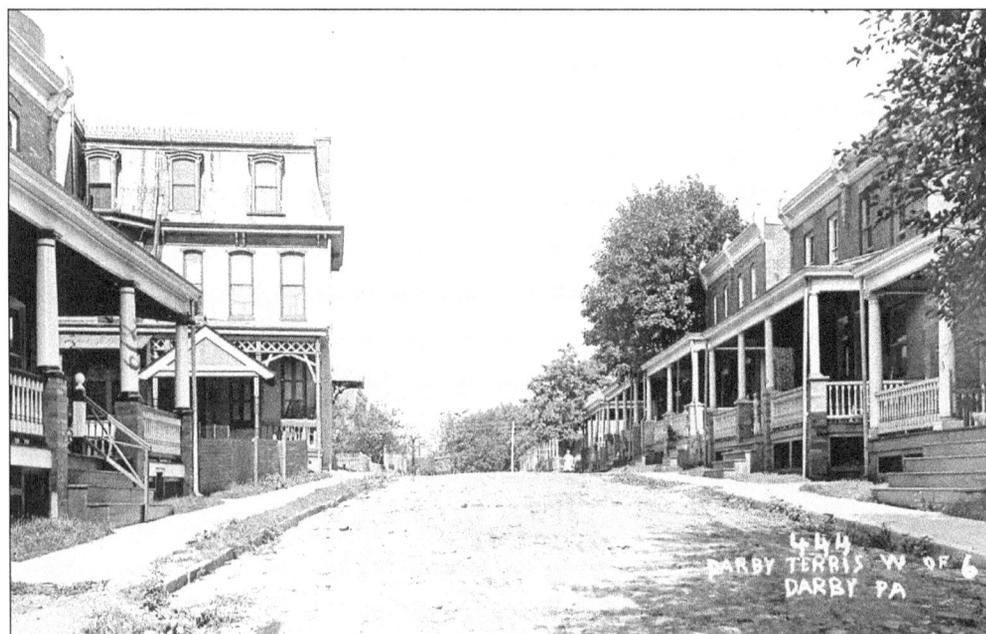

This photo postcard shows Darby Terrace c. 1900. (DBHPS, Lois Burchill Collection.)

This photograph of Elizabeth Levis's home was taken in 1888–1889. The house was located at the corner of Springfield Road and MacDade Boulevard. (DBHPS, Harold S. Finigan Collection.)

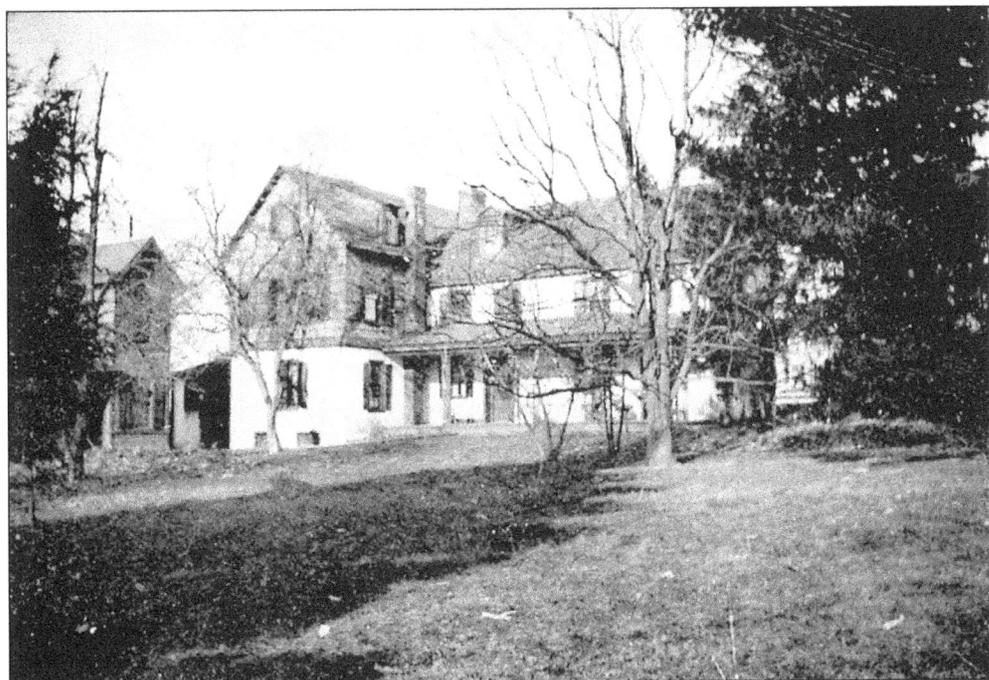

The Bailey home on Lansdowne Avenue is seen in this photograph, taken prior to 1899. Early residents of Darby, the Bailey family owned Bailey Banks and Biddle Jewelers. The physicians' office building of Mercy Health Center was built on part of this estate. (DBHPS, Harold S. Finigan Collection.)

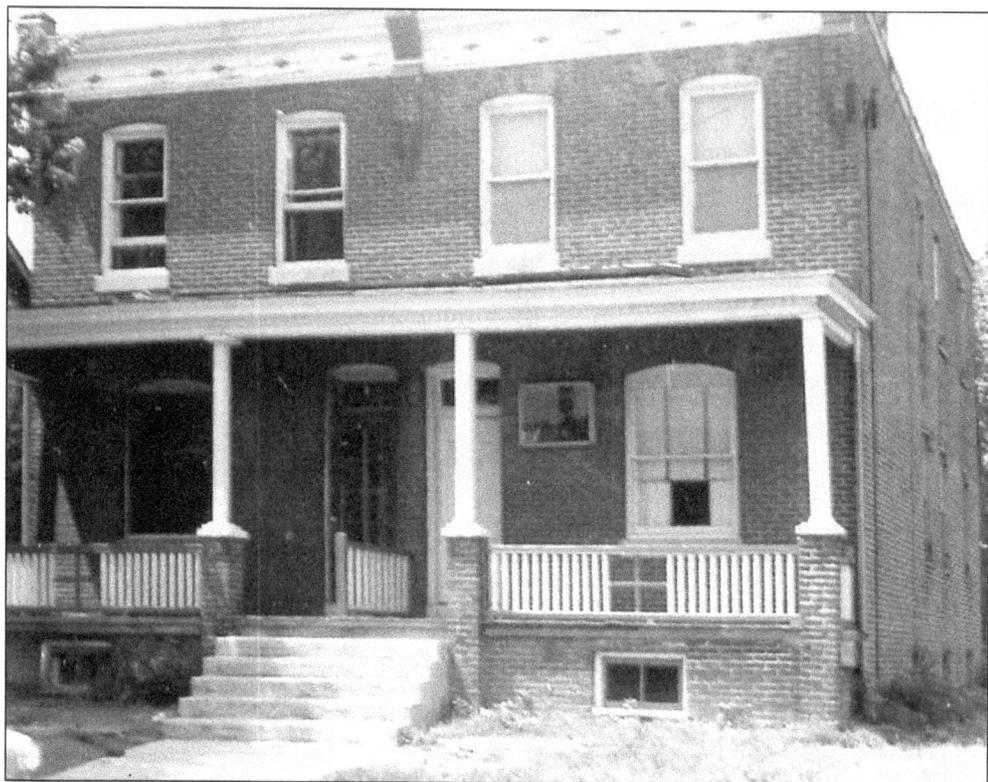

The Rose of Sharon Masonic Lodge No. 39, located on North Ninth Street, is pictured before it was remodeling in 1940. (Courtesy the Rose of Sharon Masonic Lodge No. 39.)

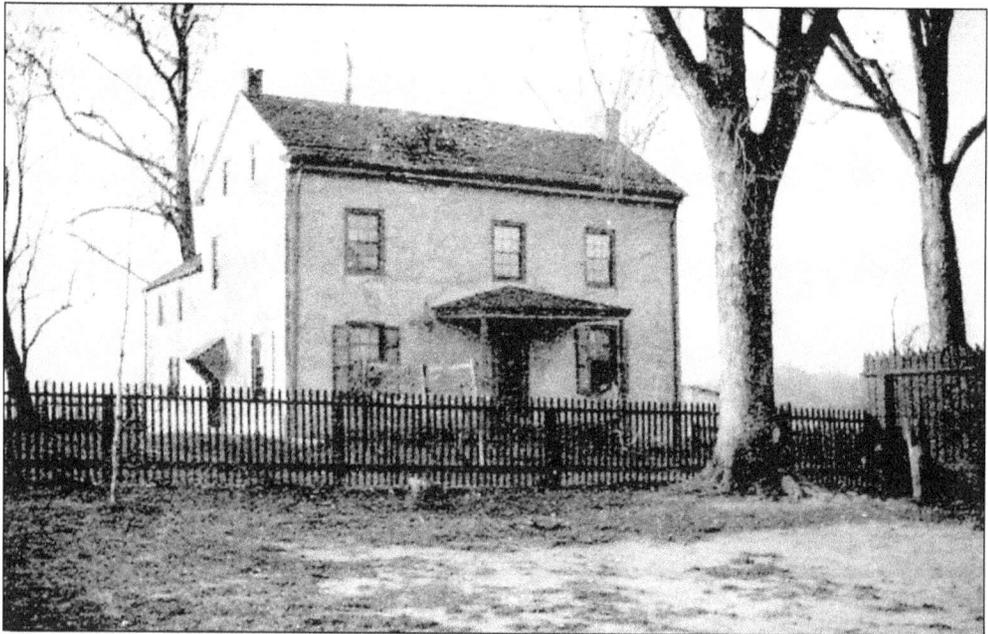

The members of the Moore family were early settlers of Darby. The Moore property, at 6th and Spruce Streets, is shown in 1899. (DBHPS, Harold S. Finigan Collection.)

Four

MAIN STREET

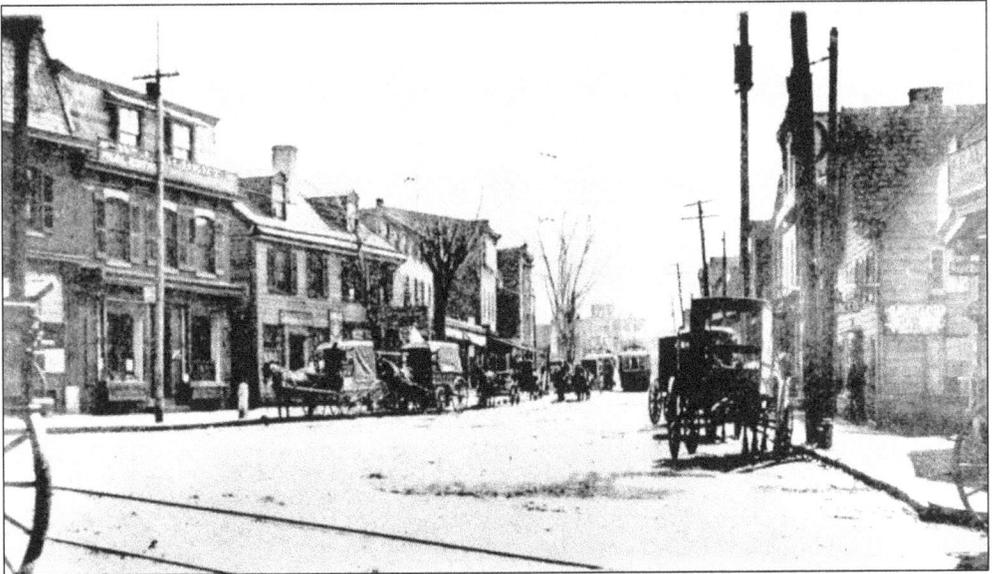

In this c. 1880–1885 view of Main Street, the building on the left is the Gilbert Real Estate office. As much as Main Street has changed, it still retains the feeling of the late Victorian era. (Courtesy the Historical Society of Pennsylvania.)

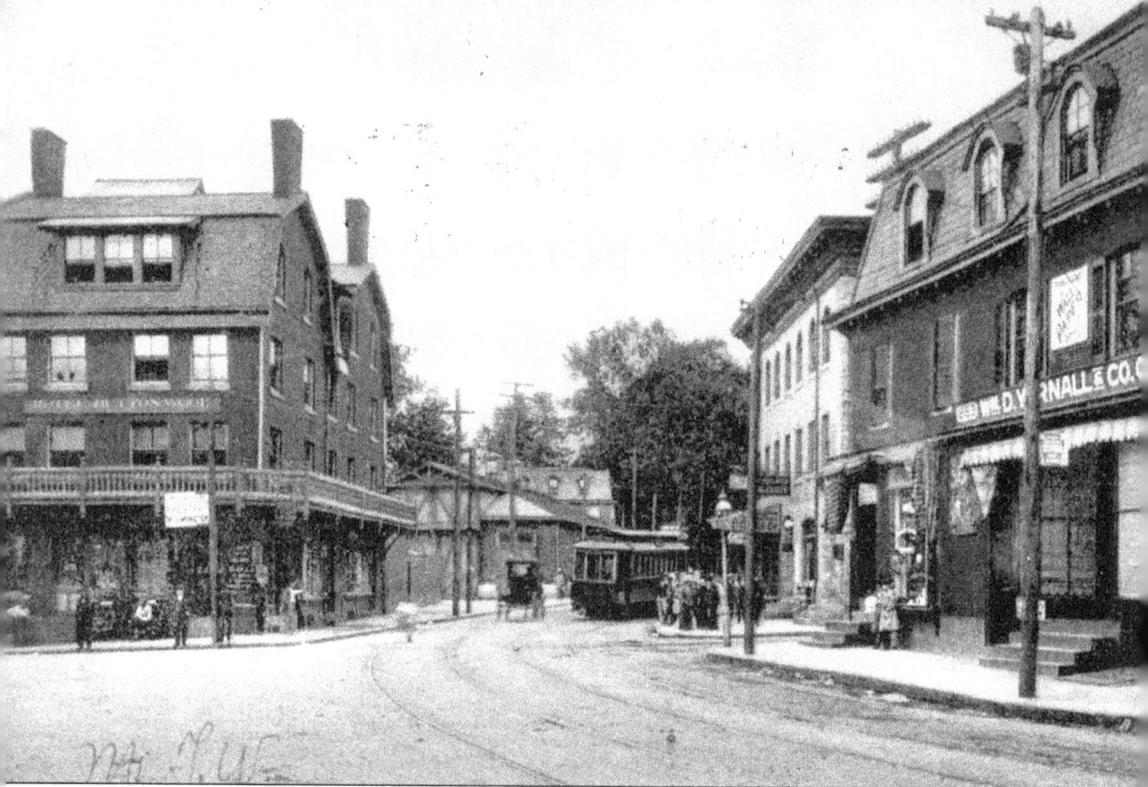

This view of Main Street soon after 1900 looks west from 9th Street. The Buttonwood Hotel is on the left. The Yarnell store was located at 889 Main Street.

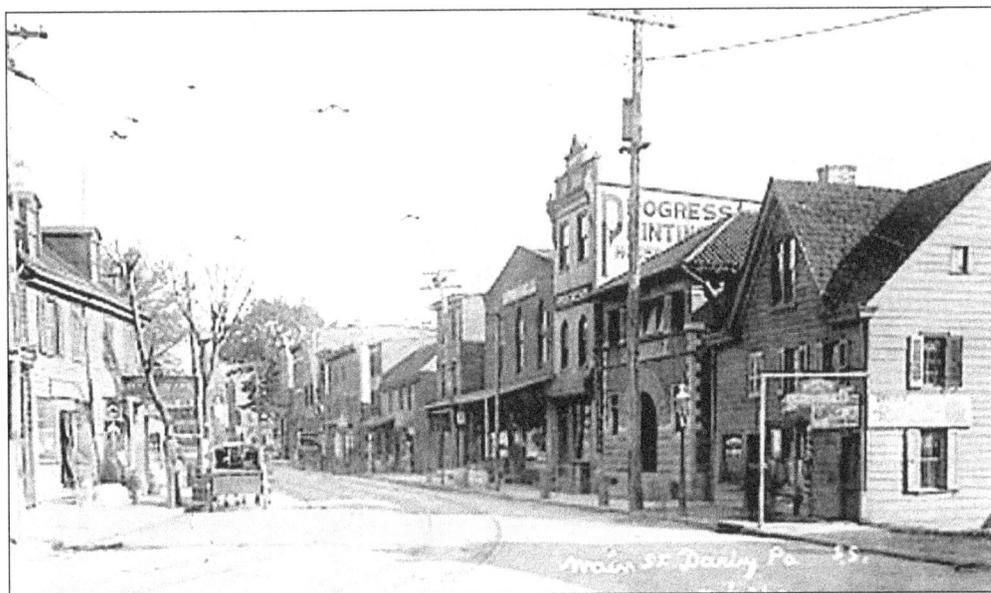

This view looks east on Main Street sometime after 1886. The second building from the right is the Darby National Bank, which was designed by Morgan Bunting and Frank Furness.

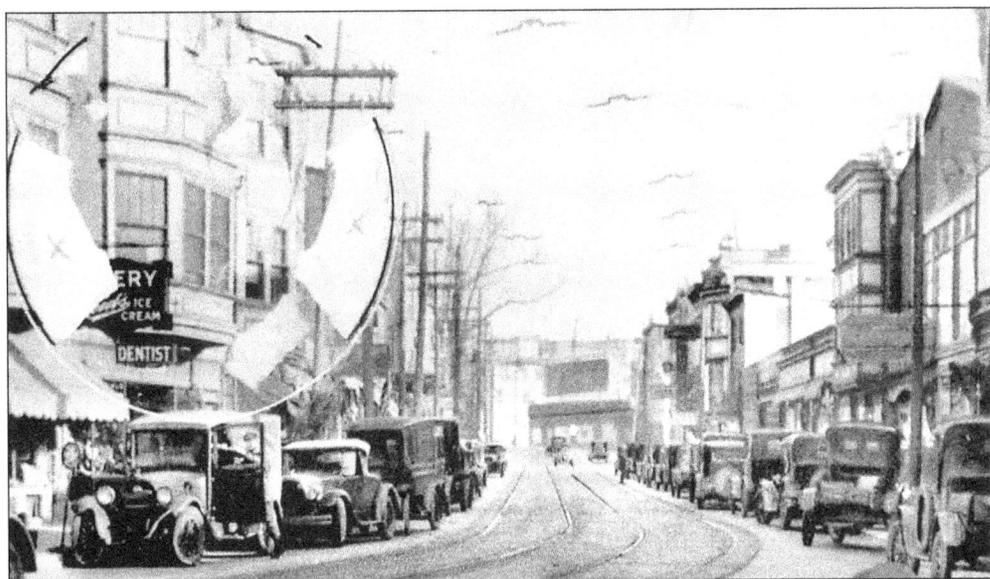

This 1927 Main Street photograph shows Finigan's store and bakery and the sign for the dentist Dr. George Niles on the second floor. Note the automobiles belonging to shoppers. (Courtesy the Temple University Urban Archives.)

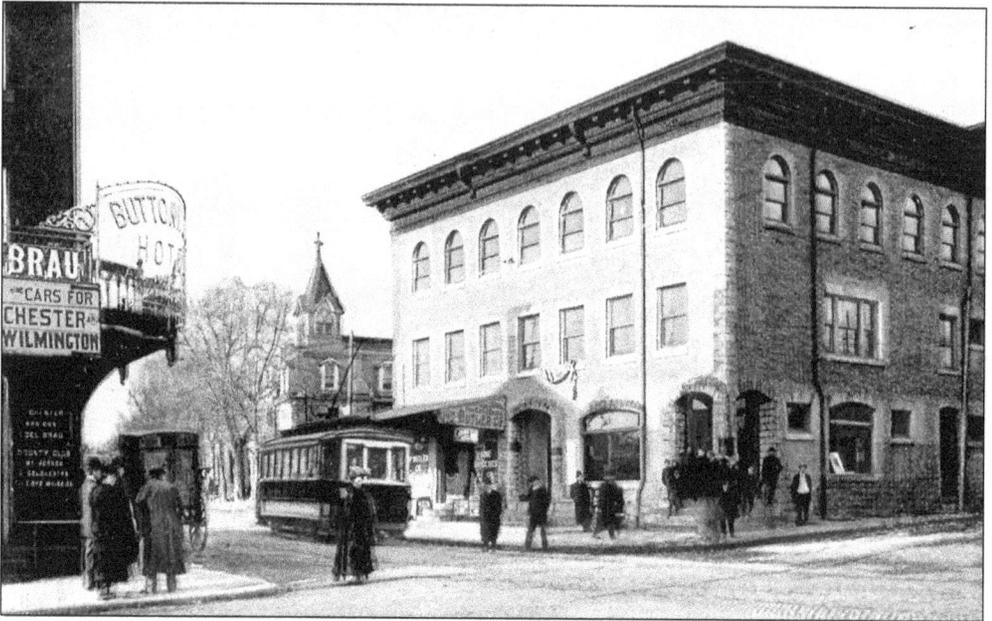

The Engineers Building was located at the corner of 9th and Main Streets. The Fox newsstand can be seen. This side of the building also was used for the post office. (DBHPS, Lois Burchill Collection.)

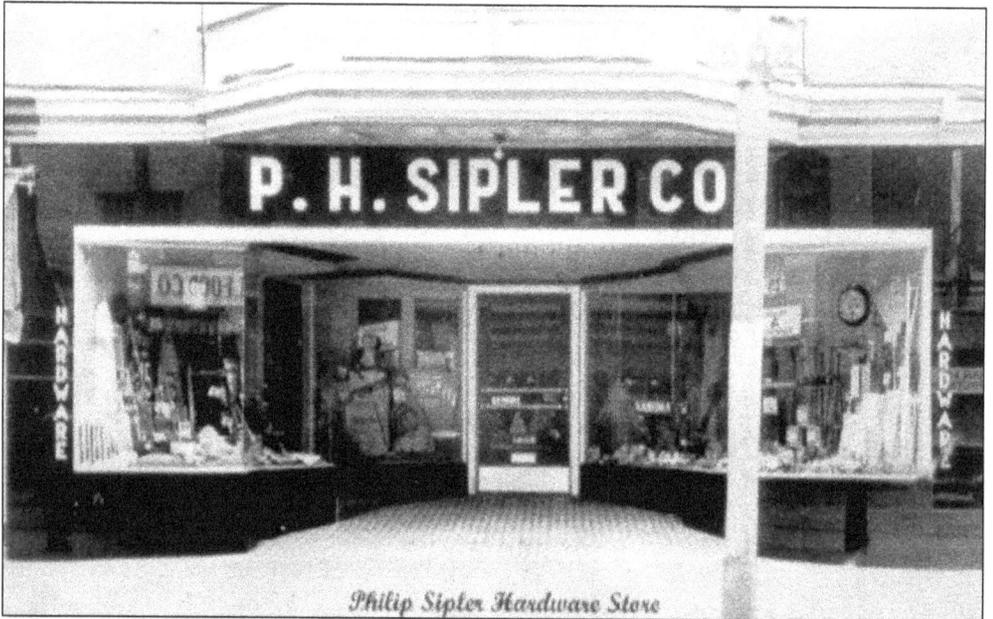

Philip Sipler Hardware Store

Seen is Sipler's hardware in 1933, looking much the same as it did before the store was remodeled earlier that year. Philip Sipler was a justice of the peace in 1836 and served as a Darby Borough councilman. In 1830, he operated a brickyard between 4th and 5th Streets and Walnut and Pine Streets. He and Edward D. Sipler were harness makers from 1866 to 1921. Philip H. Sipler, a Civil War veteran, was also a harness maker, and he founded the hardware store in 1901. The company was incorporated in 1929 and was located in the building at 883 Main Street. (Courtesy the Darby Library.)

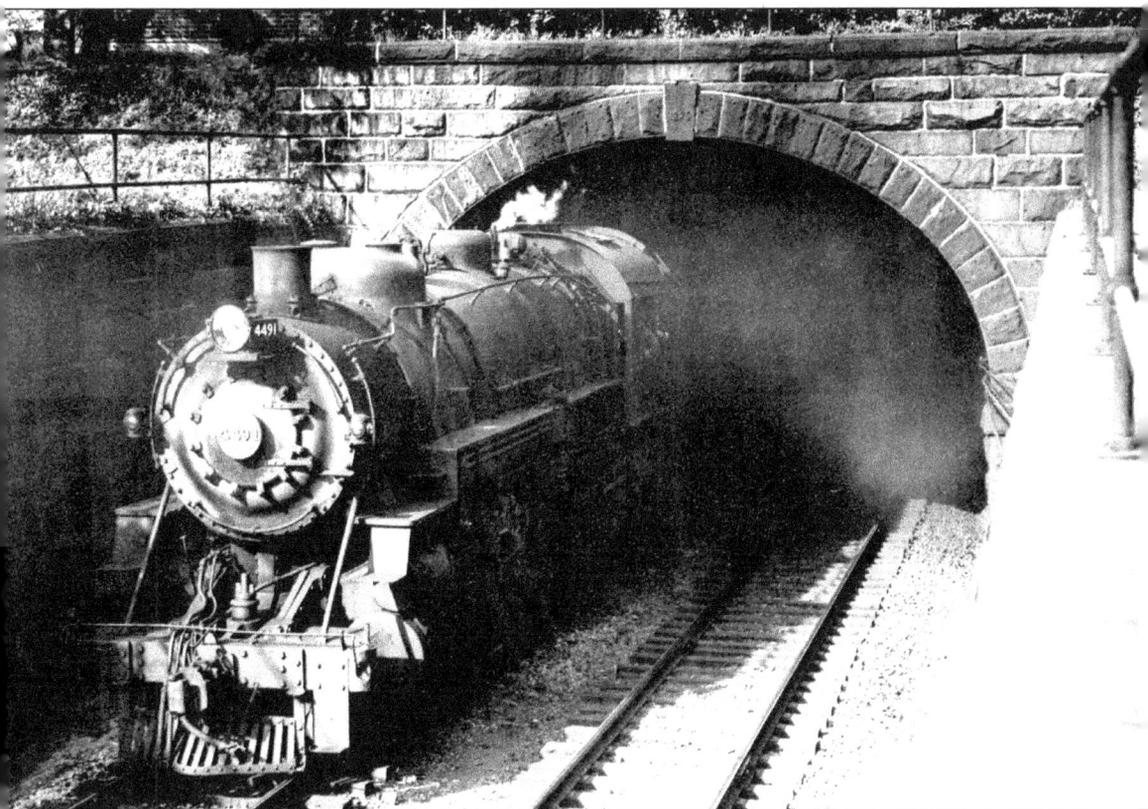

Even though Baltimore and Ohio engineers could respond with a column of smoke on demand, these skilled men could also reduce smoke to a wisp, increasing efficiency and reducing risks to health. The engineer of Q4b 4491 shows his ability to control the smoke while leaving Boone's Tunnel in Darby in June 1940. (Courtesy the Baltimore and Ohio Railroad Historical Society.)

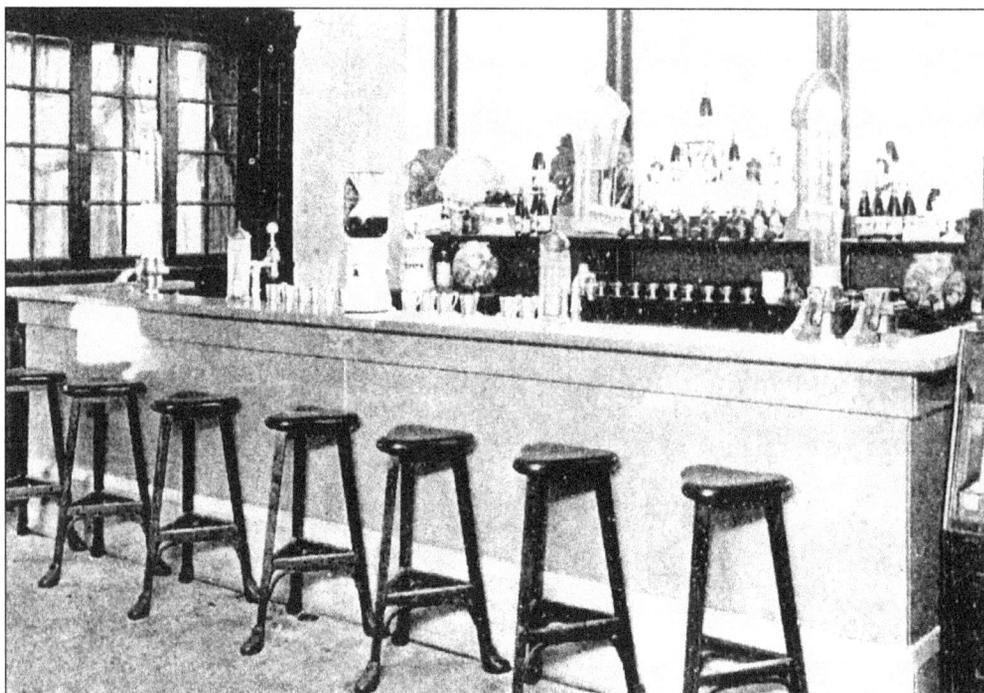

The Cloud and Shin drugstore, once located on the corner of Chester Pike and Main Street, later moved to the location of today's Public Drugs. The drugstore had a soda fountain and pharmacy. This interior view of the new store was from a brochure printed for the grand opening at 915 Main Street. (DBHPS, Lois Burchill Collection.)

The celebration on Chester Pike for the opening of the Buttonwood Bridge shows the new Pappas Apartments at 829 Main Street, built in 1927 by Collins Construction. (Courtesy the Temple University Urban Archives.)

This picture shows the 900 block of Main Street in 1920.

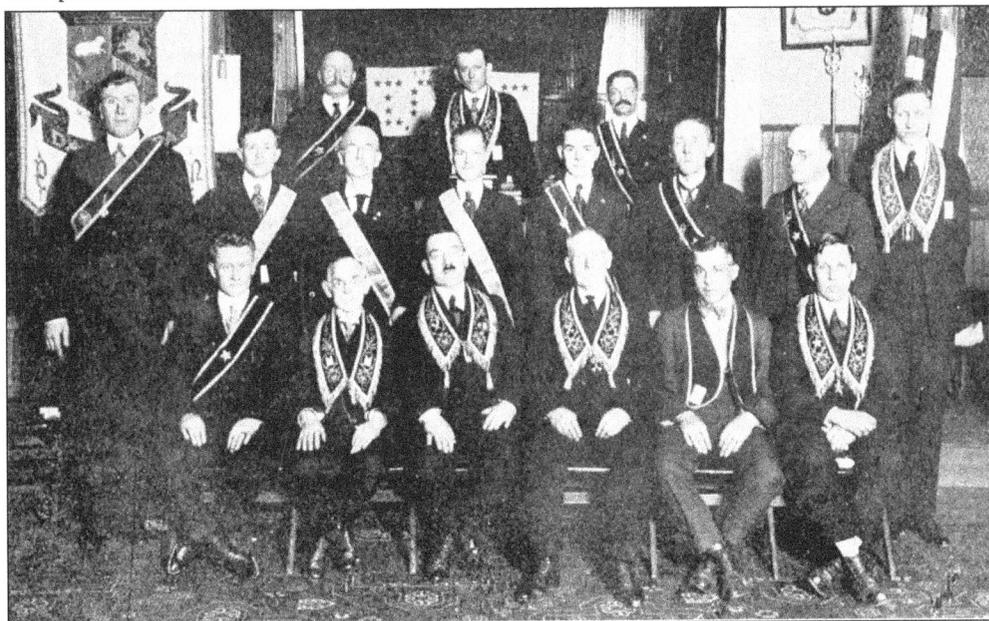

The International Order of Odd Fellows temple at 848–850 Main Street is not the first home of the Odd Fellows. The group received its charter on October 25, 1845, and held a special session and celebration at the old Buttonwood Hotel on November 8, 1845. Photographs of that meeting show the members on the upper porch and on the street level. Elsa Rebekah Lodge No. 104 was instituted on April 29, 1905. The sisters of this lodge helped the Orphan's Rest Lodge No. 132 in many ways to support their charitable activities. Composed of those considered to have high integrity and a sincere devotion to their fellow man were members of this lodge. They cared for orphaned children, the elderly, and the sick, and they buried the dead. They brought home the body of the son of one of their members killed in World War I and paid for his burial. Shown are officers of 1919. (Courtesy Glen Gilman.)

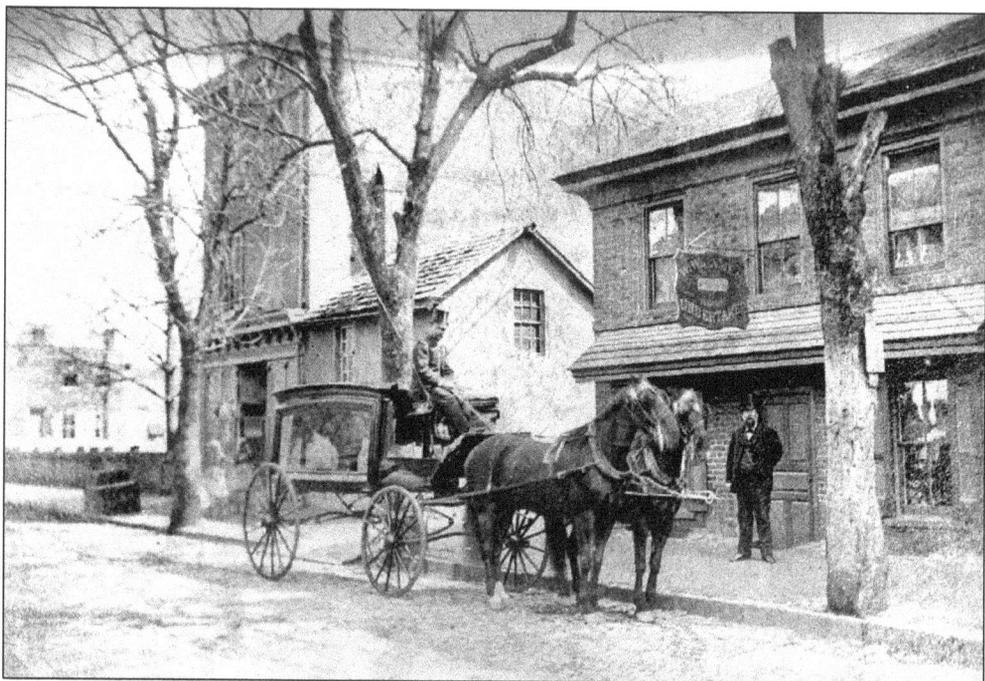

The W.W. James Funeral Home was located on Main Street. W.W. James served as coroner of Darby. This photograph was taken c. 1885. (Courtesy Dawn Allen.)

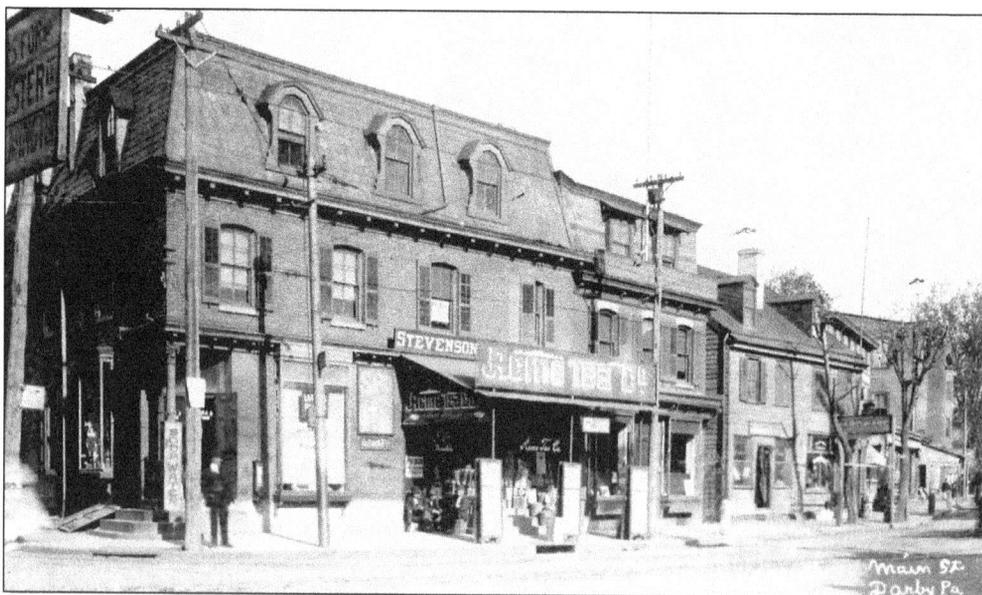

This c. 1898 view of Main Street shows the Stevenson store with a sign for the Acme Tea Company.

This photograph, taken between 1890 and 1900, shows the 900 block of Main Street. It includes a house that is referred to on the back of the picture as the parsonage and identifies Captain Serrill and Lloyd Tribbett as the two men standing in front of the Mount Zion Methodist Church. (DBHPS, Lois Burchill Collection.)

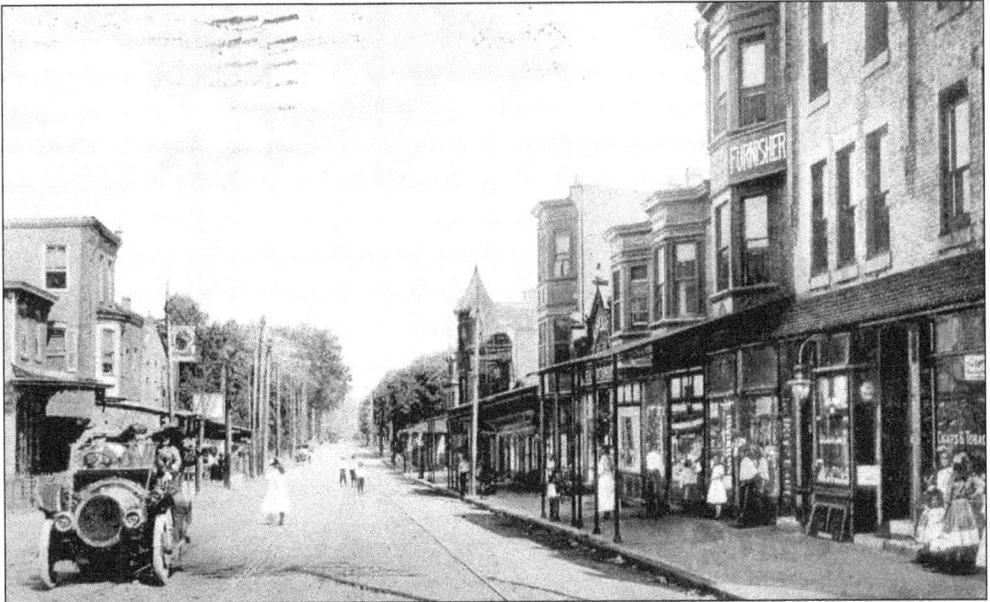

This 1914 view shows Finigans advertising as a home furnishings store and children playing in the street with few automobiles to worry about.

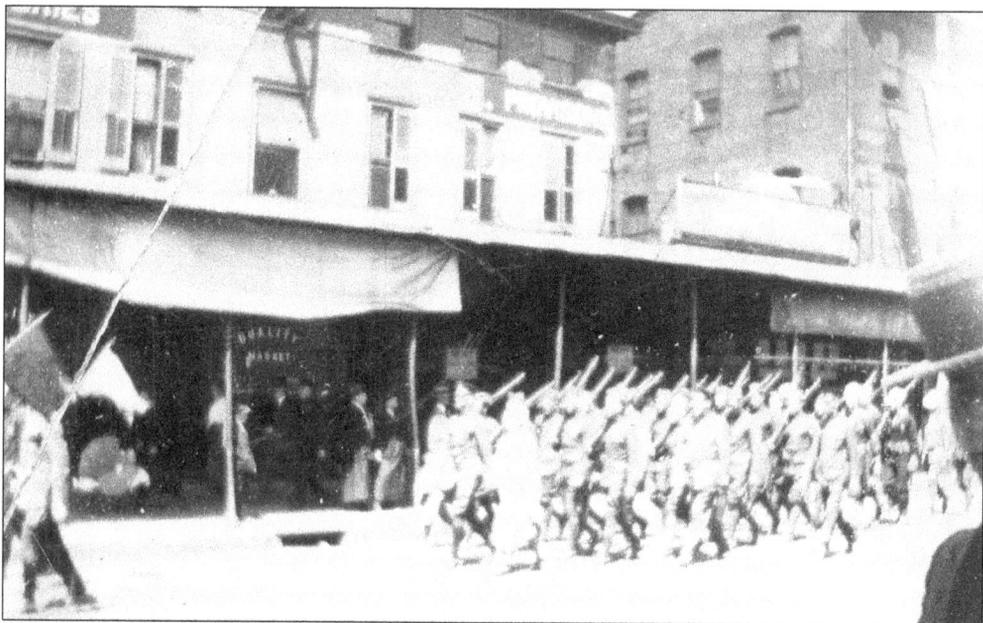

This view shot with a Brownie camera in 1917 shows World War I soldiers and nurses parading on Main Street to support U.S. armed forces in Europe.

This photograph, taken before 1899, shows the G. Roberto Powell home at the corner of Powell Avenue and Main Street. (DBHPS, Harold S. Finigan Collection.)

Five

FACES OF DARBY

Johan Printz was governor of New Sweden. New Sweden, explored and mapped by the Swedes, took in a large area of Pennsylvania from the mouth of the Delaware river to New Jersey. Under the direction of Queen Christina, Printz ruled the New Sweden territory. The Swedes built the first mill at the intersection of Darby Creek and Cobbs Creek and brought the first livestock to the area. They moved on to what they considered better mill sites, but several Swedish families built homes and lived in what is now Darby Borough by 1639. William Wood, one of the first Quaker settlers, purchased the old mill and 100 acres and started a mill on the same site. (DBHPS, Jane Keene Collection.)

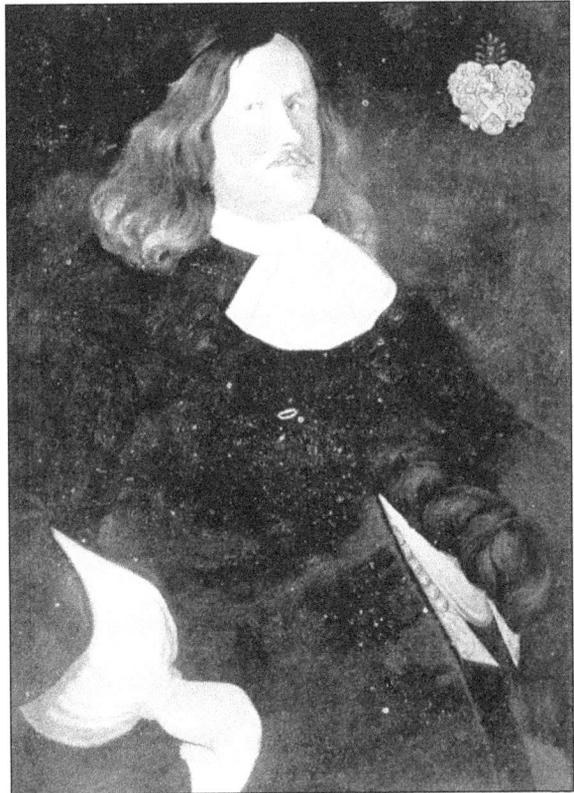

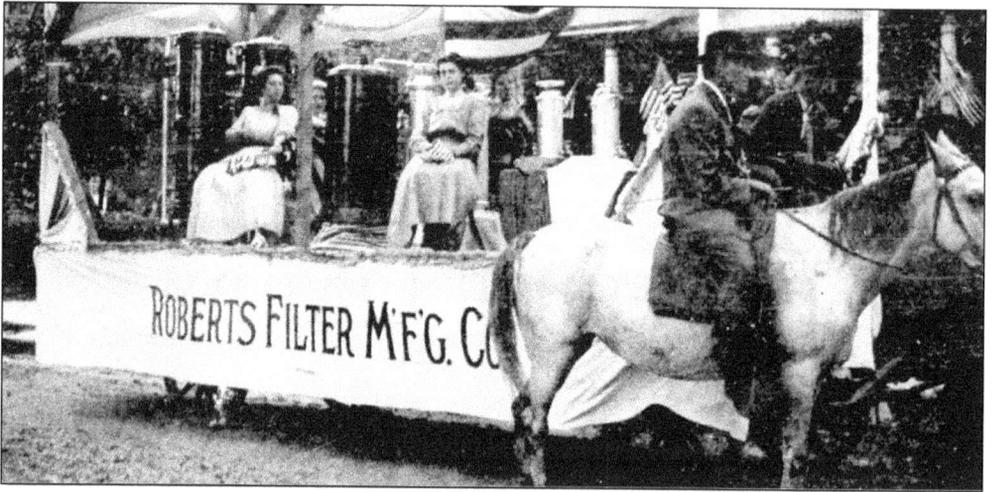

Seen is the Roberts Filter Manufacturing float in a parade in the late 1890s. Charles V. Roberts, the founder of the company, is the rider on the white horse. Pennsylvania Filter Company, organized in 1896 by Charles V. Roberts, became Roberts Manufacturing Company and, during the last century, became Roberts Filter Group. This worldwide organization has supplied systems and expertise to atomic projects, municipalities, and military projects and is the largest privately owned U.S. water company. Using computer technology, it has revolutionized how the world's water is cleaned. Four generations of the Roberts family have managed the company. Company presidents and their terms are Charles V. Roberts (1896–1924), Jesse W. Roberts (1924–1935), Charles V. Roberts II (1935–1980), and R. Lee Roberts (1980–present). (Courtesy Roberts Filter Group.)

James Pearson Serrill was born in 1810. He died in 1898 at the age of 88. His daughter, Mary Wright Serrill, married W. Lane Verlenden I in 1876. (Courtesy Donald Parker Verlenden.)

William Lane Verlenden I (1847–1921) was married to Mary W. Serrill. He assumed charge of the Verlenden Imperial Mills when he was only 19. In 1870, he and his brother Enos formed a partnership, Verlenden Brothers, and when it was incorporated in 1900, he became the president. He was the founder and president of the First National Bank of Darby, organized in 1890. He was the vice president of the Lansdowne and Darby Saving Fund and Trust Company of Chester. For nearly 50 years, he was active in the Sharon Building Association as secretary and later as president. He was president of the Library Company, and he had previously served as secretary. He was president of the Home Protection Society and was active in the Spring Haven and Lansdowne Country Clubs and the Manufacturers Club of Philadelphia. He was the burgess in Darby (1882–1886) and was president of the school board for many years. (Courtesy Donald Parker Verlenden.)

Dr. William Pierce Painter graduated from Jefferson Medical College in 1875 and began his practice in 1879 at his home at 1016 Main Street. He married Margaret Middleton on April 28, 1886, and they named their property Painter's Garden. He practiced in Darby until his death in 1919. He was a director of the First National Bank of Darby and held the same position with the Lansdowne and Darby Trust Company. He served as treasurer of the borough, the school board, and the Darby Friends Meeting. Painter was an emergency soldier of the 29th Regiment Pennsylvania Volunteers and was stationed at Duncannon to guard the pass. He was a member of the Society of Friends and the Delaware County Medical Society.

Stanley G. Child, born in 1880, was the fifth generation to live in the family home on 2nd Street in Philadelphia. He served as the clerk of the Darby Friends Meeting from 1927 to the early 1940s. He graduated from the University of Pennsylvania and was a professor of engineering at Drexel University from 1920 to 1950. In 1905, he was made quality control manager for Baldwin Locomotive Works. Before World War I, the company sent him to London to assist the English and French governments and Baldwin Locomotive in the manufacture of military weapons. He was in London for about four years. During one of his trips home, his ship was sunk and he was one of five survivors. He served as the president of the board of directors of the Quaker home in West Chester from 1937 to 1943. His wife, Edna M. Sowden Child, also served on that board. (Courtesy John S. Child.)

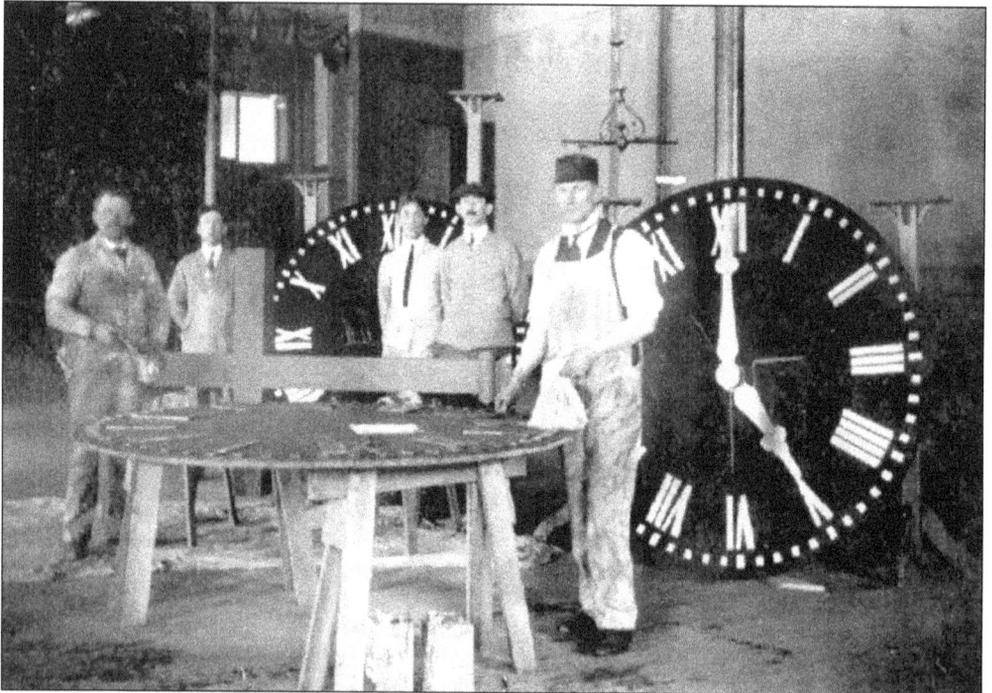

William C. Tole and his family lived on Chestnut Street in Darby. He was a painter. He is shown on the right painting the bell tower and clock at old St. Clement's Church in 1892. (Courtesy the Tole family.)

Ethel Smiley has devoted her life to the civil rights cause. In the 1960s, in conjunction with the NAACP, she purchased the Bunting house at 1205 Main Street and formed the Bunting Friendship Freedom House. With the help of personal pledges and grants, she and others developed a center that helped seniors and provided young people with educational programs on African American heritage. Multiple programs, including day care, were offered. The Bunting house is an Underground Railroad site. The nonprofit corporation dissolved, but the work of those involved in the project is an important part of Darby's history.

Harold S. Finigan often sat in front of his store and talked to his customers and other shoppers. He decorated his store with flags for Memorial Day and the Fourth of July and with lights for the Christmas holidays. A rowing champion, Finigan once owned two bakeries in Darby. His mother owned Finigan's department store, which later sold used furniture. She originated the doll hospital on the second floor of the building just before World War I, when shipments came damaged and were curtailed. This photograph was taken on the Fourth of July two years before the arson at the Buy and Save store destroyed part of Darby's business section. (Courtesy Frank M. Wardell.)

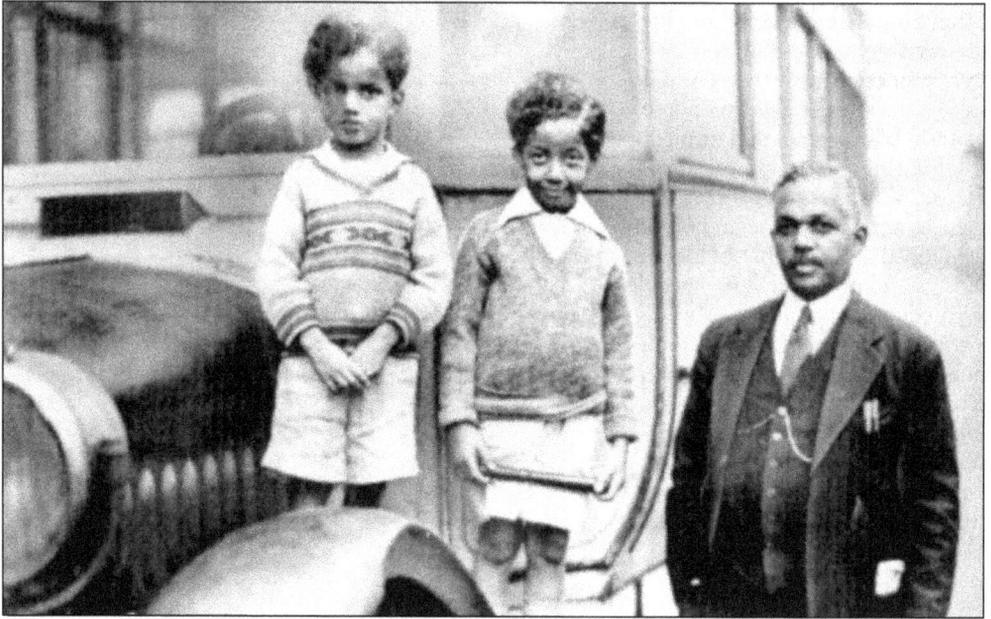

John Mott Drew was one of Darby's outstanding citizens. He was owner of Drew Bus Company, which he started after World War I, when he recognized the transportation needs of many Darby black women and others to get to their employment in Lansdowne and Upper Darby. His first bus was a Ford Flivver. His company was sold to the Red Arrow division of the Southeastern Pennsylvania Transit Authority with the stipulation that his drivers would keep their job. He served on the Darby council and was instrumental in getting Walter Davis appointed to the police force. He was a stockholder in the financing of the Hilldale Stadium. He married Jessie Vine of Darby, and they had two sons, John Mott Drew Jr. and Andre Lind Drew, shown with their father in this photograph. Drew died in 1977 at the age of 94. (Courtesy of the Philadelphia Daily News.)

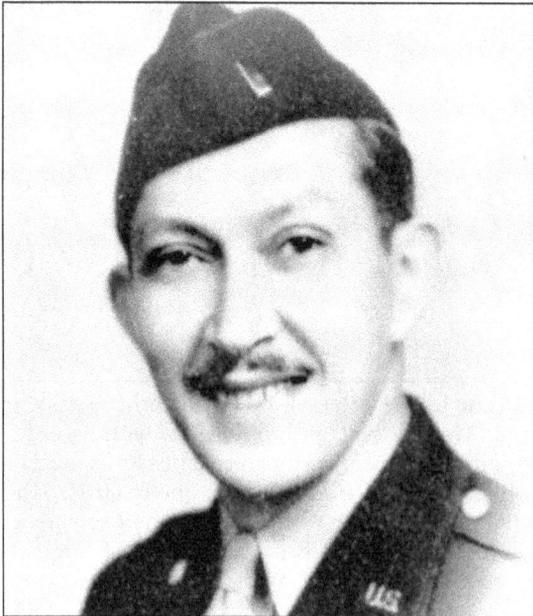

Dr. E.V. Liberace was a physician in Darby on Main Street for many years. He was a member of the school board and gave time to many other interests in Darby. He is shown here in his U.S. Marine Corps uniform in 1943.

Michael and Helen Murray lived at 1125 Main Street. In 1923, at the age of 14, Helen learned to play the organ at St. John's Church in Philadelphia, and during this same time, she began to play the organ at the Blessed Virgin Mary Church in Darby. For 70 years, she played the organ for choir practices, funerals, weddings, holy days, and other services, as well as for Sunday Mass. She was given the DBHPS Citizen Award on April 17, 1999. She was an example of the commitment and dedication that nurtures a community. The Murrays are shown in this photograph participating in a wedding at the Blessed Virgin Mary Church. (Courtesy the Blessed Virgin Mary Church.)

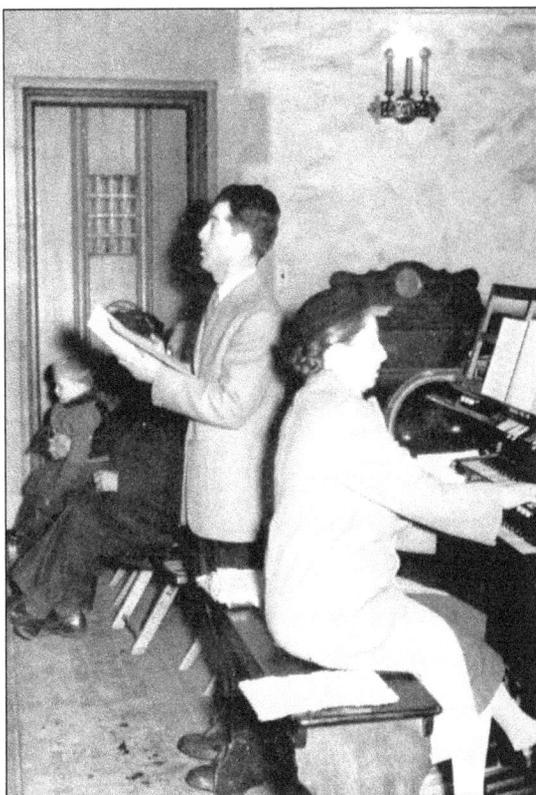

George Clinton Niles and his wife came to Darby as a young couple. Dr. Niles was the second dentist to set up a practice here. His first office was over Finigan's store. He soon moved to 1124 Main Street, where he lived until his death. The couple had one child, Ruth Niles (left), who became a teacher and taught in Darby schools. Ruth was given the DBHPS Citizen Award for her work in the schools, her church, and the community that helped many Darby children. (Courtesy Ruth Niles.)

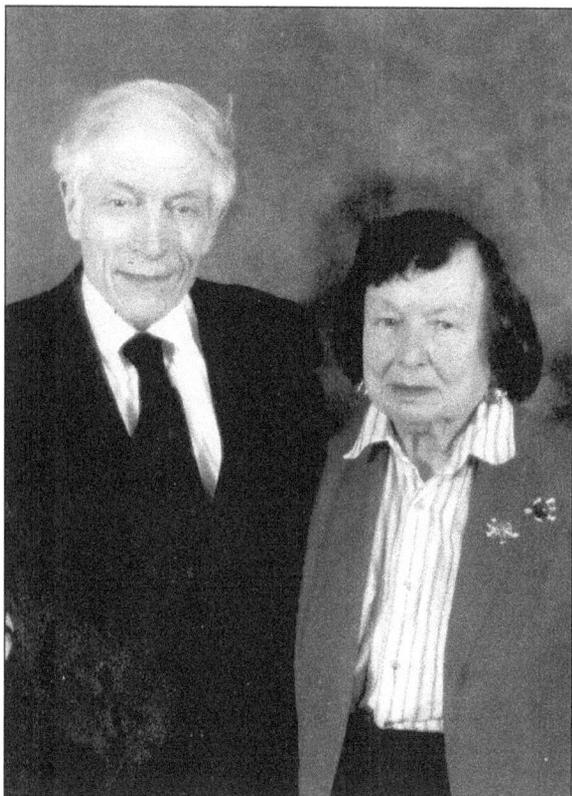

John Serrill Child is a ninth-generation Quaker. He is a descendant of John Kirk, a 1682 founder of Darby Friends Meeting, and a past clerk of Darby Friends Meeting. His wife, Beatrice L. Child, is the present clerk. John Child was an officer in World War II. He has been with the Darby Friends since 1919. Married in Darby Friends Meeting, the couple has served on the board of the Hickman Boarding Home for the elderly in West Chester for 20 years. Darby Friends Meeting is one of eight constituent meetings that founded the home in 1891. In December 2005, the Childs plan to have Darby Friends Meeting publish the meeting records from 1682 to 1783, including correspondence with England, to celebrate the 200th anniversary of the present building. (Courtesy John S. and Beatrice L. Child.)

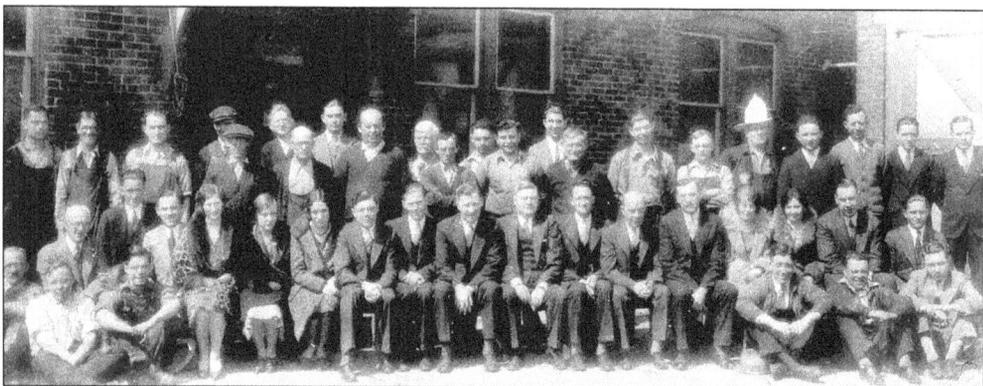

As a youth, Charles Roberts had an intense interest in waterborne diseases. Disturbed with the way industrial and population growth contaminated the quality of the raw water supply, he became interested in various water treatment processes. He was a contractor for Baldwin Locomotive Works in Philadelphia, but in his spare time, he began making small natural stone filters for household use. There was a market for these filters, and soon he was on his way to a very successful business, supplying estates, hotels, industries, and municipalities with his water filters, one of the earliest filters patented (1889). Shown are employees of Roberts Filter Company in 1927. (Courtesy Roberts Filter Group.)

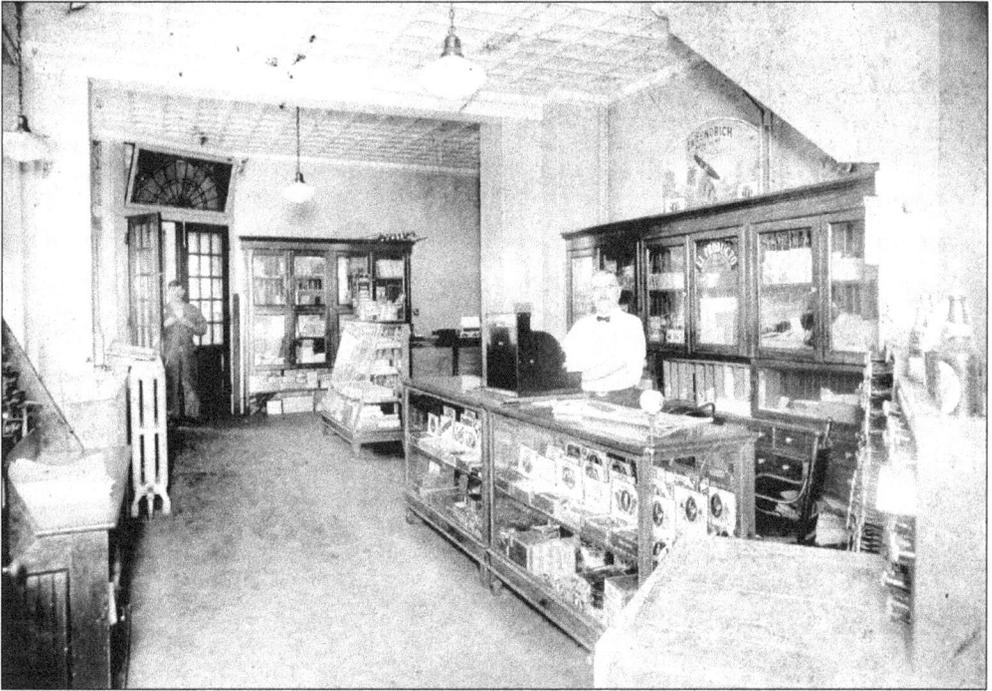

This photograph shows the inside of of the cigar store in the 800 block of Main Street, on the north side. It was located next to the Hewes hardware store. (DBHPS, Harold S. Finigan Collection.)

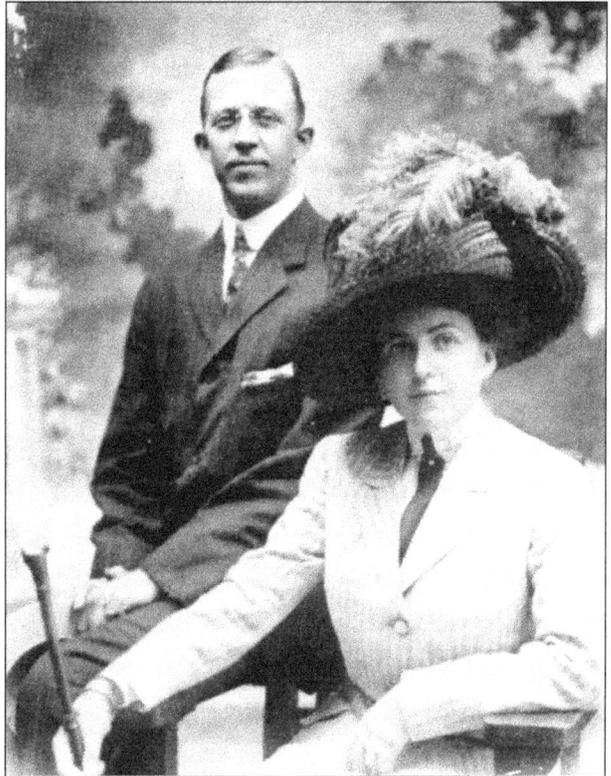

Seen are Jacob Serrill Verlenden and Jean Bell Parker before their wedding in 1909. Verlenden was vice president of Standard Coosa Thatcher Mills. In 1890, the Verlenden Imperial Mills moved its manufacturing operation to Chattanooga, Tennessee, and became a part of the Standard Coosa Thatcher Corporation. The two mills of the Verlenden Imperial Mills were located on Ridge Avenue. The family lived at 112 Ridge Avenue and 15 Ridge Avenue and had another home on Main Street. (Courtesy Donald Parker Verlenden.)

63

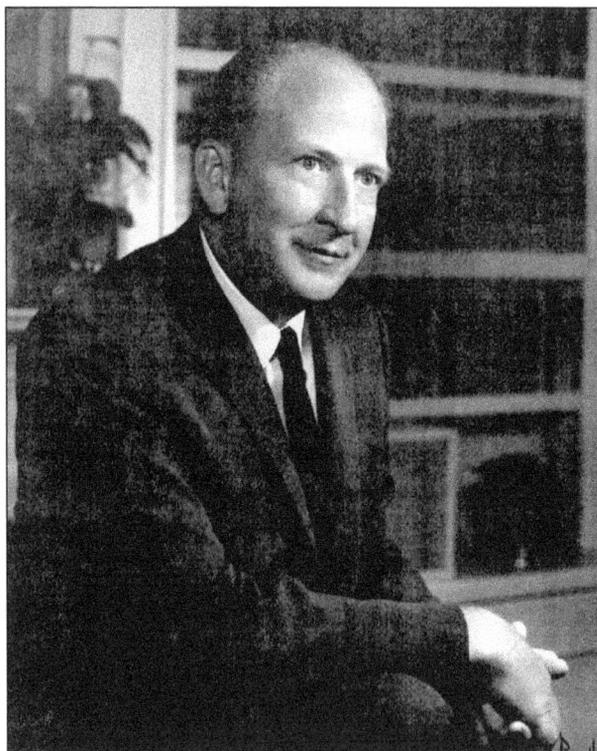

William Lane Verlenden II, shown here in 1970, was born in Darby at 112 Ridge Avenue. He was the son of Jacob Serrill Verlenden and Jean Bell Parker. William Verlenden was associated with the Standard Coosa Thatcher Mills in Chattanooga, Tennessee, and the Philadelphia offices. After he retired, he wrote the Verlenden family history, which also includes much of the Serrill family history. (Courtesy Donald Parker Verlenden.)

Martha Schofield was a member of the Darby Friends Meeting. She was very concerned about the effects of slavery on children. A teacher, she taught children in Darby and, after the Civil War, established a school for the children of freed slaves in Aiken, South Carolina. Several buildings and schools in Aiken carry her name in honor of the work she accomplished as an educator and her other contributions to the city. The cupola from her school is preserved and sits in front of the Aiken County Historical Museum. (Courtesy Aiken County Historical Museum.)

The Hilltop Community Center was the beneficiary of a $500 check from the Atlantic Richfield Company in the 1960s. The money was used to finance a recreation center at the corner of MacDade Boulevard and Wycombe Avenue. Shown at the check presentation, from left to right, are Tony Ditullio, Atlantic Richfield dealer; Murrell T. Brown, Atlantic Richfield's eastern area director of community service; Robert Tyler; Charles Buckborn, vice president of Hilltop; Mrs. Charles Ramseur, treasurer; Eunice Toatley, financial secretary; and Alfred Thomas, board chairman. (Courtesy the Temple University Urban Archives.)

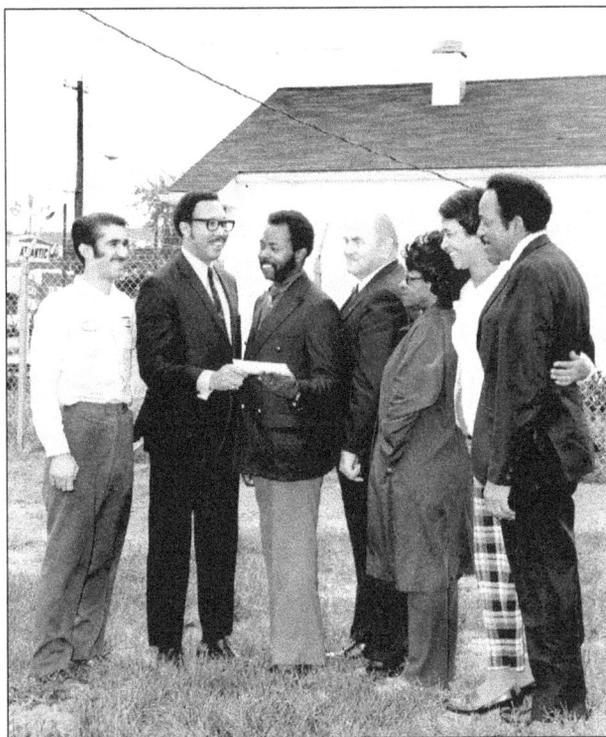

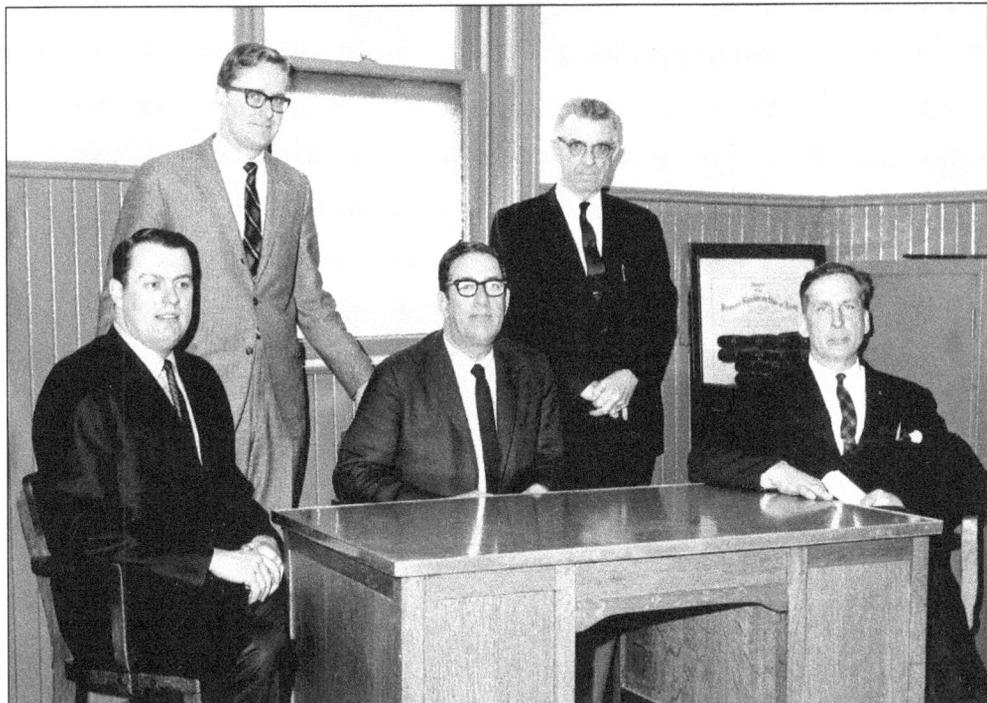

The Darby Chamber of Commerce officers met in March 1969. From left to right are Raymond Banner, vice president; Thomas Kimmel, recording secretary; J. Wesley Sulgar, treasurer; and Harold Finigan, corresponding secretary.

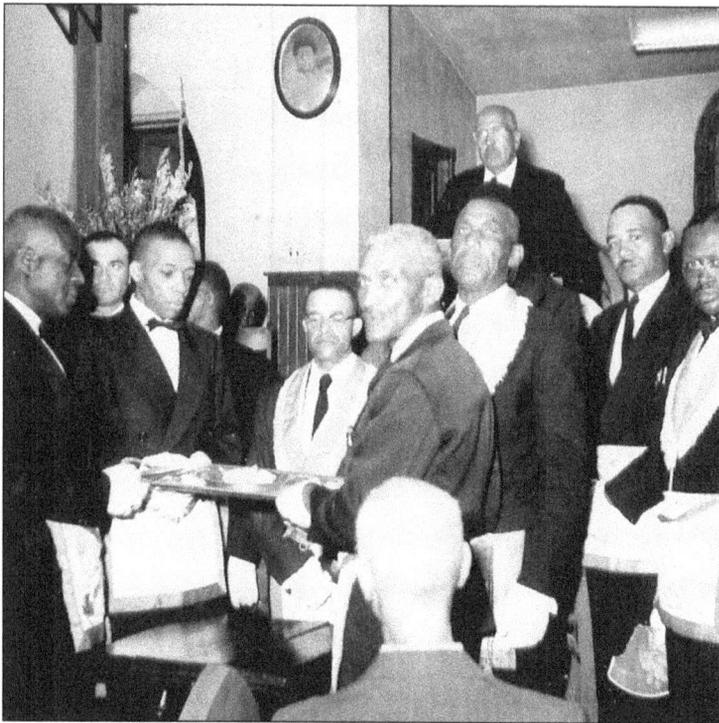

The Rose of Sharon Masonic Lodge No. 39 celebrated the burning of its mortgage in 1949. A happy occasion, it signified that lodge members had fulfilled the financial responsibility that they assumed to remodel their building. (Courtesy Rose of Sharon Lodge No. 39.)

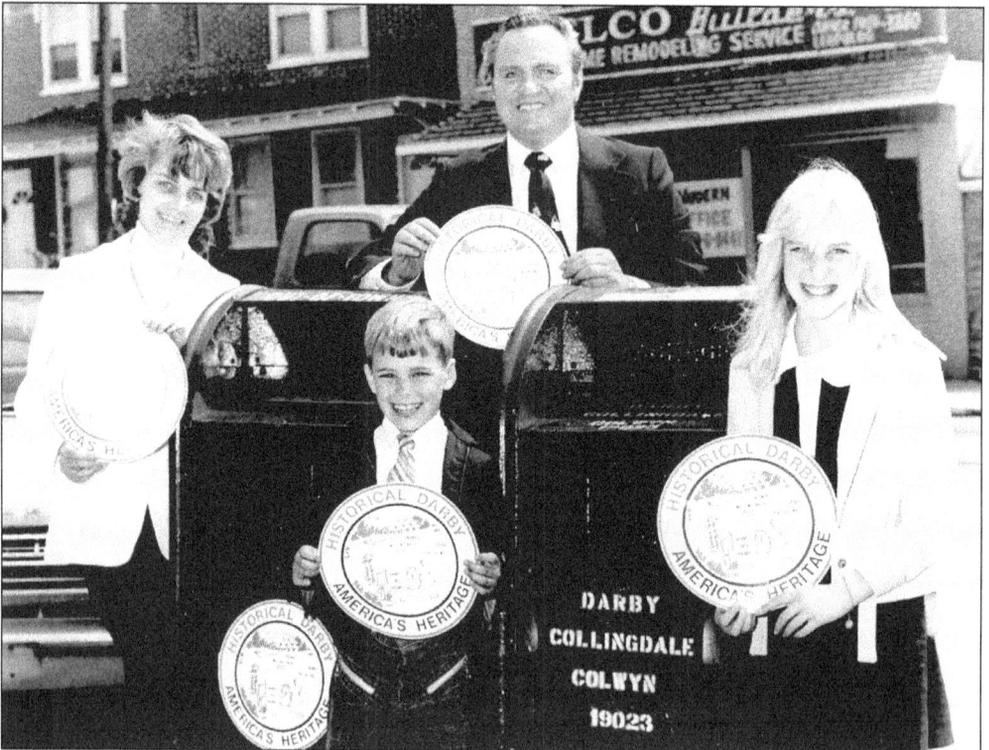

Darby's postmaster Robert Doherty and friends display the seals designed for the tricentennial celebration of Darby Borough in 1982. (Courtesy Robert Doherty.)

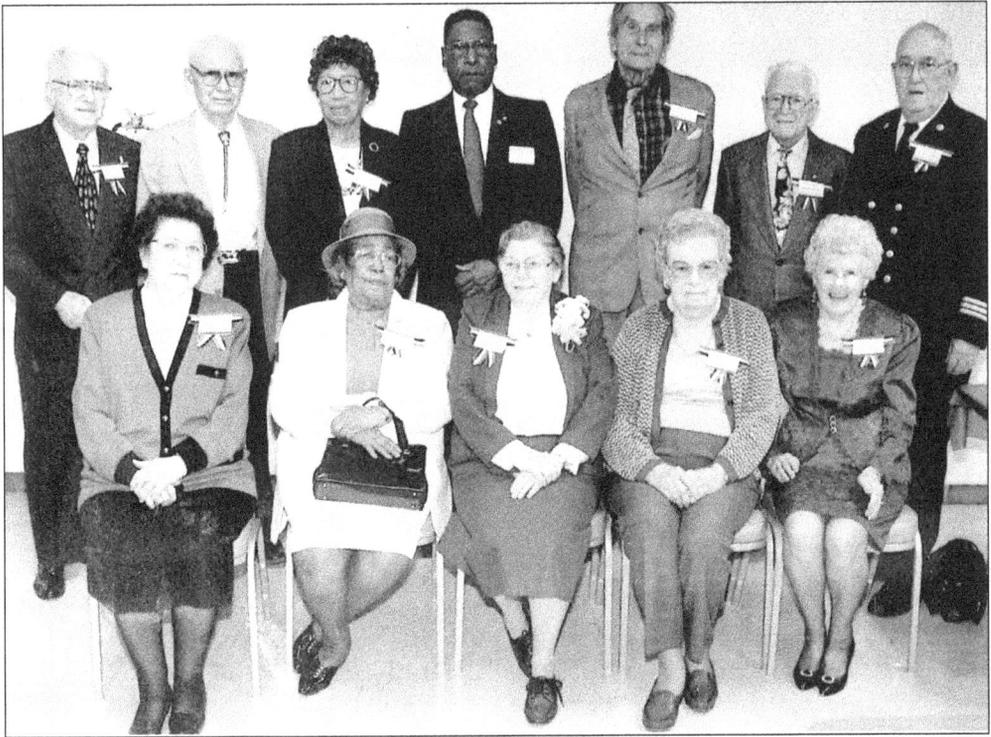

On February 14, 1998, the Darby Borough Historical and Preservation Society honored 12 Darby residents with the first annual DBHPS Citizen Awards. Those honored, from left to right, are as follows: (front row) Catherine Deaver, Lovie Simpson, Ruth Niles, Naomi Valutas, and Marion Pugh; (back row) Charles Sanders, John Tribbett (accepted for William J. Frasch), Beatrice Harris, Emery C. Graham (accepted for Mary Ethel Graham), Harold S. Finigan, Harold W. Pugh, and Freeman L. Cox Sr.

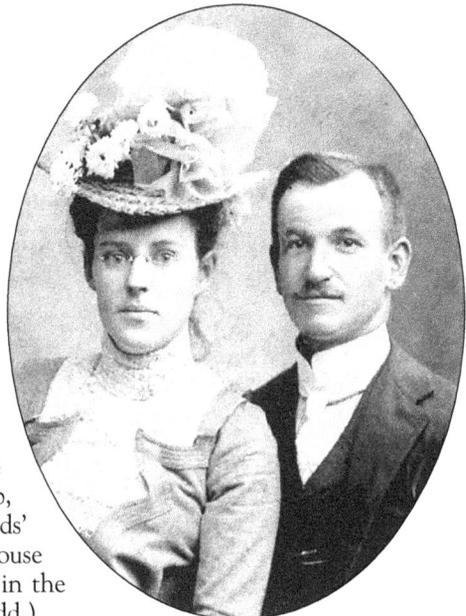

Mazi and Walter Ladd lived on 7th Street. As was the custom then, they occasionally took in boarders. One of the men who had the privilege of living in the Ladds' home was Joseph Bobb, a member of Fire Company No. 1. The Ladds' grandson, Marshall Ladd, grew up in that same house on 7th Street. He later served in World War II in the 69th Division U.S. Army. (Courtesy Marshall Ladd.)

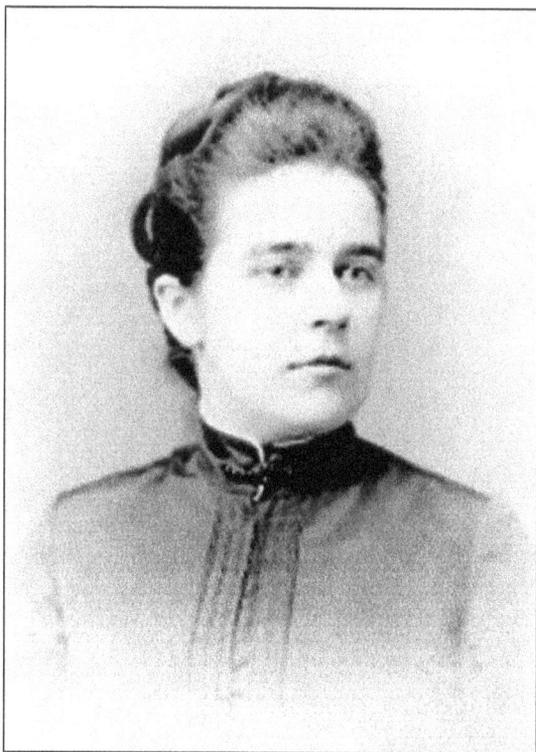

Martha Quinn was appointed assistant postmaster of Darby on January 24, 1889. On October 11, 1891, in Darby, she married William McCracken, who also worked for the postal service. The couple had one son, William Lane Verlenden McCracken, born at 931 Lansdowne Avenue on February 2, 1893.

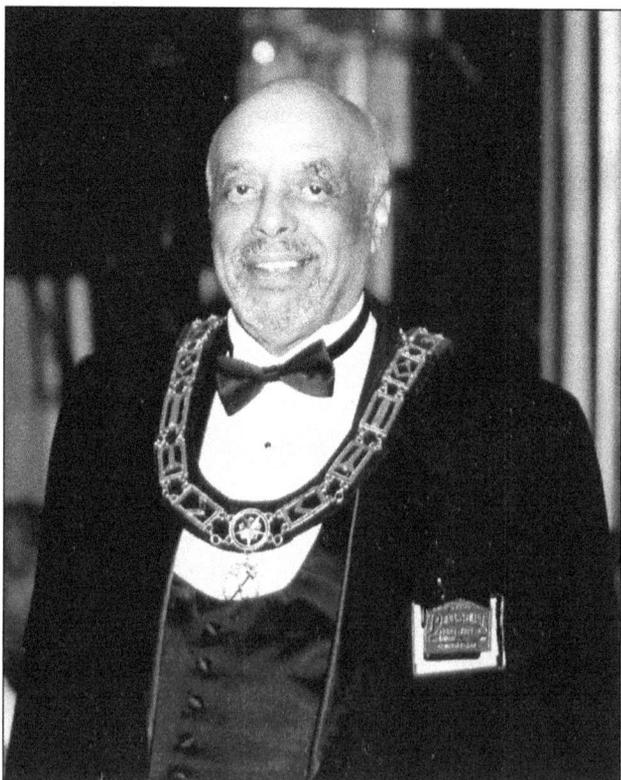

William R. Coleman has lived in Darby all of his life. He was the first member of the Rose of Sharon Lodge No. 39 to be elected as a Pennsylvania grand trustee of the Masons. This photograph was taken after his election in Harrisburg. (Courtesy Rose of Sharon Lodge No. 39.)

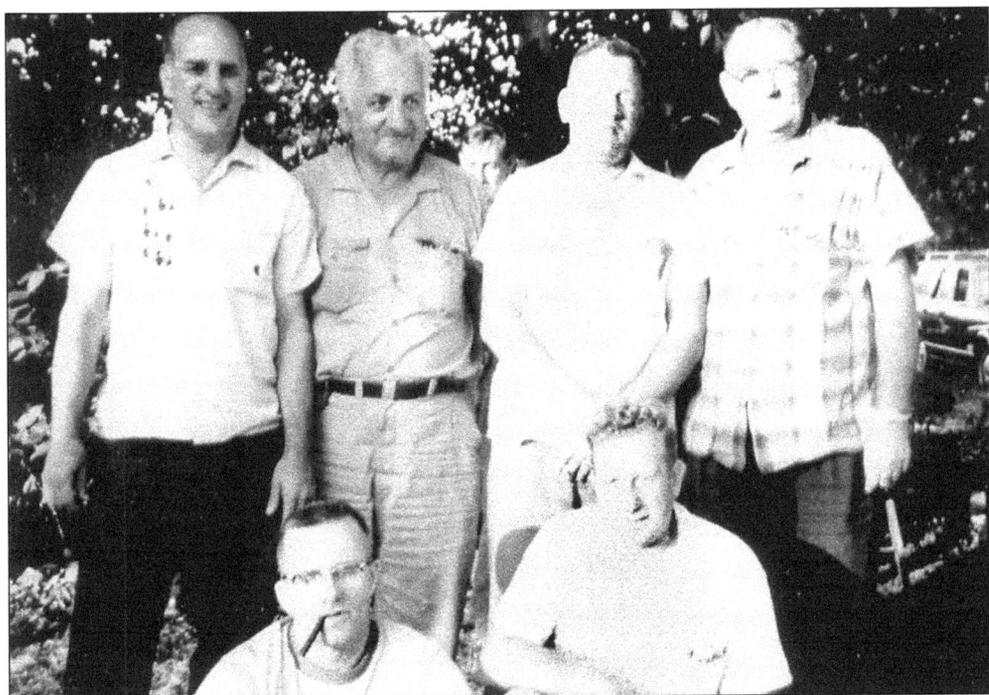

Fire Company No. 1 sponsored many picnics and barbeques to raise funds. This photograph was taken on the grounds of the Little Flower Institute. From left to right are the following: (front row) Bud Downing and J. DellaVecchio; (back row) R. Raffelle, J. Martone, J. Floyd, and unidentified. (Courtesy R. DeLuca.)

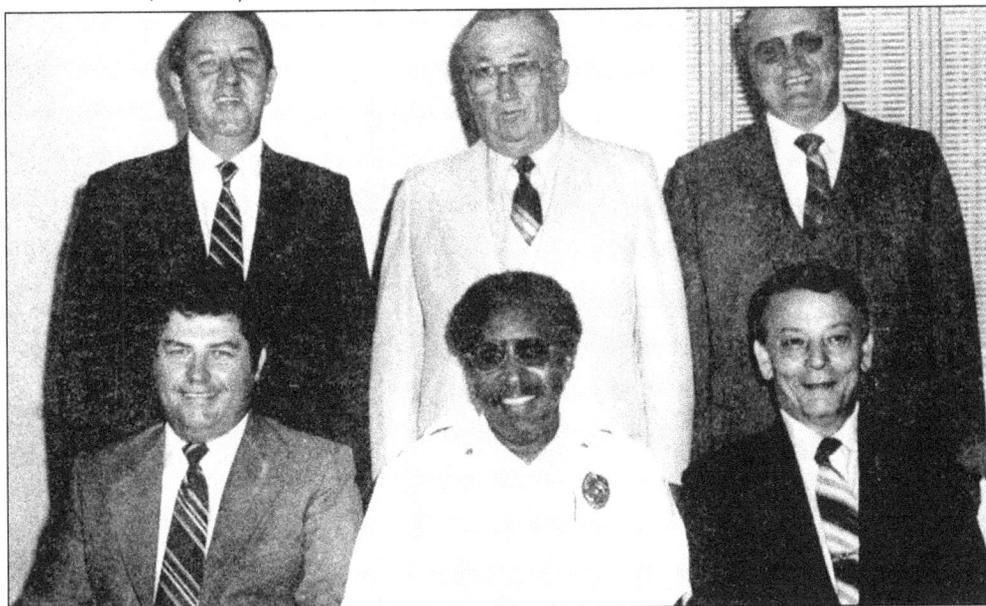

Shown during the year of the borough tricentennial (1982), from left to right, are the following: (front row) Louis Saraullo, mayor; Russell Emery, police chief; and Richard Galli, Darby Republican party chairman; (back row) Phillip Gallagher, borough manager; John Maguire, tax collector; and Robert Doherty, Darby postmaster.

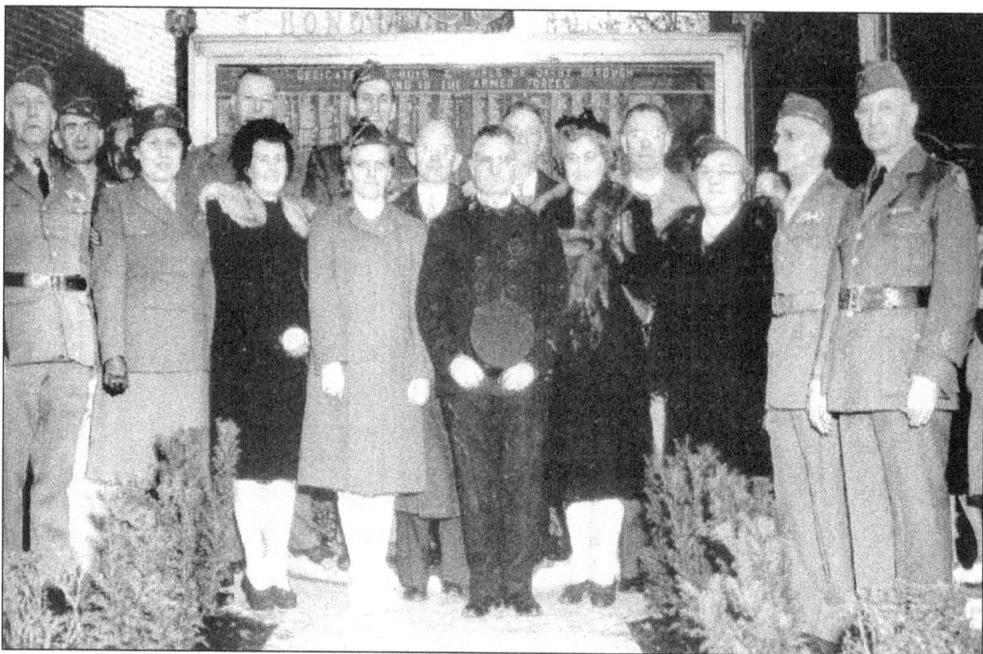

A group poses at the memorial located outside the Veterans of Foreign Wars (VFW) Post No. 598 on Main Street during World War II. The young man in the center of the back row is Richard Tole. Everyone from students to grandparents was involved in some way in the support of the war effort. Many Darby manufacturers became defense factories, producing ammunition, uniforms, and other products. (Courtesy the Tole family.)

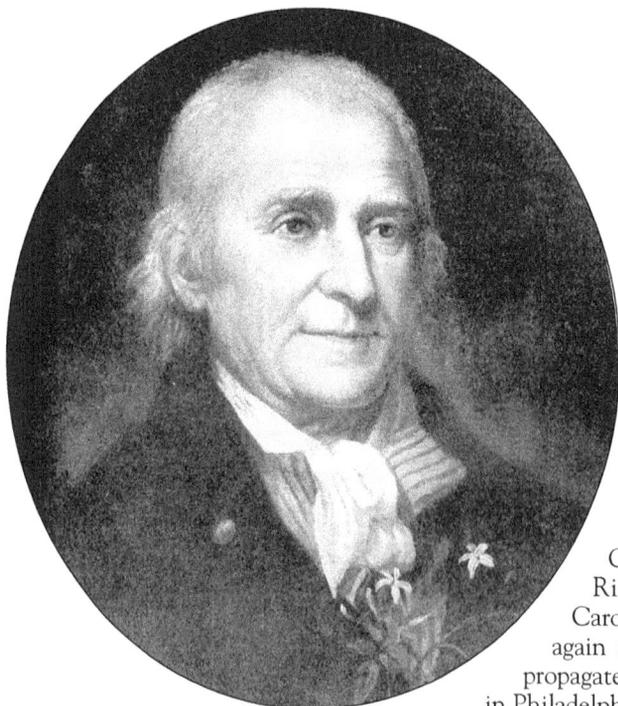

This portrait of William Bartram is attributed to artist Charles Willson Peale. The painting once hung in Independence Hall. Bartram's travels took him to the Gulf of Mexico, the Mississippi River, and to western North Carolina. He found the franklinia tree again and brought back seeds that were propagated and grown at Bartram's Garden in Philadelphia and elsewhere.

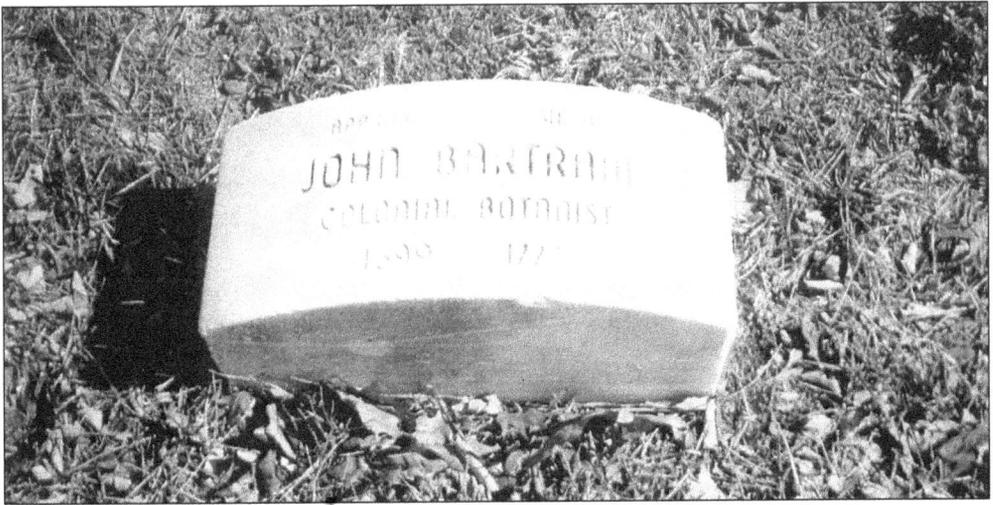

John Bartram is buried in the old Darby Friends Meeting Burial Ground on Main Street. At one time, the tombstones were removed because a consensus of the meeting was that perhaps they did not reflect the simple lifestyle of the Quakers. It was later decided to make all of them uniform in size, and new ones were put on the graves. John Bartram's grave is on the top of the hill. (Courtesy Carol Anderson.)

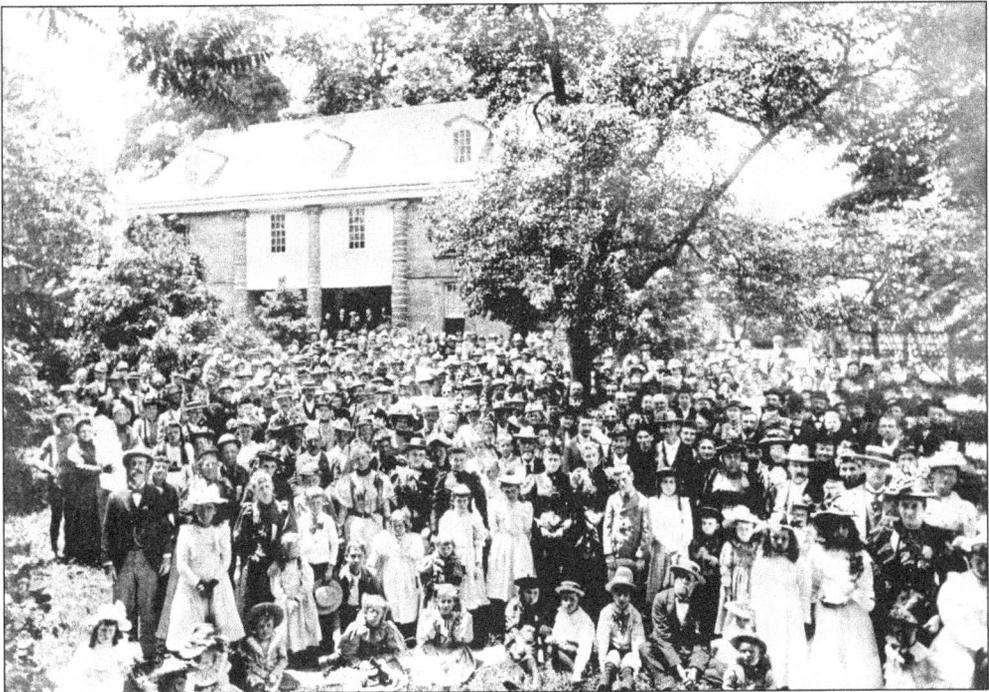

The first Bartram family reunion was held in 1893 at John Bartram's home in Philadelphia. This house and property is known as Bartram's Gardens and is where much of his work concerning plants was done. The family members shown in this photograph are descendants of William Bartram and Eliza Hunt, who married in 1696. John Bartram was born in 1699 at the family home on Springfield Road in Darby. (Courtesy the John Bartram Association.)

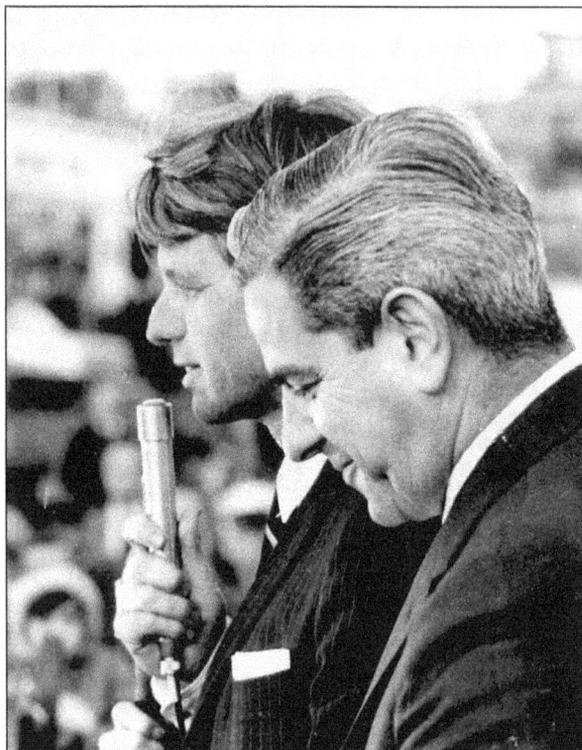

An invitation from Democratic party officials brought Robert F. Kennedy to Darby on April 2, 1968. Darby Borough had a population of 11,000 then, and it is estimated that there were more people to greet him than lived in the borough. Shown with Kennedy on top of a police car in front of the post office is Charles F. Sanders (right), chairman of the Darby Democratic party in 1968 and today, and former mayor and councilman. Kennedy was campaigning for the presidency and was on his way to California, where he was assassinated two months later. The funeral train came through Darby, and the Democratic Party erected a memorial at the train station at 5th and Pine Streets. Townspeople prayed as the train slowly moved through the borough. (Courtesy Charles F. Sanders.)

School board members and their wives are seen at a holiday party in the 1960s. From left to right are Jim Boice; Harold Pugh; Herm Solar, principal of the high school; Jack Tucker, a jeweler on Main Street; Jean Taylor, secretary to the superintendent of schools; Emily Boice; and Marion Pugh. (Courtesy the Temple University Urban Archives.)

VFW Post No. 598 was named for Cpl. William C. Greifzu, a young World War I soldier who died of wounds on May 16, 1918. He is buried in the Oise-Aisne American Cemetery in France. His nurse finished writing his last letter home and said that he was one of the bravest and most patient young men she had ever encountered. He died a few days after the letter was mailed. The letter is framed and displayed on the mantle of the fireplace in the post meeting room. (Courtesy VFW Post No. 598.)

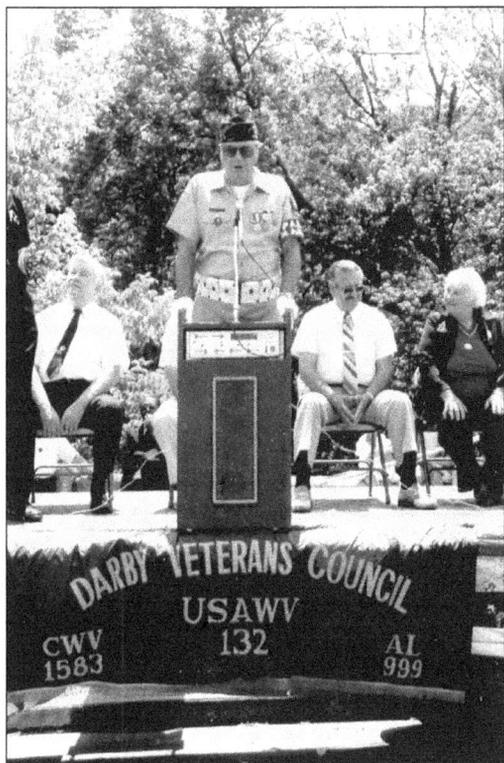

The Darby Veteran's Council honors the veterans on Memorial Day each year. Robert Doherty, commander of VFW Post No. 598 in 1985, is seen giving an address at the war memorial on Chester Pike. The American Legion Catholic War Veterans Post on MacDade Boulevard, Willie G. Childs VFW Post No. 974, and William C. Greifzu VFW Post No. 598 take turns chairing the veteran's council each year. (Courtesy VFW Post No. 598.)

Mamie Smith is a charter member of the VFW Post No. 974 Auxiliary. She is shown here at the age of 85. Moses Garvin, the first commander, organized the auxiliary because he knew the wives and mothers would be helpful to the post in their efforts to serve the veterans and their families. The auxiliary has given service to veterans since it was organized. (Courtesy VFW Post No. 974 Auxiliary.)

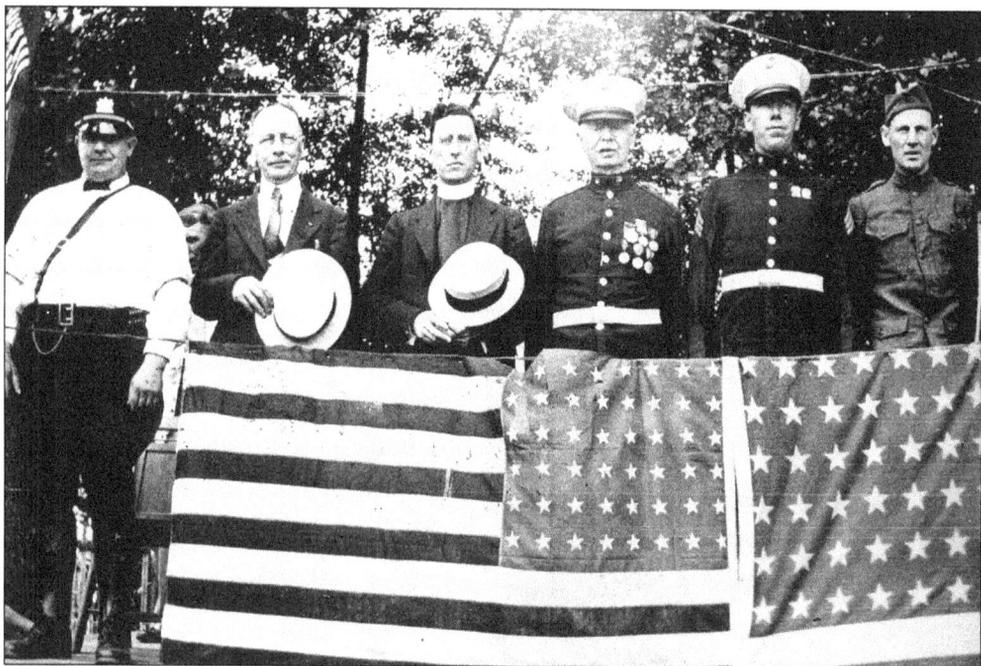

Father Gallagher (third from the left) of the Blessed Virgin Mary Church is shown with veterans on Memorial Day in the 1930s. (Courtesy the Blessed Virgin Mary Church.)

In 1895, Jane Carroll bought the corner property across from Holy Cross Cemetery. She established Carroll's Florist, and for three generations, until 2001, the family conducted the flower business at this location. Carroll's Florist closed when John and Helen Carroll (above) retired. For more than a century, Carroll's flowers brought comfort to the bereaved and added joy to the celebrations in life. (Courtesy Charles F. Sanders.)

In May 1987, VFW Post No. 598 selected its Poppy Queen. (Courtesy VFW Post No. 598.)

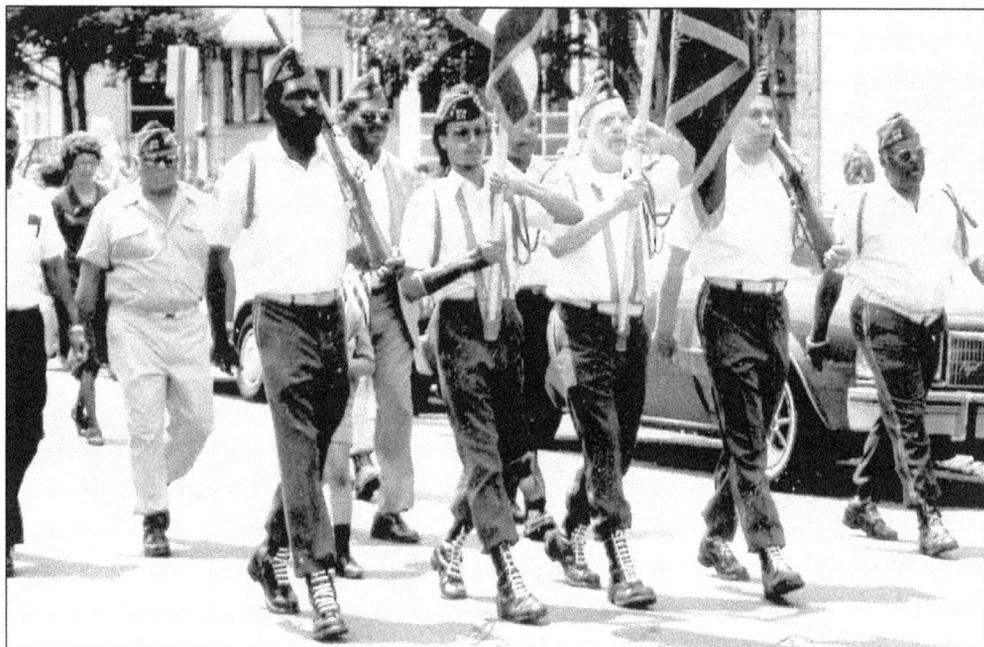

Members of the Willie G. Childs VFW Post No. 974 are shown in a Memorial Day parade. The post was organized in 1932 and named for Willie G. Childs, a tailor and charter member. Moses Garvin was the first commander. The post, which has a very active membership, is located at 1115 Summit Street. (Courtesy VFW Post No. 974.)

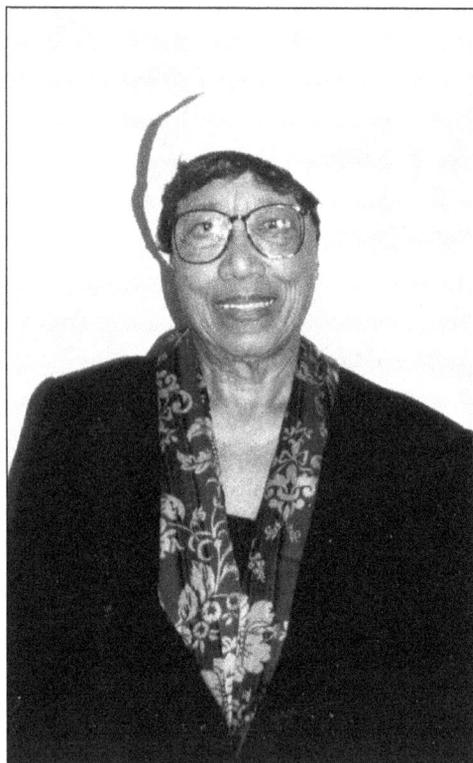

Beatrice Lewis Harris's work as the director of the senior citizens center of Freedom House under the direction of the County Office of Services for the Aging (COSA), her service on the advisory board of Delaware County COSA, and her work as vice chair of the senior citizen club of the Mount Zion African Methodist Episcopal Church earned the respect of the whole community. Her work as a missionary earned her the Unsung Hero Award of the Philadelphia Conference Missionary Society. Beatrice Harris was a volunteer at the Darby Library, a Cub Scout leader, the history lecture chair for the Darby Borough Historical and Preservation Society, and a past matron of Rose of Sharon Chapter No. 80 Order of the Eastern Star. In cooperation with Dr. Leroy Gates and Rueben Pritchett, she helped research and write the history of the Mount Zion church. Her great-grandmother and grandmother came to live in this area in the post–Civil War days. Her mother, Florence Lewis, was born in Darby in 1890. Harris received the DBHPS Citizen Award in 1998.

Six

INKWELLS,
BLACKBOARDS,
AND BOOKS

This desk is one of two given to Harold S. Finigan that came from the first Quaker Friends school. Students sat on stools at these high desks dating from 1687. The desks had built-in inkwells. The picture was taken during the time the desk was on display in Finigan's window as part of a historical information exhibit arranged by the Darby Borough Historical and Preservation Society. (Courtesy Lindy Wardell.)

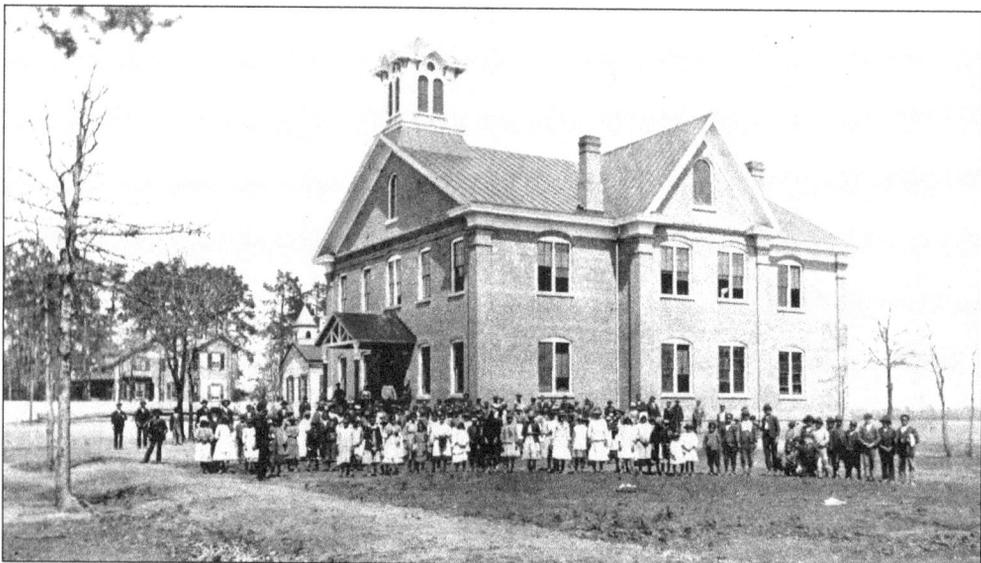

The Martha Schofield School is shown here soon after it opened in Aiken, North Carolina. Schofield was renown for her work as an educator. This school was opened soon after the Civil War to teach the children of freed slaves. (Courtesy the Library Company of Philadelphia.)

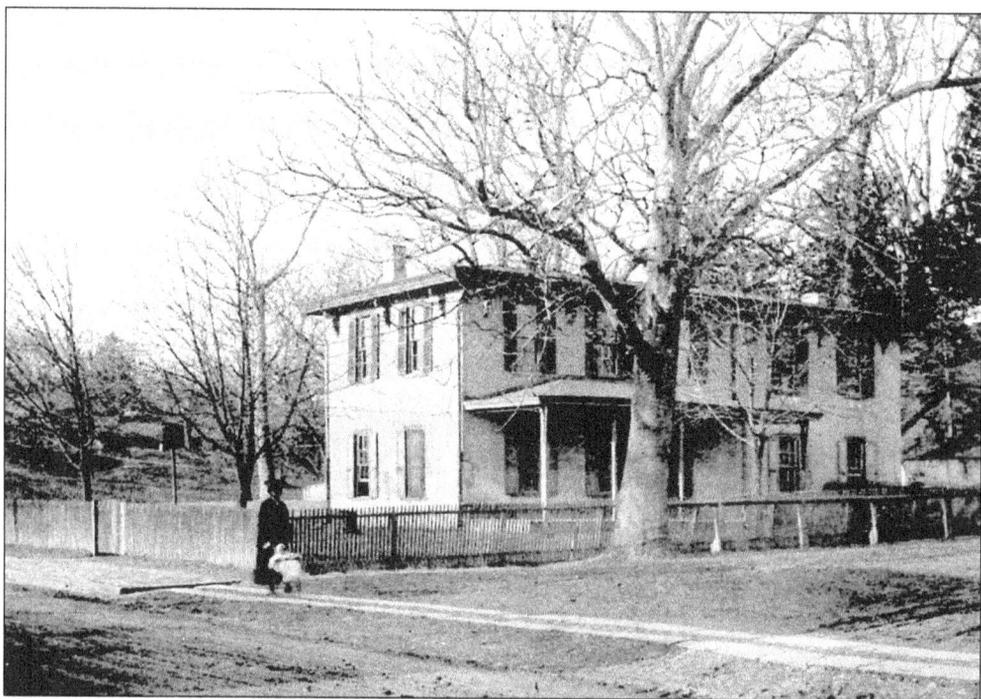

Seen in 1900, Buttonwood Hall was the first school building erected by the Quakers. Classes were earlier held in the first meetinghouse. Buttonwood was the school for boys and was built on the exact site of the 1701 meetinghouse on the burial ground property. Later, Willow Hall, the girls' school, was opened.

78

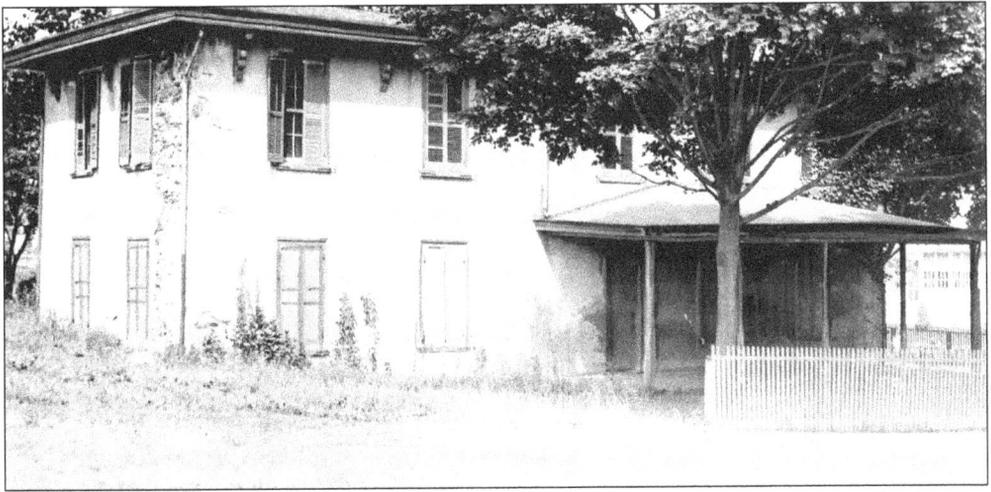

Quakers educated the children of Darby until 1917. Buttonwood was closed after the Quaker school attendance dropped because the public schools had opened. This school was demolished in 1928. (Courtesy Darby Friends Meeting.)

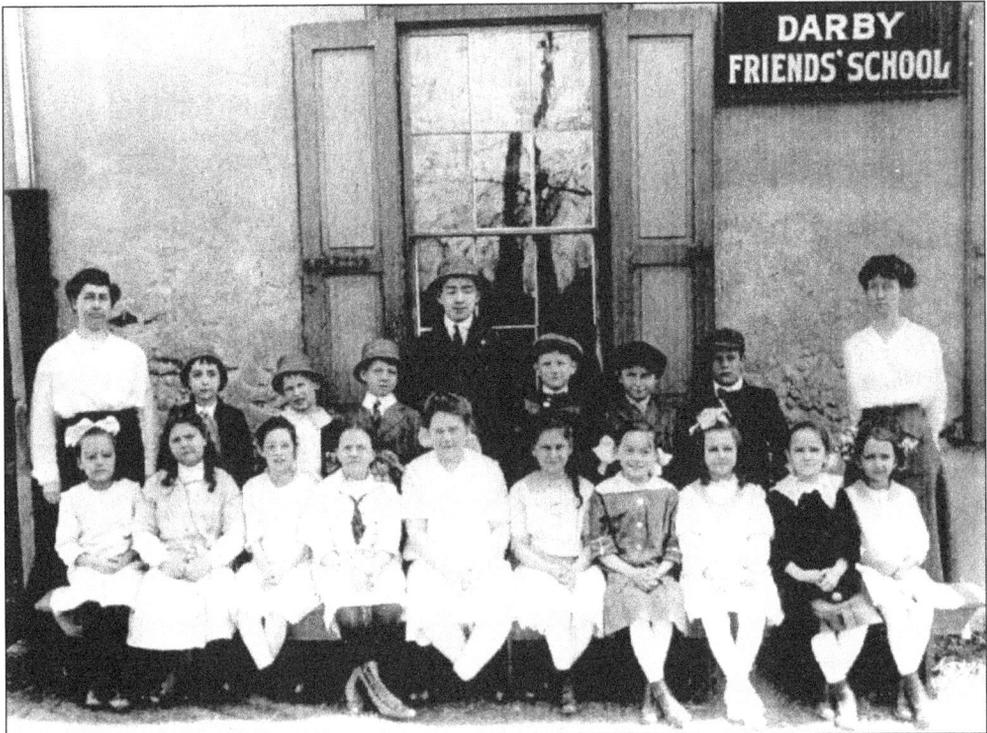

This photograph shows the last class at the Friends school. The young man standing in the center of the back row is Harold S. Finigan. (DBHPS, Harold S. Finigan Collection.)

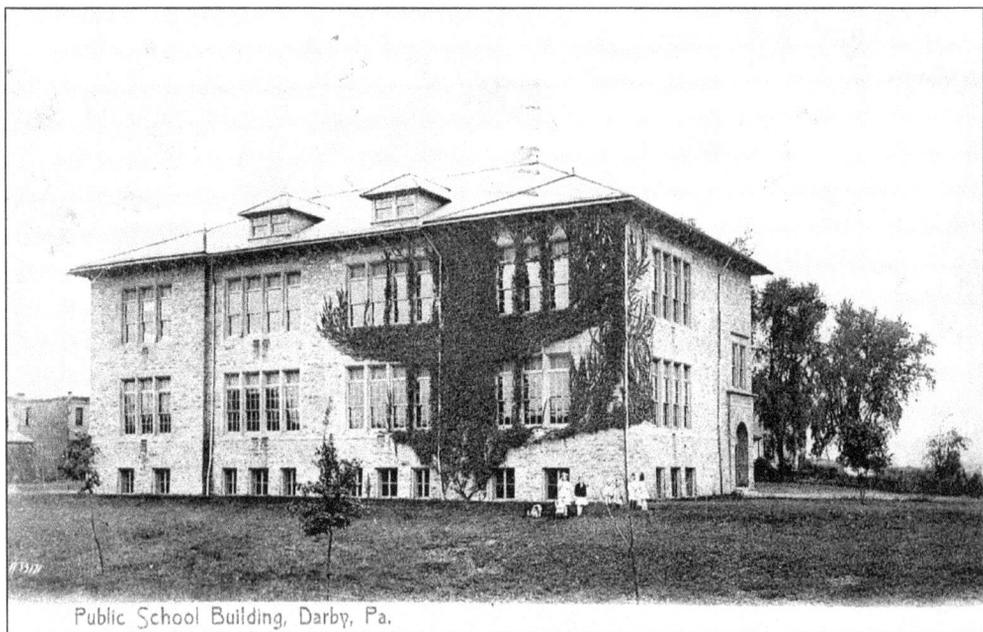

Public School Building, Darby, Pa.

Ridge Avenue School was built in 1896 and is remembered by many Darby residents. This school replaced the building across the street that was used at an earlier date. This view of the school is from 1907.

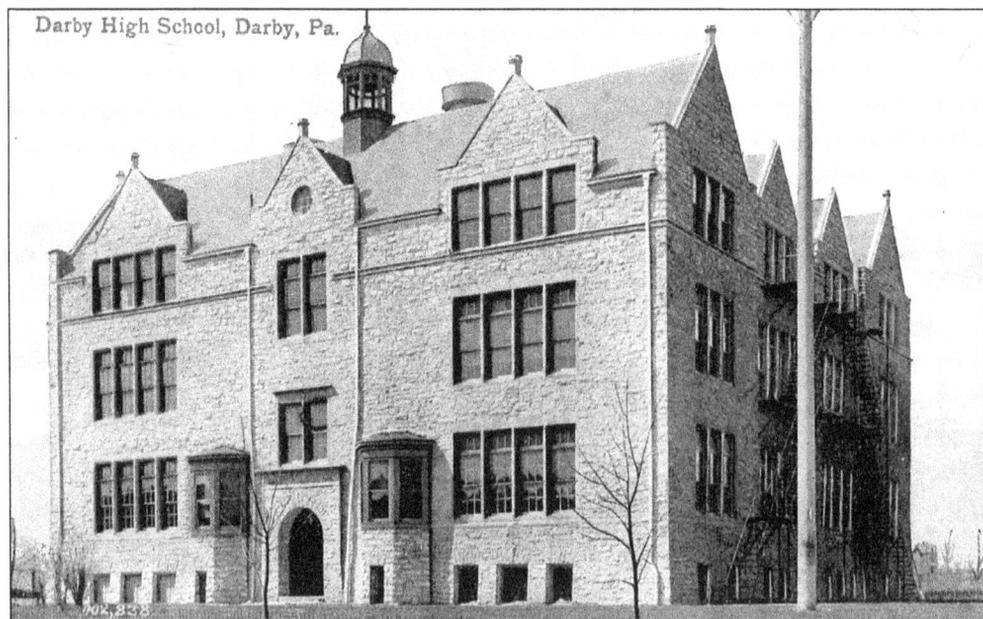

Darby High School, Darby, Pa.

Darby High School is seen in this 1905 view.

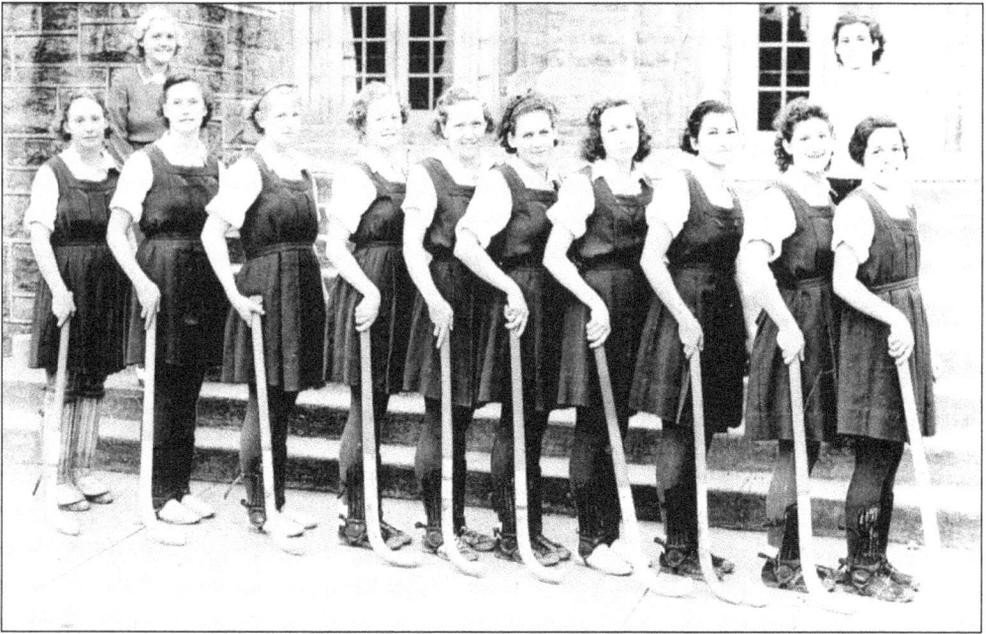

Girls' hockey was a popular sport at Darby High School. This photograph is of the 1936 team. In the back row are manager Miss Carlson (left) and Miss Walker (right). Among the team members pictured are Frenchie Michael, Bertha Douthett, Gertrude Snowden, Helen Phillips, Peg Thompson, Rosemary McGonigle, Ann Bosako, Dottie Costelli, and captain Evelyn Gionnoscoli. (Courtesy Evelyn Cain.)

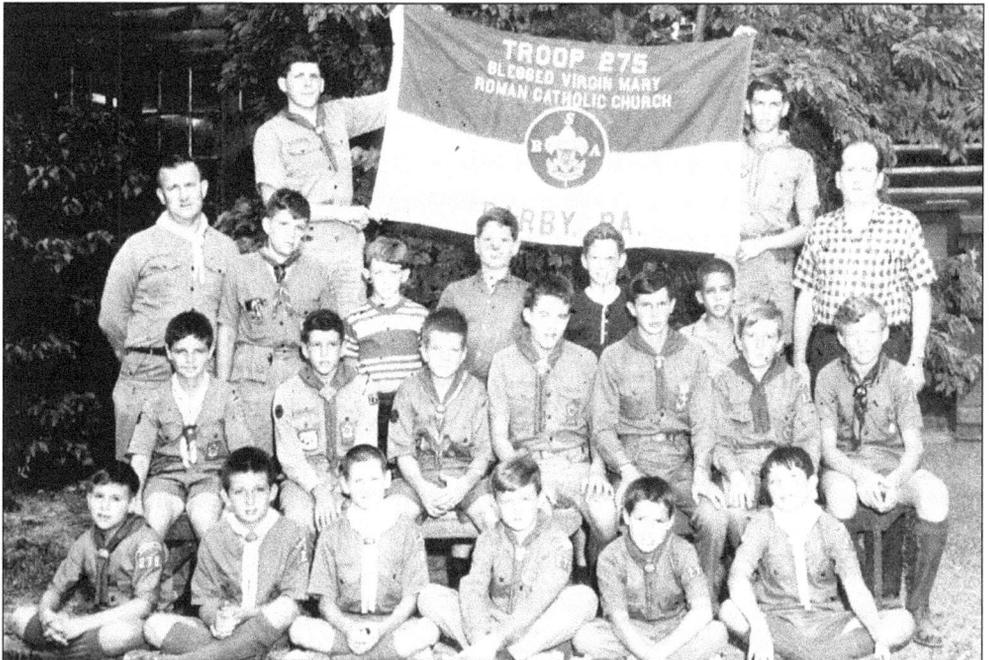

Seen is Boy Scout Troop No. 275 from the Blessed Virgin Mary Church at Delmont Camp in 1966. The scouts are accompanied by scoutmaster John O'Doherty and assistant scoutmaster James Bradley. (Courtesy the Blessed Virgin Mary Church.)

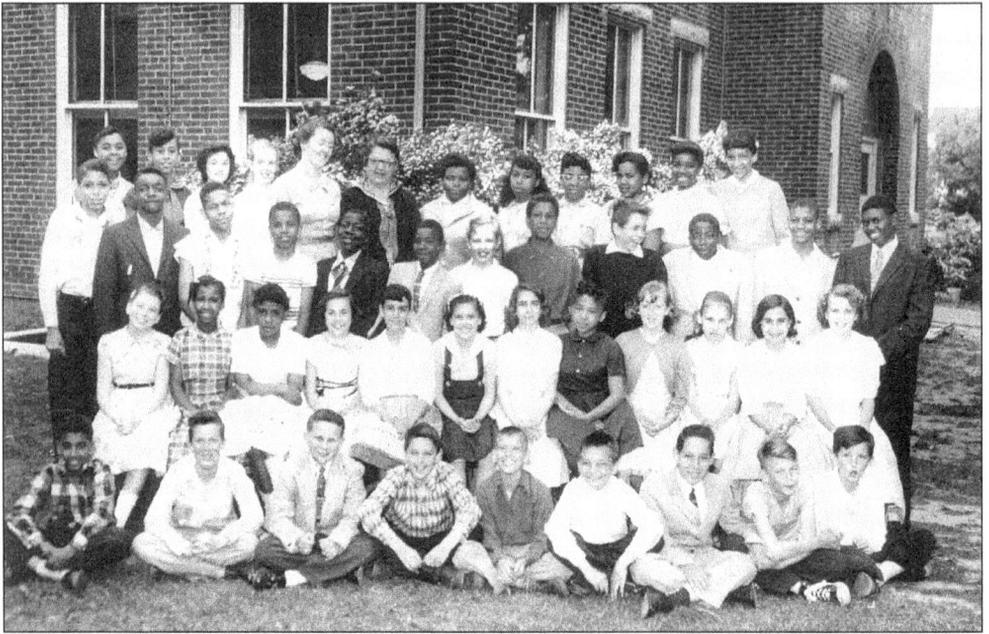

In this view is the Ridge Avenue School class of 1956. (Courtesy Nancy Hack.)

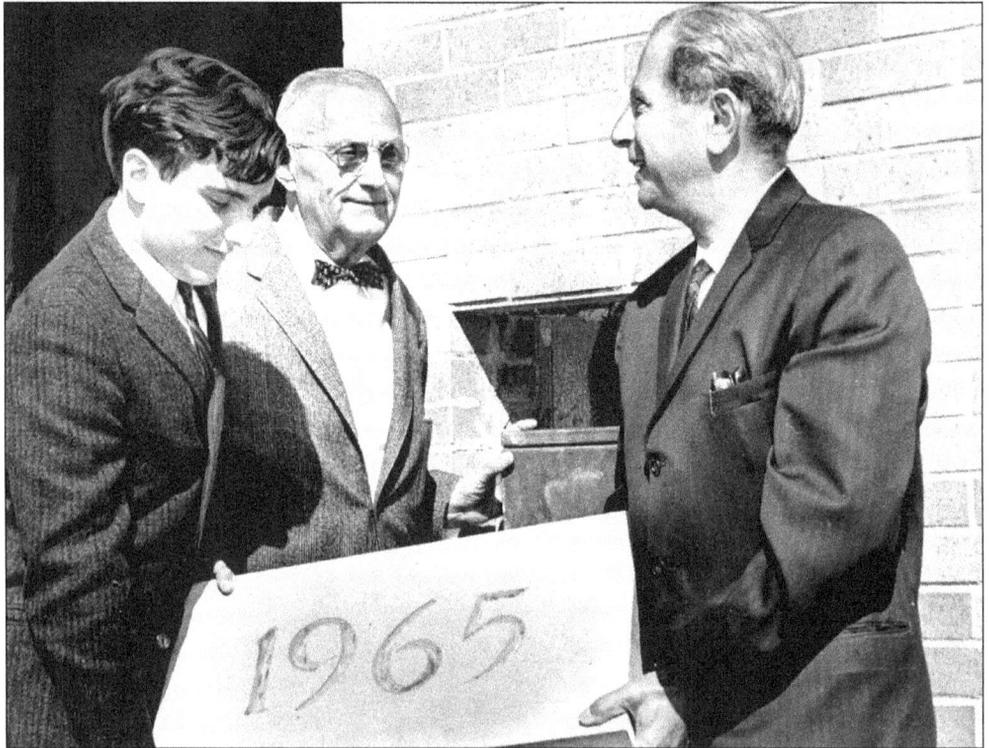

On hand October 6, 1965, to lay the cornerstone of Darby Colwyn High School were school board members, students, and residents of Darby and Colwyn. Shown is student Wallace Saner on the left, Herman Solar in the center, and Harold S. Finigan on the right. (Courtesy the Temple University Urban Archives.)

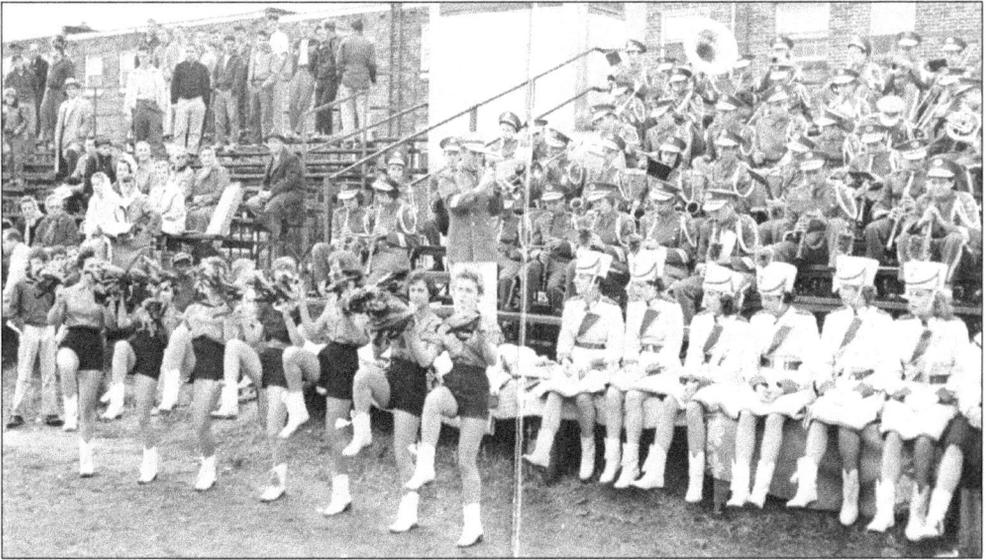
Shown are the Darby High School band and cheerleaders at a Saturday football game in 1956.

Memories are made of proms, and this one at Darby High School in 1943 provided special memories for the students who were entering a new world of military service and technology.

Children at the Walnut Street School take part in a hand-clapping rhythm class outside on the playground on August 1, 1946. (Courtesy the Temple University Urban Archives.)

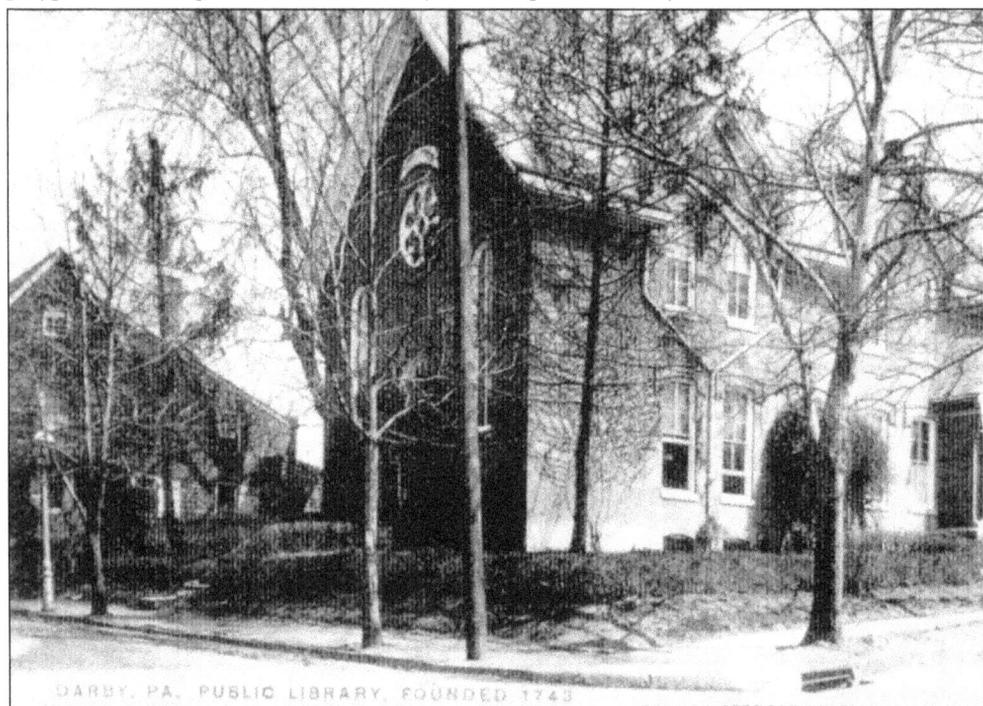

DARBY, PA. PUBLIC LIBRARY, FOUNDED 1743

This photo postcard shows the Darby Library prior to 1898. The Blunston Bake House was still next door. Organized in 1743 by members of the Darby Friends Meeting who "actuated by a laudable desire to acquire and diffuse useful knowledge, did in the year 1743, form themselves into a Society for that purpose, by the name and title of 'The Darby Library Company.'" This library is the second-oldest library in continuous operation in the United States. The original books purchased in England were carried from home to home and to temporary library facilities in a case until the present library building was erected.

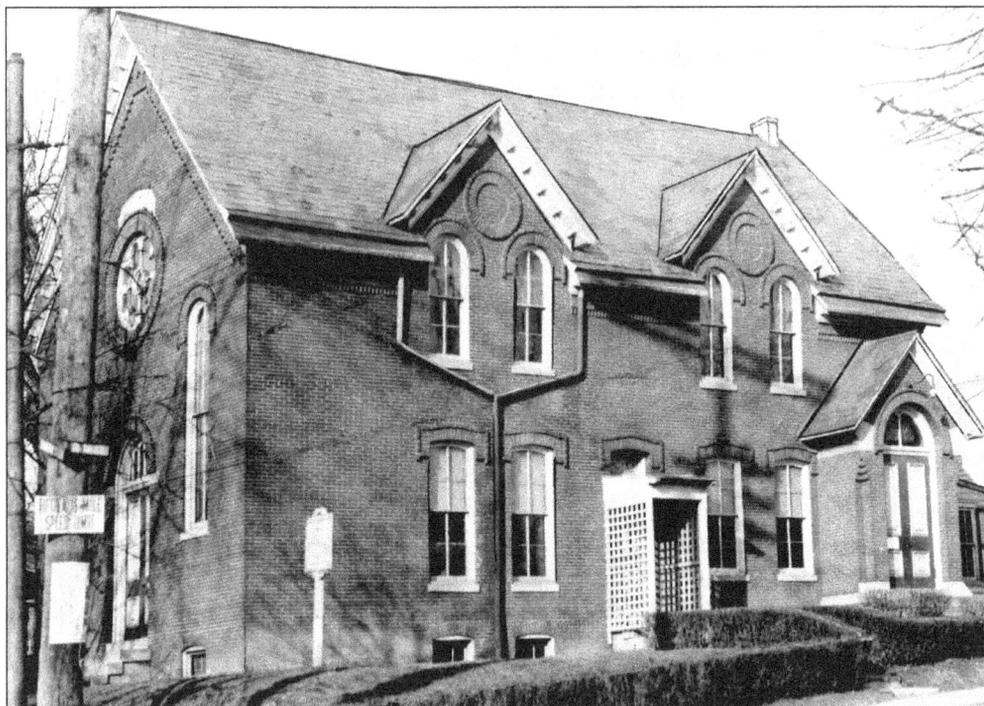

The Darby Library Association merged with the Home Protection Society on January 8, 1928, the 185th anniversary of the library. The library inherited the assets of the Home Protection Society and, upon merging, became the Darby Library Company. The library was given the original shares of stock issued by the Home Protection Society and also the society's charter. This photograph emphasizes the architectural details of the building, which was designed by Benjamin D. Price and erected between 1872 and 1873. The building resembles a church and is often mistaken for one. (Courtesy the Temple University Urban Archives.)

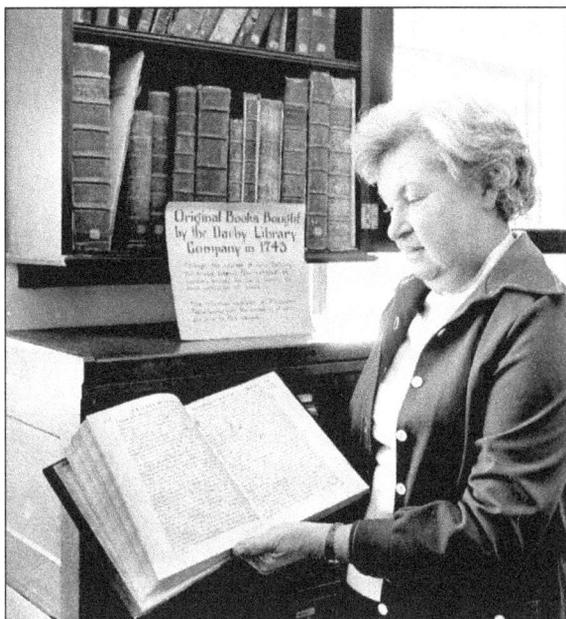

Naomi Valutas, the wife of Charles K. Valutas and a longtime Darby Library volunteer, is shown here on October 26, 1977, with the original books purchased to start the library. She was awarded the 1998 DBHPS Citizen Award for the impact of her volunteer work on the quality of life in Darby Borough. (Courtesy the Temple University Urban Archives.)

The Bandages and Bundles Red Cross Club at Darby High School (seen here in 1942) made bandages for the military during World War II. It was one of many clubs at the school that reflected the wide interests of the students.

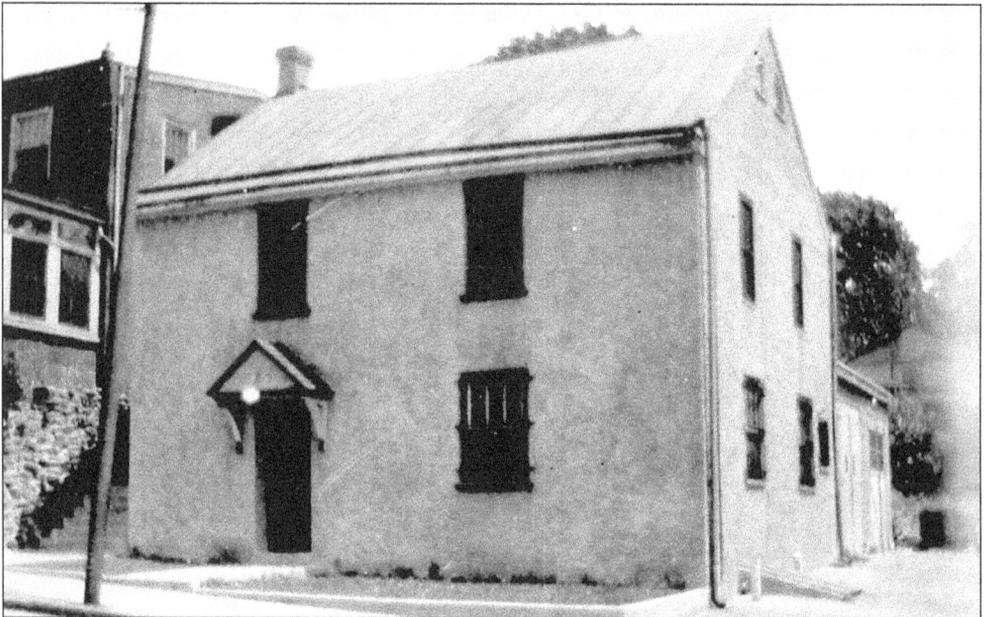

This old home on North Ninth Street was at one time the property of the Lloyd family. It was used as the first public school. It is believed that the school opened in 1845 and remained a school until Ridge Avenue School opened in 1855. Soon afterward, the old school became the municipal building and police station. It had one jail cell. Borough officials sat around a large round table in the room on the second floor to conduct their meetings. Space was so limited that borough residents were not always able to attend meetings. (Courtesy the Temple University Urban Archives.)

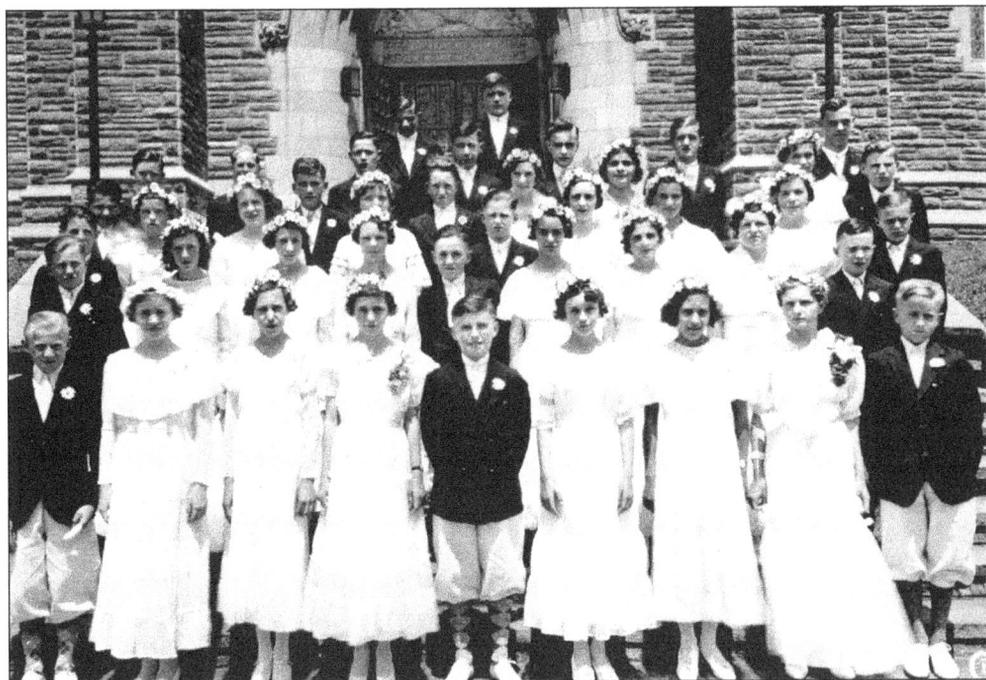

The 1935 graduating class was featured in the 75th anniversary book of the Blessed Virgin Mary Church. (Courtesy the Blessed Virgin Mary Church.)

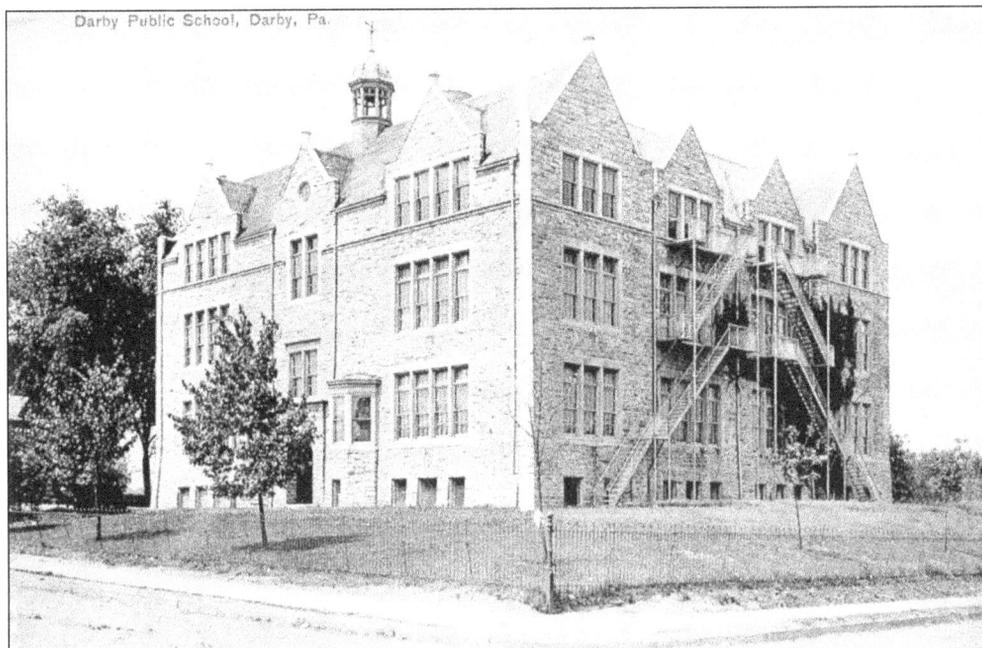

Darby Public School, Darby, Pa.

This view of Darby High School was featured on a postcard sold *c.* 1910.

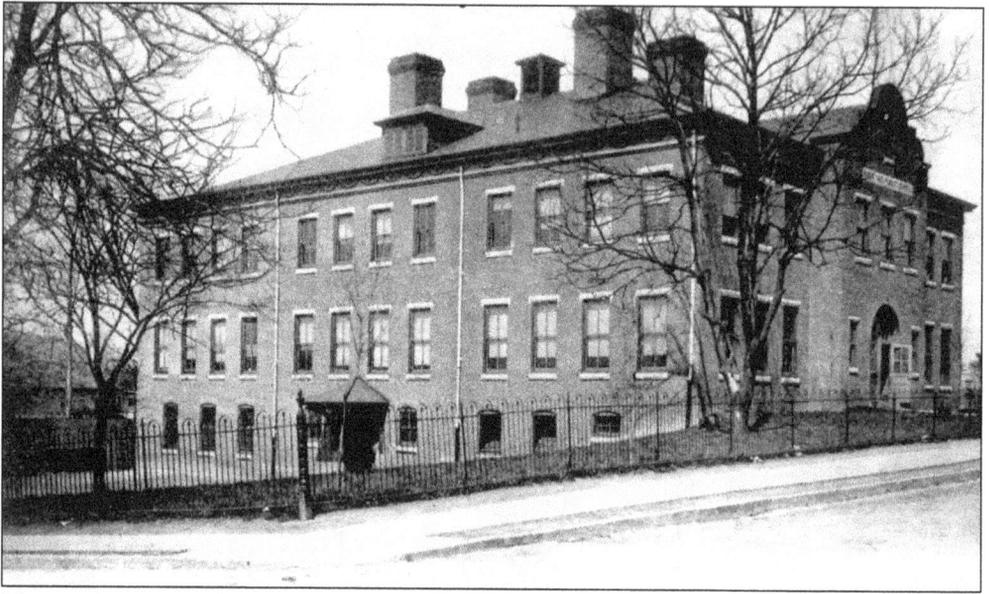

This *c.* 1900 postcard view shows Ridge Avenue School. These cards were sold locally at Fox's newsstand and other stores.

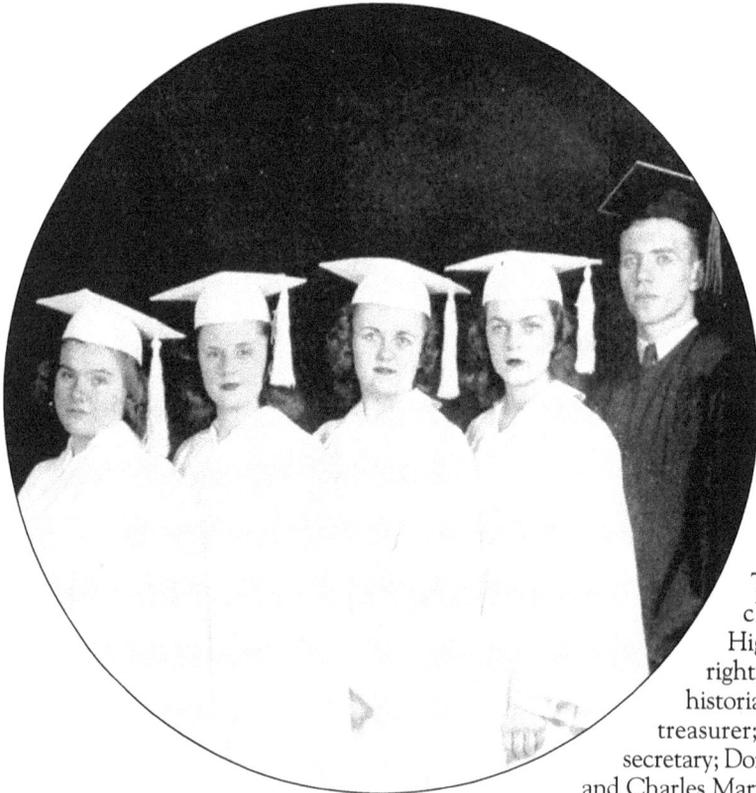

The officers of the class of 1943 at Darby High School, from left to right, are Henrietta Wahl, historian; Eleanor Crompton, treasurer; Doris Callahan, secretary; Dorothy Burns, president; and Charles Marvil, vice president.

Seven

FIRE COMPANIES, POLICE, HEALTHCARE, AND THE MAIL

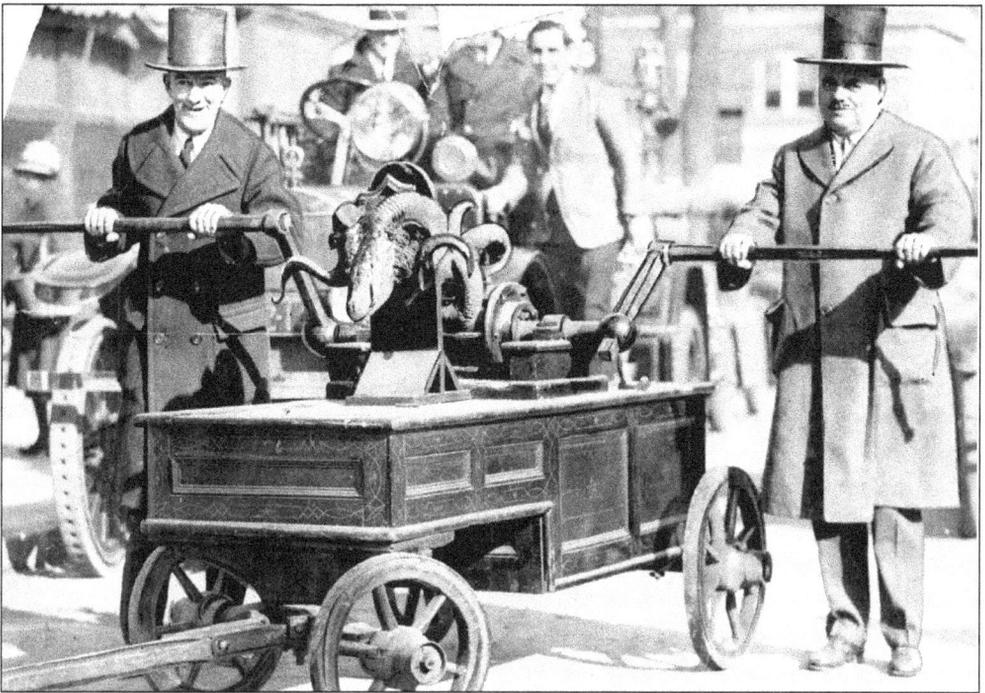

The ram, a symbol of the woolen mills in England, was adopted by Darby to represent its mills. When the borough's first fire engine, made in England in 1749, arrived in Darby in 1813, the fire company named it the Ram. An actual ram's head was carried on the engine to emphasize its importance to the community. It is a treasured relic of Darby's past and has a special place of honor in the firehouse on Chester Pike. This photograph, taken on January 27, 1927, the 152nd anniversary of the company, shows Joseph Barnes (left) and Charles H. Drewes (right). Drewes was a member of Fire Company No. 1 and operated a funeral home on Main Street. (Courtesy the Temple University Urban Archives.)

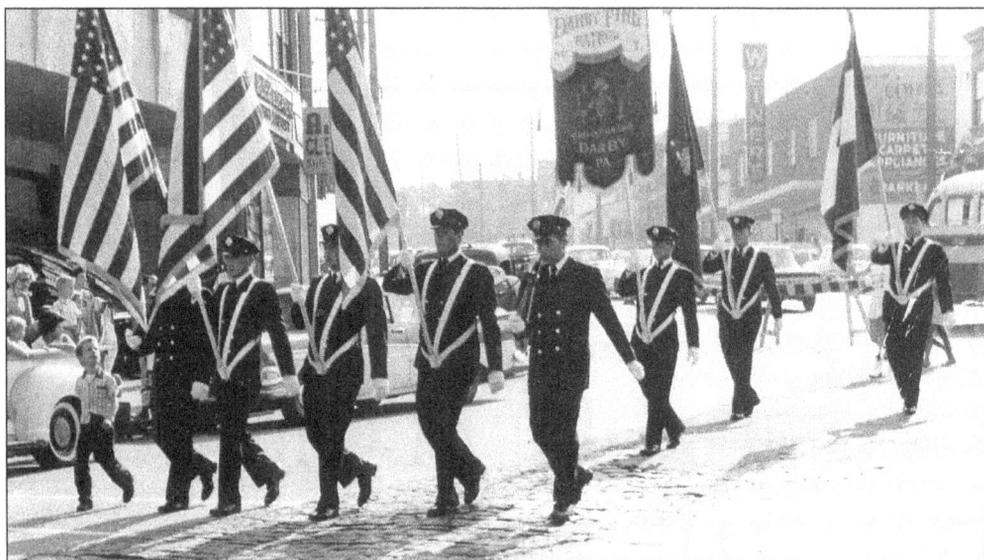

The color guard for Fire Company No. 2 leads the parade on Chester Pike. (Courtesy Evelyn Cain.)

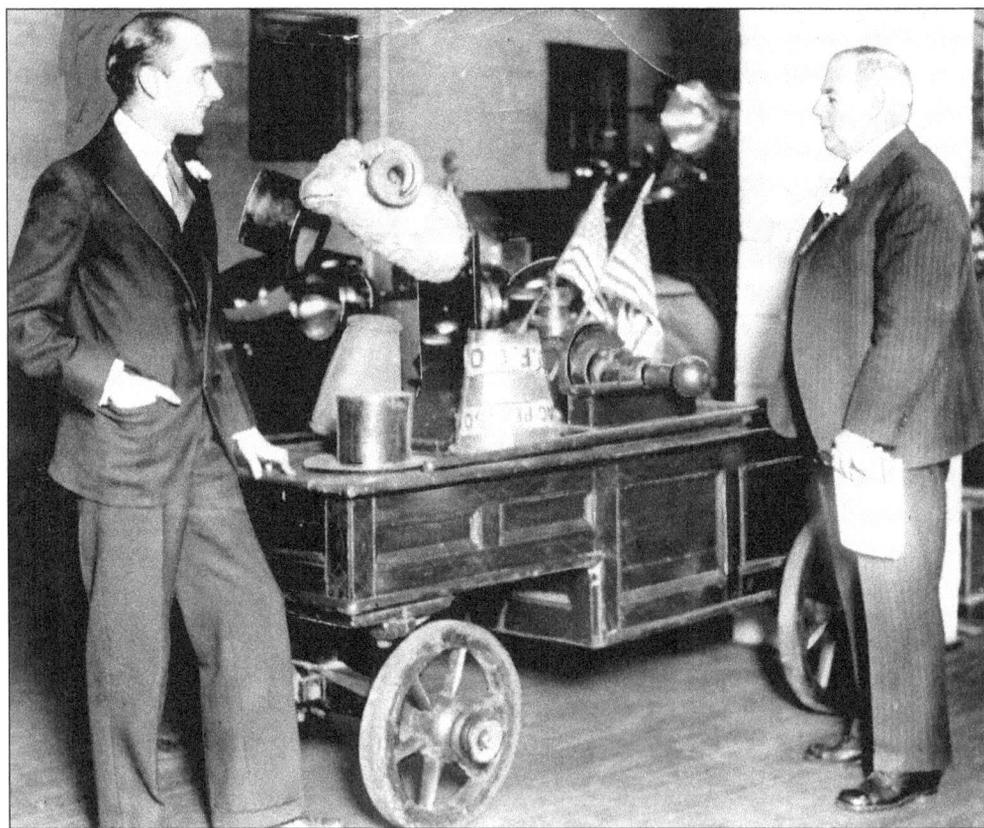

The custom seems to have been to have officers of the fire company photographed with the Ram. Shown here are James Boyle (left) and Charles Drewes on January 27, 1947, on the 172nd anniversary of the Fire Company No. 1. (Courtesy the Temple University Urban Archives.)

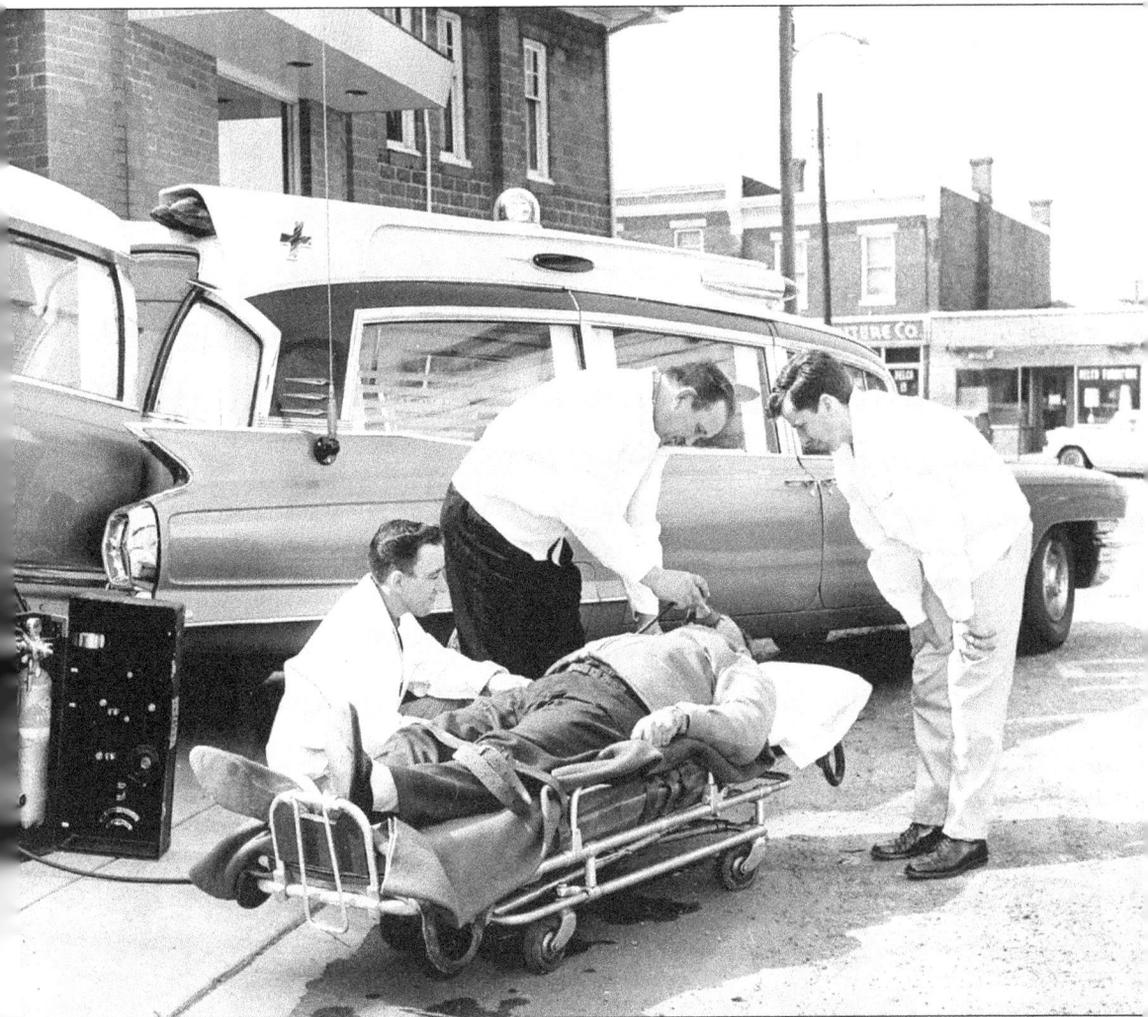

On March 13, 1962, James Lewis was the patient as James Horan (left), Freeman Cox (center), and Robert Card demonstrated the new $13,500 Cadillac ambulance. (Courtesy the Temple University Urban Archives.)

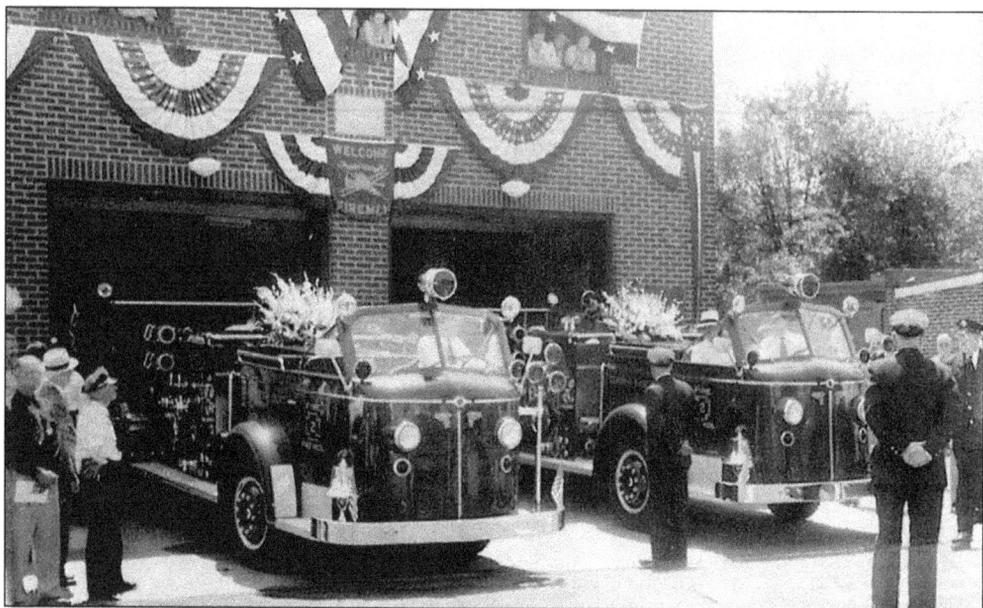

Fire Company No. 1 participated in a memorial service on July 4, 1951. The company, organized in 1775, was serving Darby before this country became the United States. (Courtesy the Temple University, Urban Archives.)

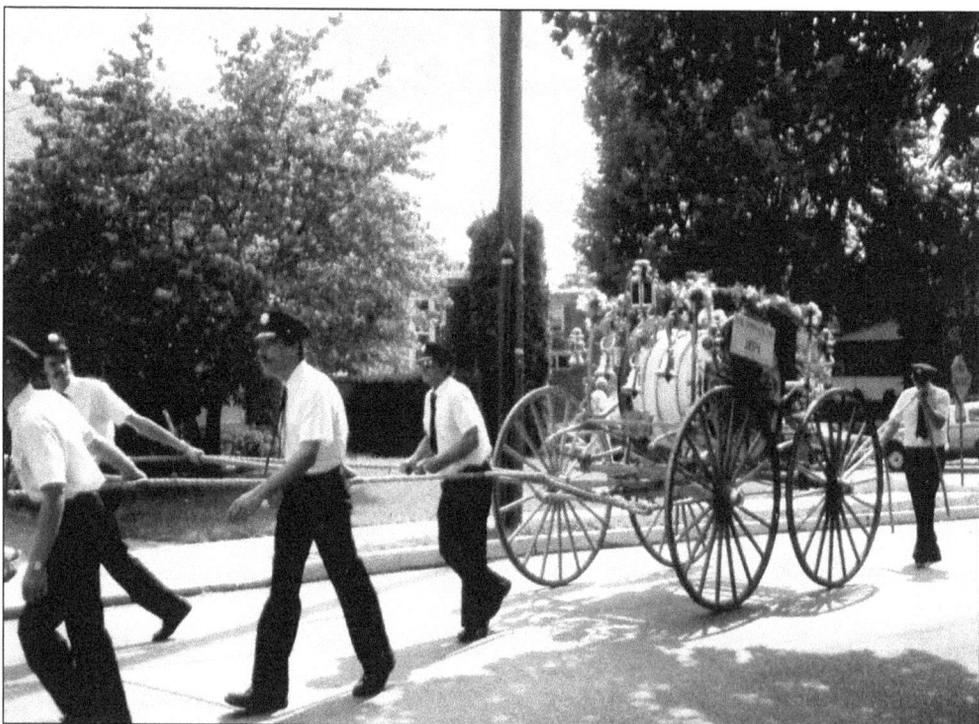

Fire Company No. 2 paraded in Philadelphia in 1976, pulling the antique hose reel through Independence Hall area streets. (Courtesy the Temple University Urban Archives.)

Freeman Cox Sr. was a life member of Fire Company No. 1. He volunteered for more than 50 years, serving in several capacities within the company. He was a familiar figure on the streets of Darby during emergencies. His dedication and that of others like him have guaranteed service by Fire Company No. 1 since 1775. Company volunteers have served the community continuously for 229 years. Cox received the DBHPS Citizen Award in 1998 in recognition of his service to the Darby community. (Courtesy Blanche Cox.)

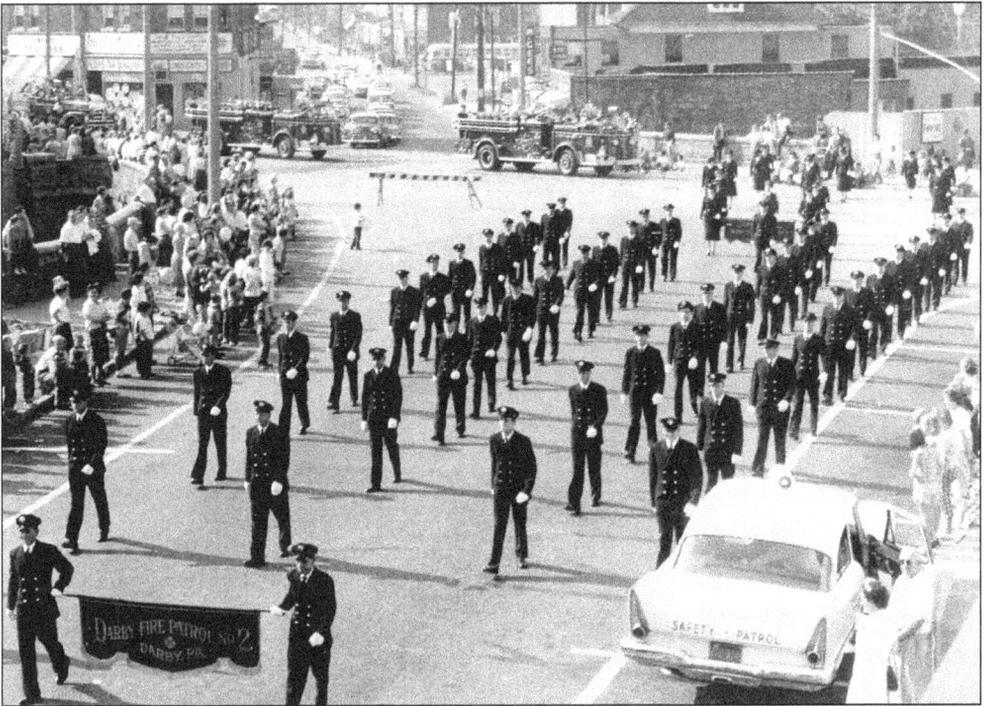

Parading in Darby at Springfield Road and Chester Pike, Fire Company No. 2 is viewed with pride by the townspeople. (Courtesy Evelyn Cain.)

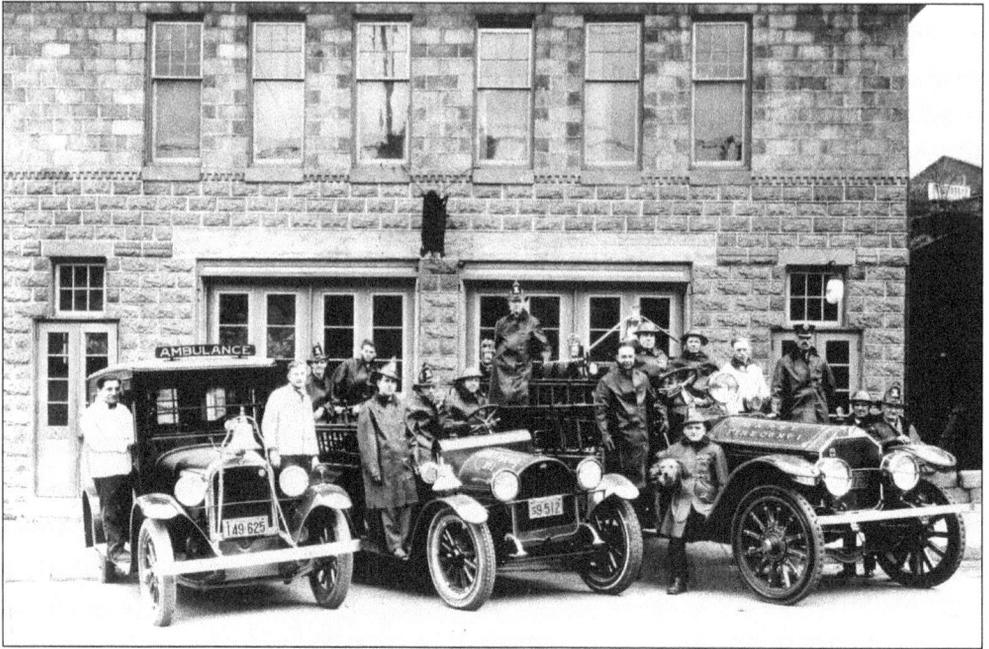

Fire Company No. 1 members were always ready for service. The firehouse has been altered from time to time to accommodate new equipment of the fire company. The equipment shown here is from the 1920s (Courtesy Blanche Cox.)

Harold W. Pugh was a life member of Fire Company No. 1. He served on the school board for 37 years and was a member of the board of directors of the Darby Library. He was employed as an engineer by Roberts Filter Company for 70 years. Both Pugh and his wife, Marion, were well known in the community for their dedicated volunteer work and participation in community affairs. In 1998, they both received the DBHPS Citizen Award for improving the quality of life for the residents of Darby Borough. (Courtesy Marion Pugh.)

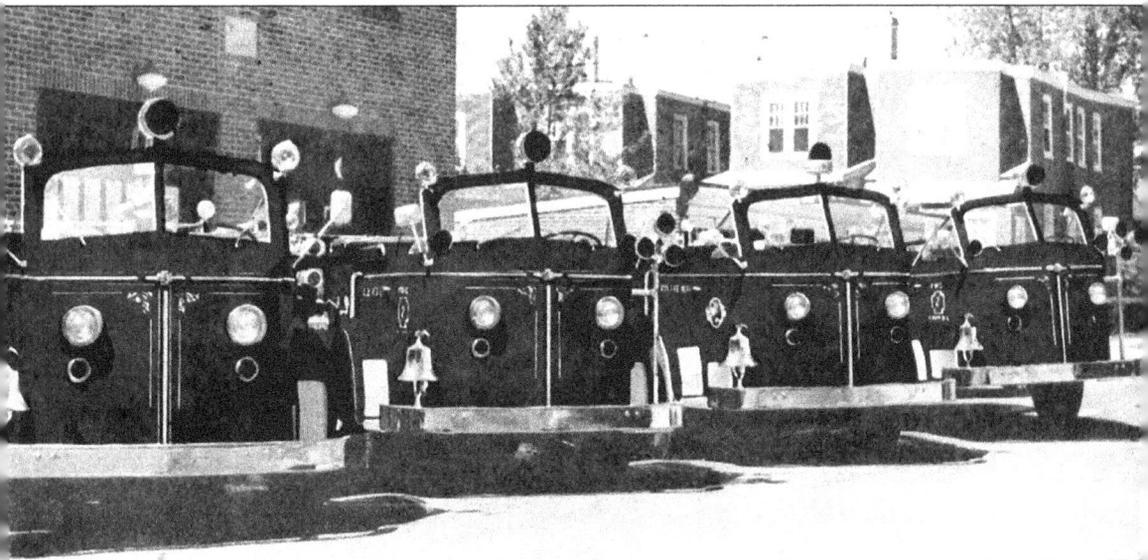

In 1952, Fire Company No. 2 invested in the newest and best equipment. Members displayed the new LaFrance Autocar and other equipment in a parade and in front of their firehouse in Colwyn.

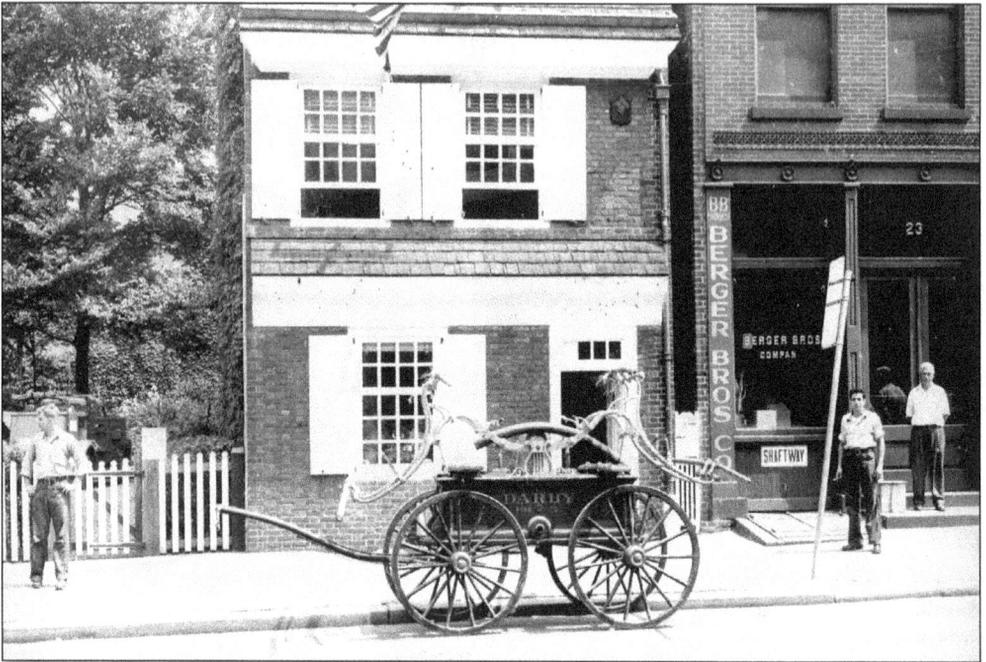

The Shifter was the second fire engine purchased by Fire Company No. 1. Brought to the United States in 1873, this and all other fire equipment has had its share of calls for help over the years. Fires were not uncommon in the early mills. Early homes and businesses were heated with wood-burning fireplaces and stoves that were frequently the cause of fires. This photograph shows the Shifter being displayed in front of the Betsy Ross House in Philadelphia. (Courtesy the Temple University Urban Archives.)

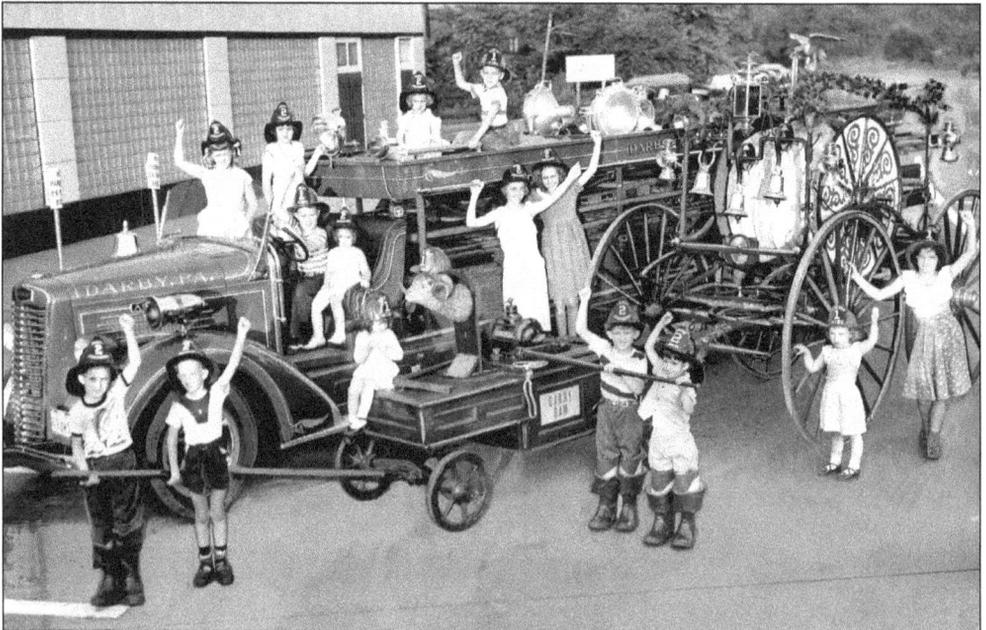

Darby youngsters were firemen for the day in July 1951 and learned about fire safety. (Courtesy the Temple University Urban Archives.)

96

The May 1953 centennial celebration gave these ladies a reason to experience how Darby ancestors fought fires. Widows of firemen were required to provide leather buckets to carry water, and each fireman was required to provide specific equipment such as ladders. (Courtesy the Temple University Urban Archives.)

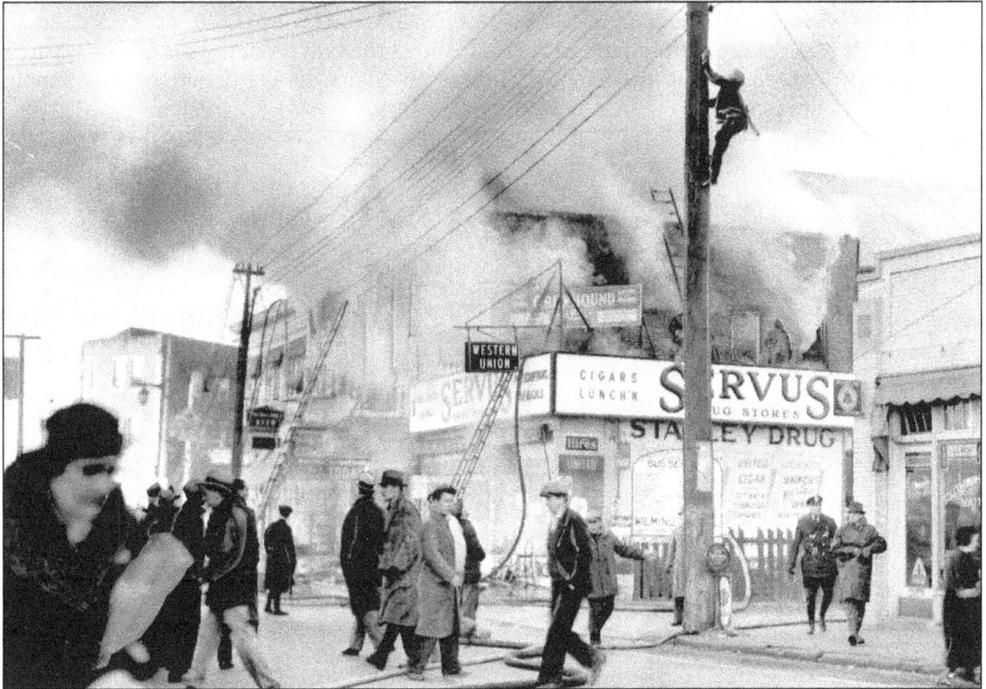

The Darby Theater burned in 1936. This photograph shows local firemen trying to diminish the flames. (Courtesy the Temple University Urban Archives.)

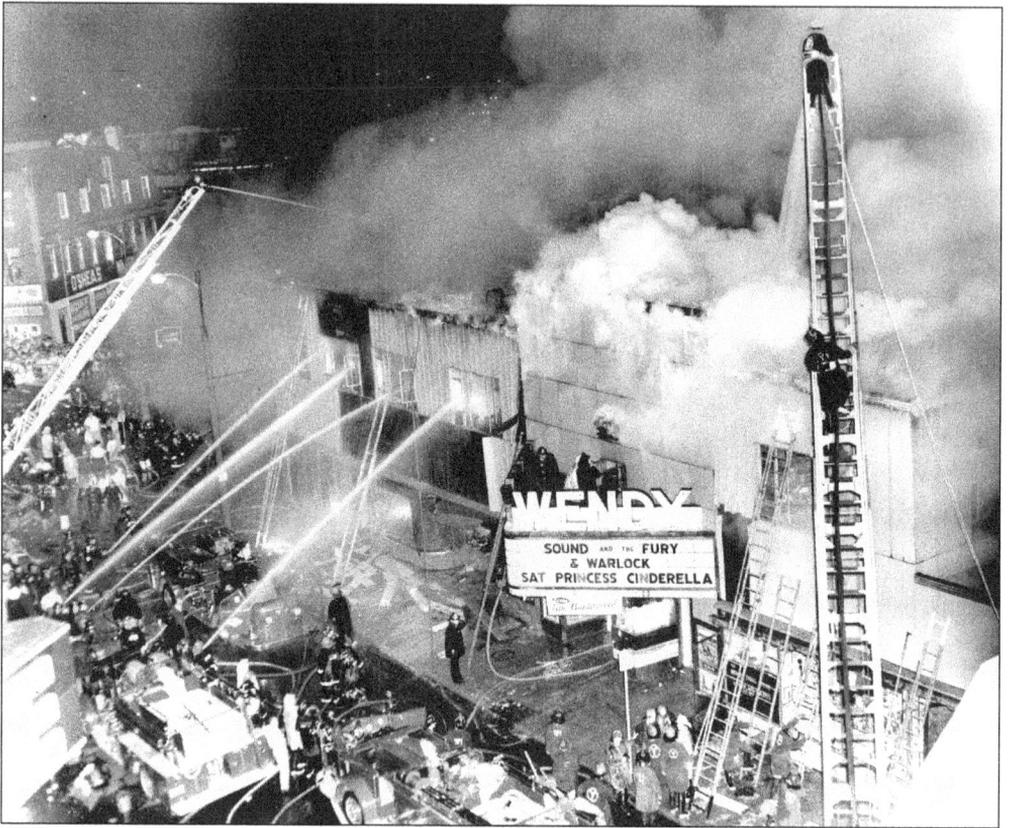

This dramatic photograph is from June 24, 1959. It shows the bravery and skills of area firemen who responded to the fire at the Wendy Theater on Main Street. (Courtesy the Temple University Urban Archives.)

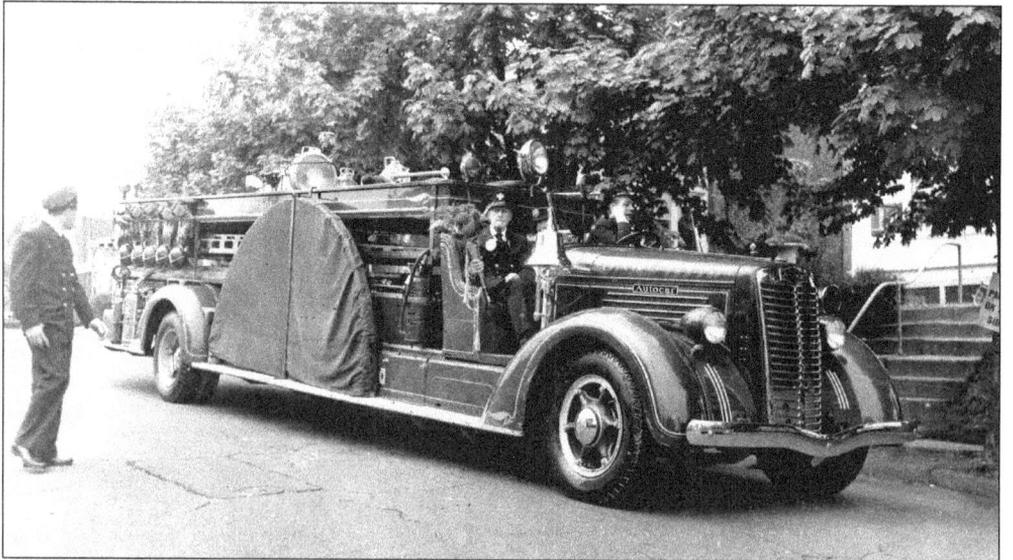

The spanking-new LaFrance Autocar is introduced to the community by Fire Company No. 2. (Courtesy the Temple University Urban Archives.)

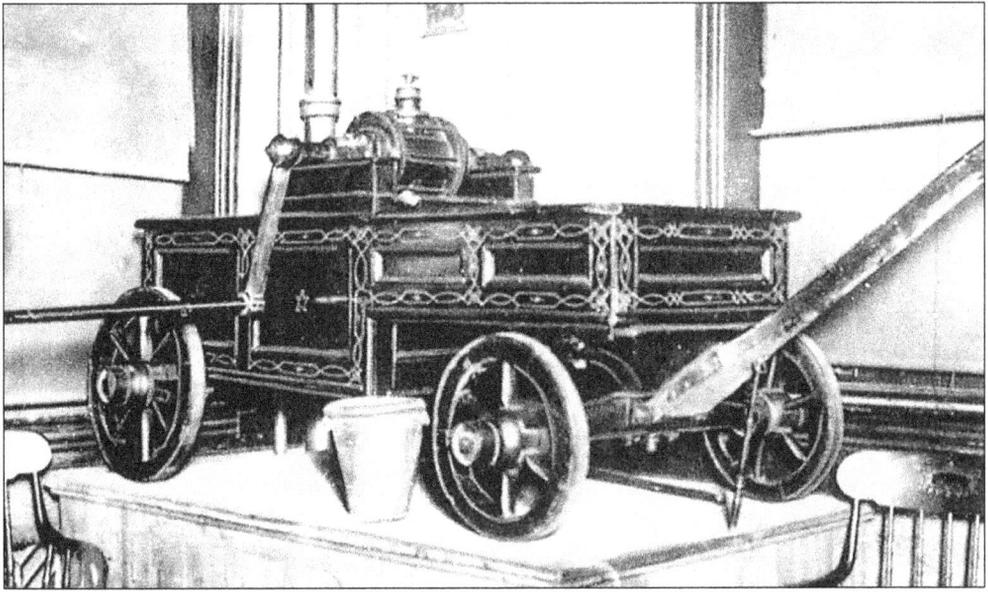

The Darby Ram is shown in its permanent surroundings at the Fire Company No. 1 firehouse with one of the old leather buckets. (Courtesy Thomas R. Smith.)

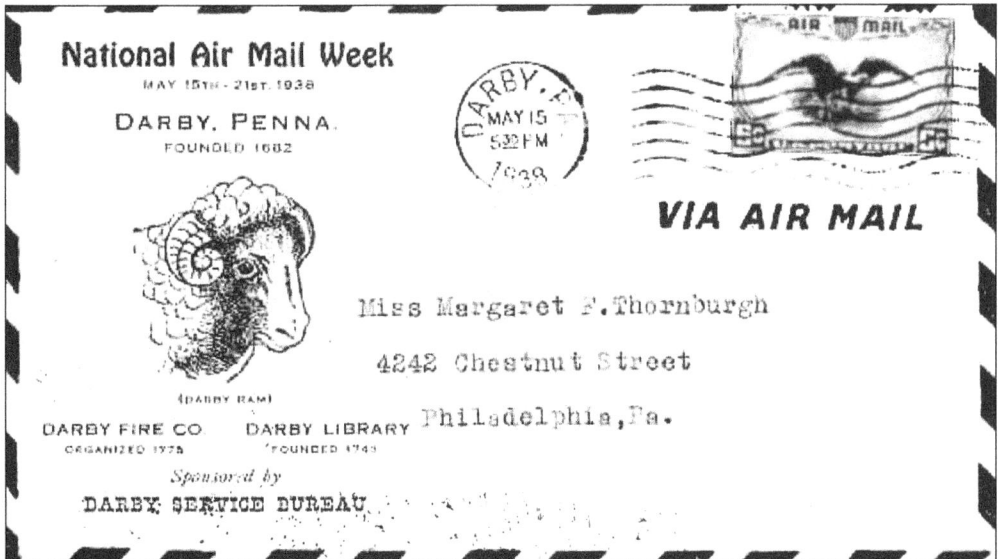

National Air Mail Week, May 15 to 21, 1938, did not go unnoticed by the Darby post office. Sponsored by the Darby Service Bureau, this first day cover bears Darby's 1682 settlement date and the Darby Ram, and mentions Fire Company No. 1 and the Darby Library. Stamped with a 5¢ airmail stamp, it was mailed from the Darby post office on May 15, 1938, at 5.30 p.m.

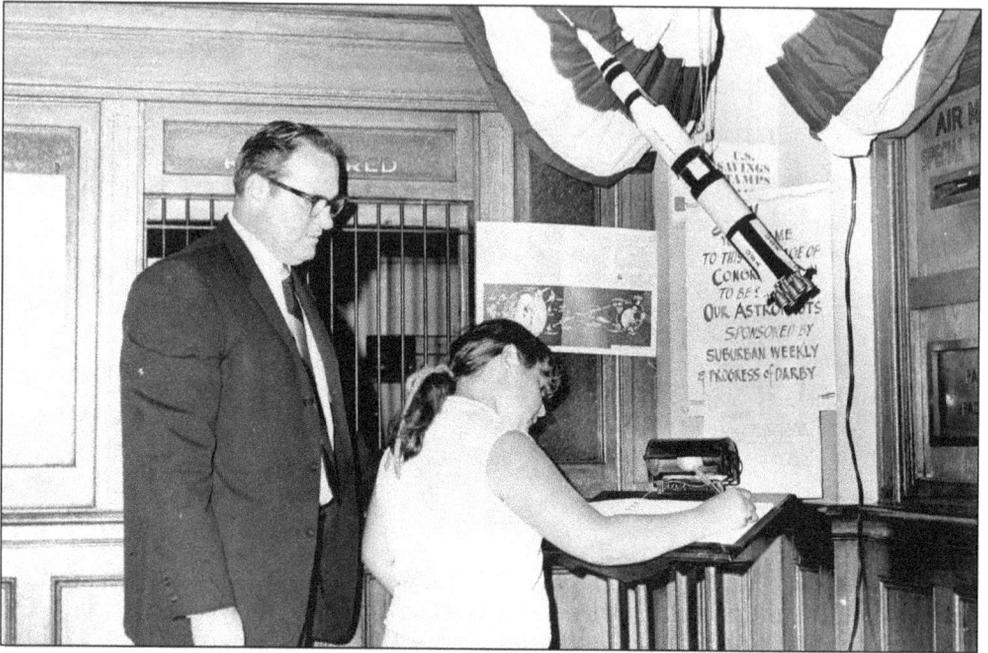

Corresponding with the astronauts on the moon was an exciting letter-writing experience. Robert Doherty, postmaster of the Darby post office, helped 11-year-old Sharon Outt post her message on July 28, 1969. (Courtesy the Temple University Urban Archives.)

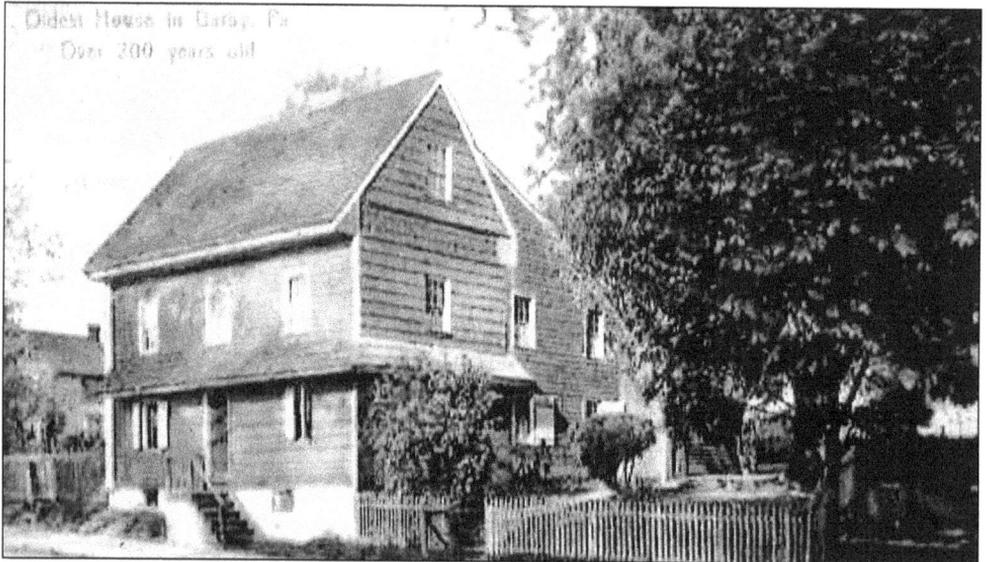

The Pearson home was used as the first official post office in Darby. Benjamin Pearson was appointed postmaster by Pres. James Madison on September 22, 1809. The post office was located in several places, including a pool hall and grocery store, until the Engineer Building was erected on the corner of 9th and Main Streets. The post office occupied the west side of the first floor of the building. The Pearson home was referred to as the oldest house in Darby. Alice Pearson was the last descendant of the Pearson family to live in the house. She refused to sell her property to provide space for the new building. The house was demolished in 1903 after her death.

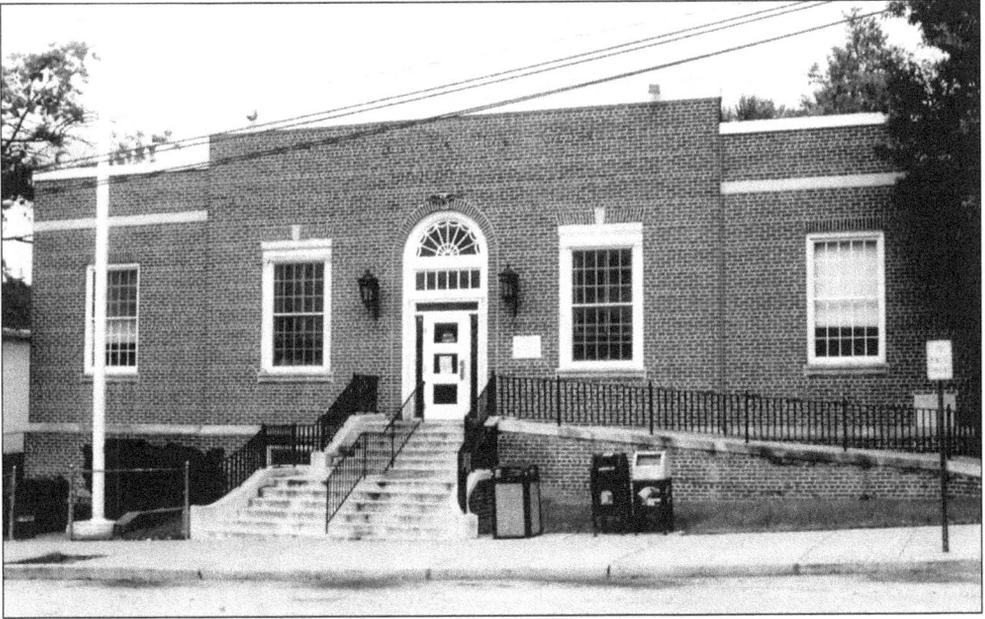

Darby's present post office serves a large area, including Colwyn and Collingdale. A branch office was opened in Collingdale in 1931. The Colwyn post office was named Gwendolin when it was established on October 19, 1891. The Gwendolin post office was closed on October 31, 1907, and serviced directly from the Darby post office. On November 10, 1891, Gwendolin's name was changed to Colwyn. The postal customer area of the present building still has its old oak woodwork around the service windows and mailboxes. The ramp for wheelchair access is an addition to the original building.

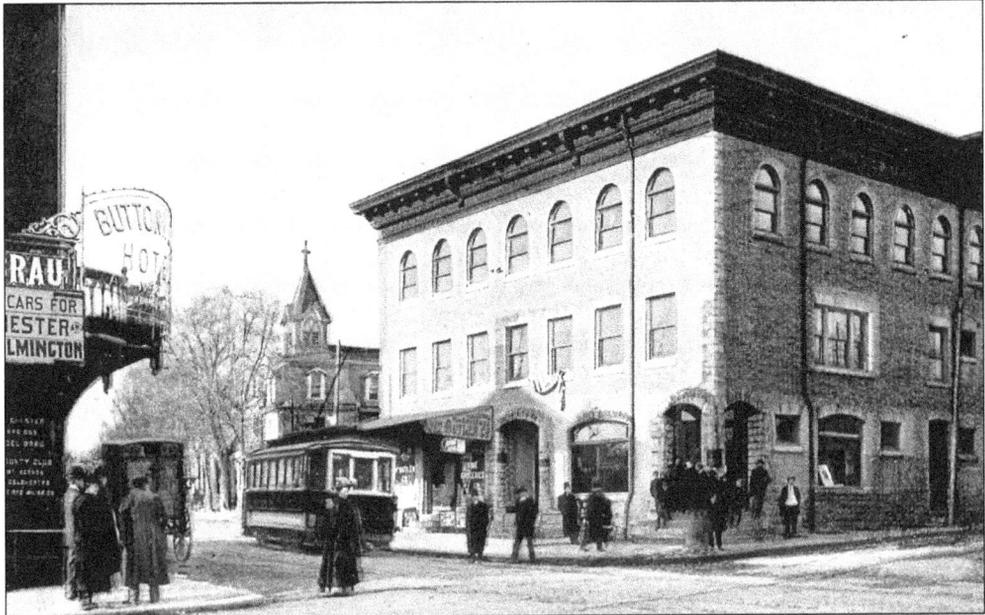

The west side of this building was used by the post office. The bell tower of Mount Zion United Methodist Church can be seen in the background, and the corner of the Buttonwood Hotel, where the trolleys used to stop, is on the left.

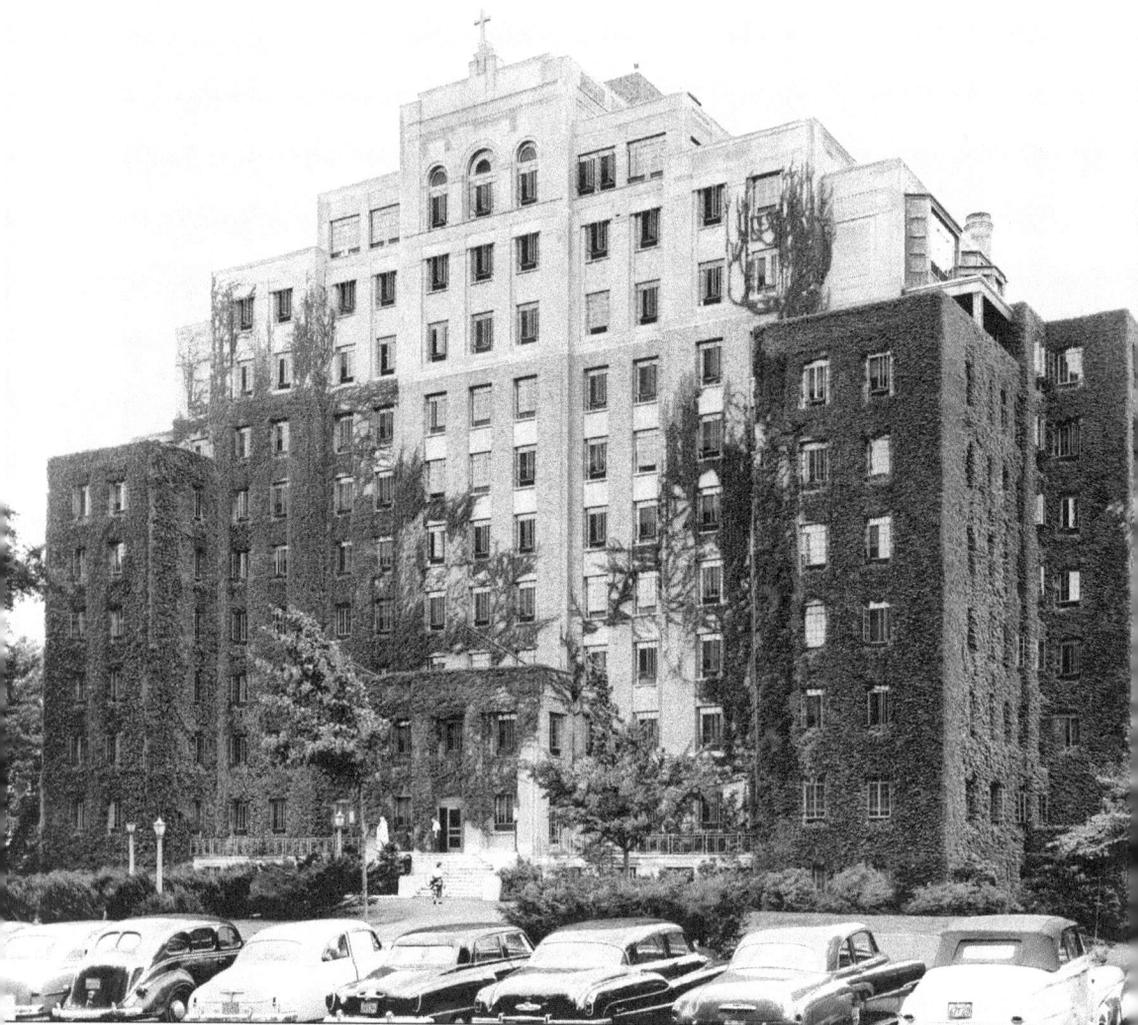

Fitzgerald Mercy Hospital has been a landmark on Main Street at Bailey Road since it opened on July 1, 1933. It has grown steadily since its beginning, serving South East Delaware County and changing with the needs of the community. It now provides the latest medical technology for its patients. A new wellness center has been added, as well as offices for physicians. This photograph shows the hospital as it looked in 1951. (Courtesy the Temple University Urban Archives.)

Dr. Beulah Sundell and nurse Barbara Seiple examine the Eggleston children: Edna, Theresa, Marie, and Lawrence. Pictured on February 2, 1965, the Egglestons were one of the many thousands of families over the years who received care at Fitzgerald Mercy Hospital. The available services and the caring atmosphere provided by the Sisters of Mercy have made the hospital a very important part of the community. (Courtesy the Temple University Urban Archives.)

This house is identified on an 1899 calendar as the Isaac T. Jones home on Lansdowne Avenue. The property was originally owned by Richard Y. Cook, a Quaker who had a large personal library and donated many books to the Darby Library. This was the building first used for the St. Francis Country House for Convalescent Women. (DBHPS, Harold S. Finigan Collection.)

St. Francis Country House for Convalescent women became the large complex of buildings now known as St. Francis Country House and St. Joseph's Villa. The house shown here was used for convalescents before World War I. The Sisters of Bon Secours have cared for convalescents and incurables there through the years. St. Joseph's Villa was opened in 1950 for the elderly priests of the Philadelphia Roman Catholic Archdiocese. The poster that features this photograph advertises "A Delicatessen Table," a food sale asking for support of St. Francis Country House for Convalescent Women, described as "a free home for sick mothers with babies or for any woman who needs rest and good food." (Courtesy the Library Company of Philadelphia.)

On March 3, 1976, the Darby police were on alert because they were transporting members of the Warlock motorcycle gang to district court. With his undercover dog, this policeman is waiting for the arrival of the gang. (Courtesy the Temple University Urban Archives.)

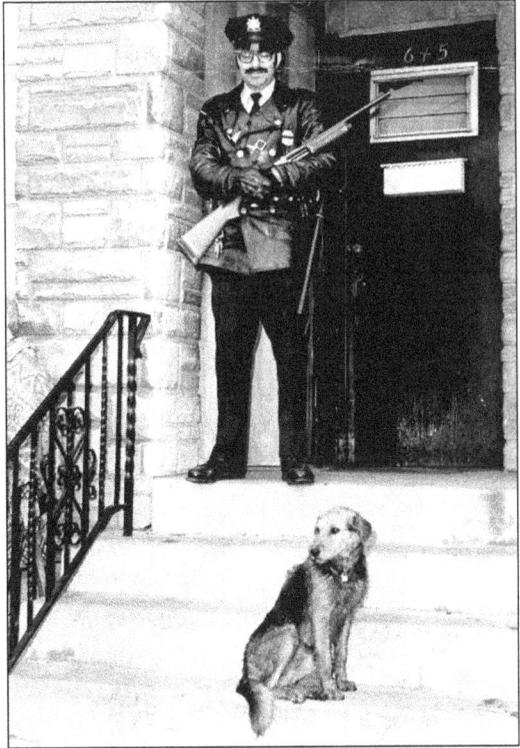

This familiar landmark on the corner of Main Street and Chester Pike was known to all the shoppers and children in the community. Long-term residents remember it as a comforting sign of protection. Officer Robert Waples directed traffic from here and could view Main Street and storefronts. Removed in 1971, the small structure is still missed by residents. (Courtesy the Temple University Urban Archives.)

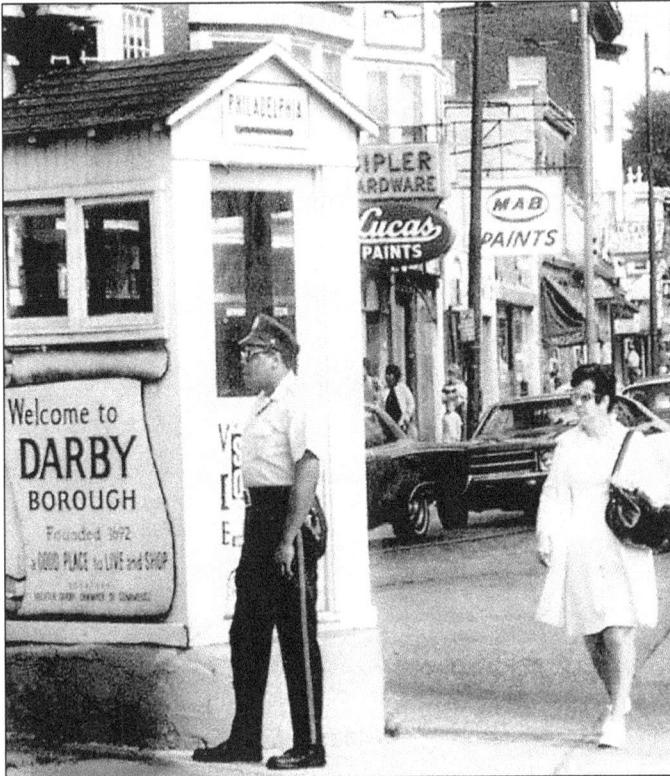

105

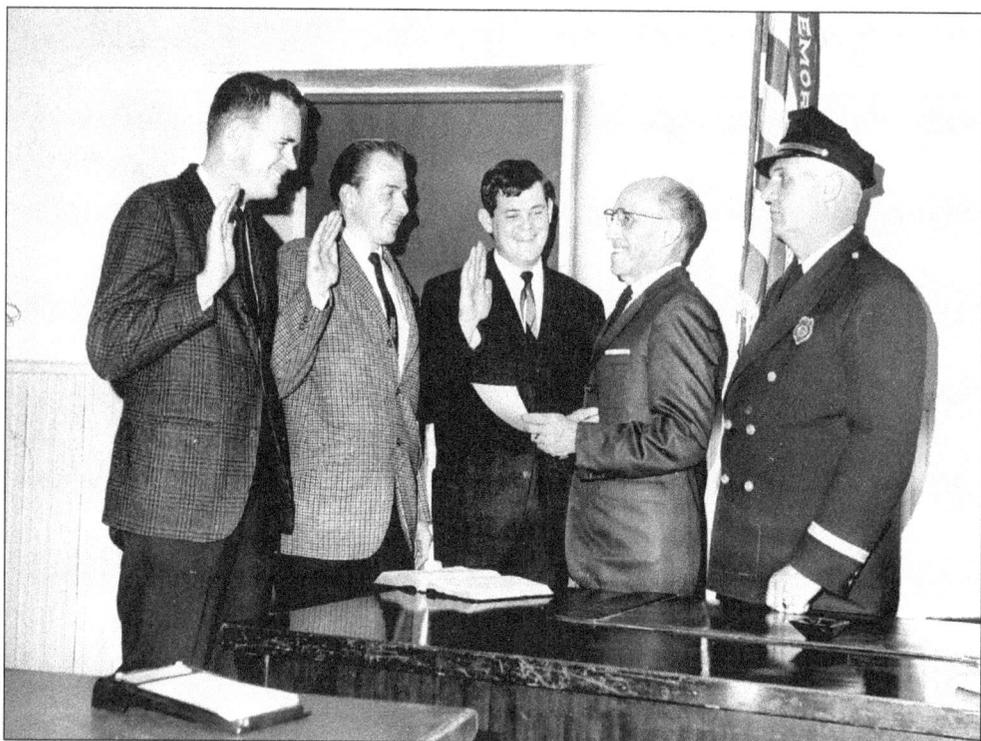

New policemen were sworn in at the borough hall on April 4, 1966. From left to right are patrolmen Richard Gibney, Allen Parker, and George Kiedel; Mayor George D. Marvil; and Police Chief Gordon H. Livingood. (Courtesy the Temple University Urban Archives.)

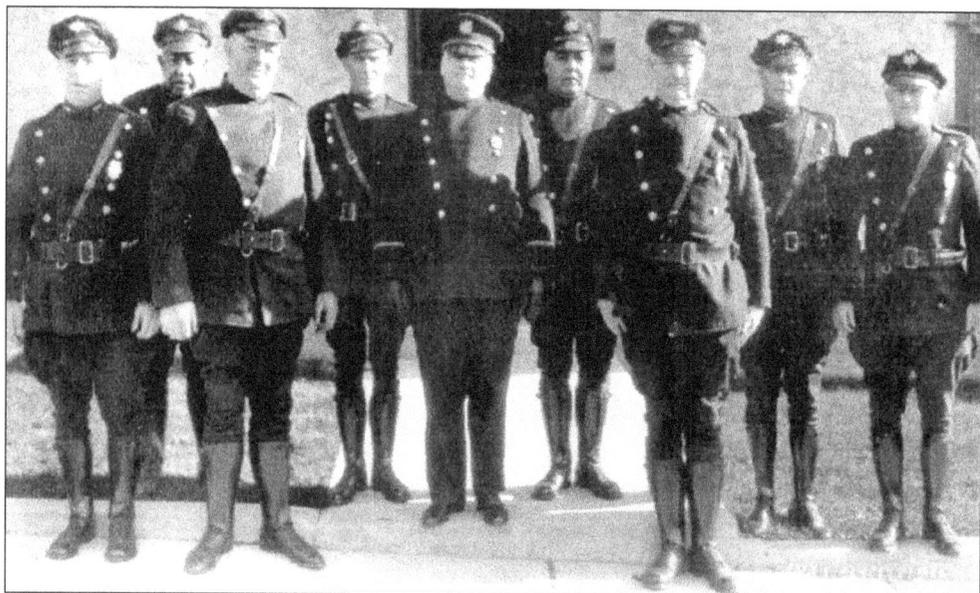

This group of policemen from the 1930s wore leather boots and often patrolled Main Street on foot, getting to know residents and shopkeepers. (Courtesy Charles F. Sanders.)

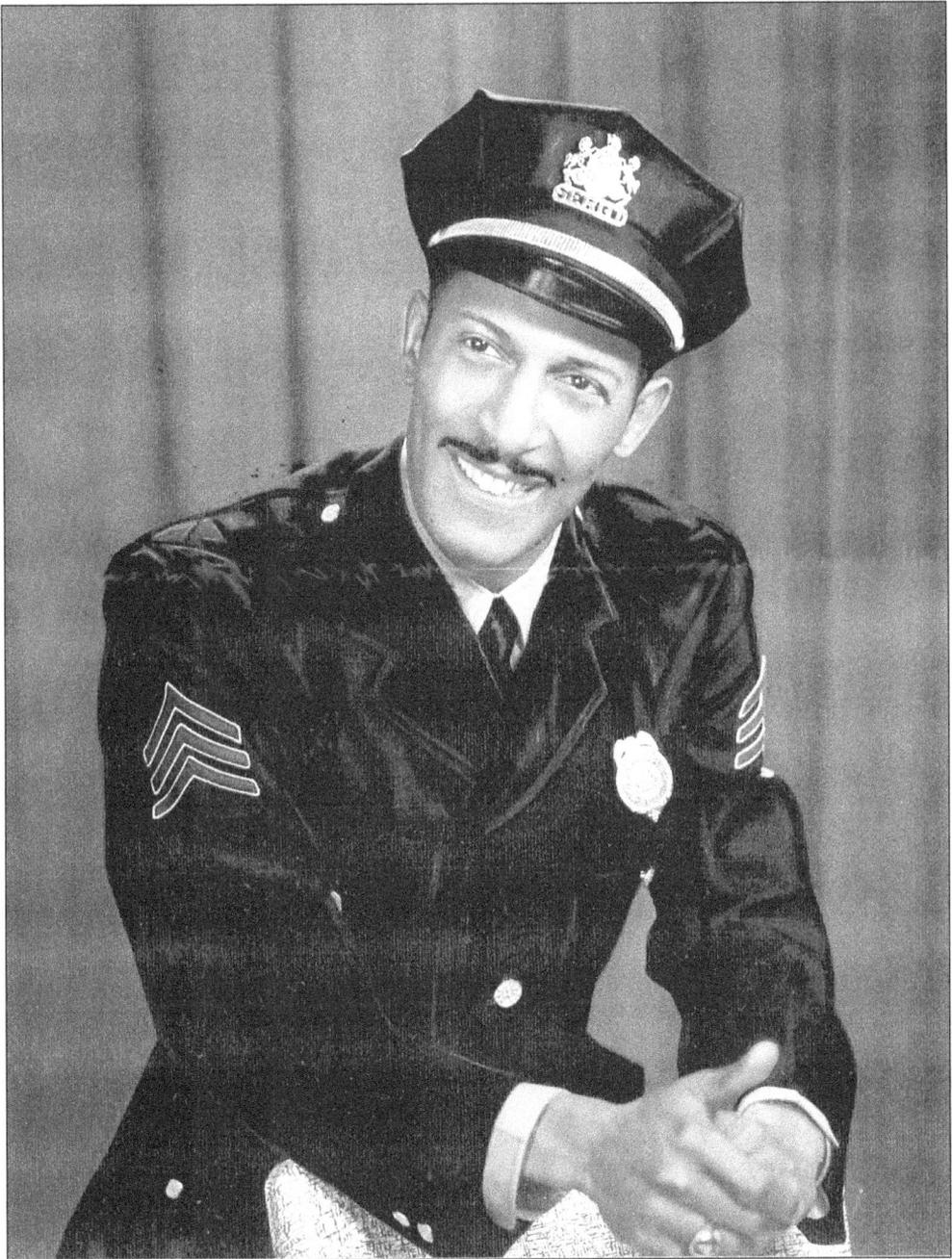

Sgt. Howard Carrington was often described by Darby children as "very tall." Youngsters and adults enjoyed seeing the smile of this well-liked policeman. Many Darby residents remember being shepherded across the street by Carrington on their way home from school. (Courtesy Melvin McCalla.)

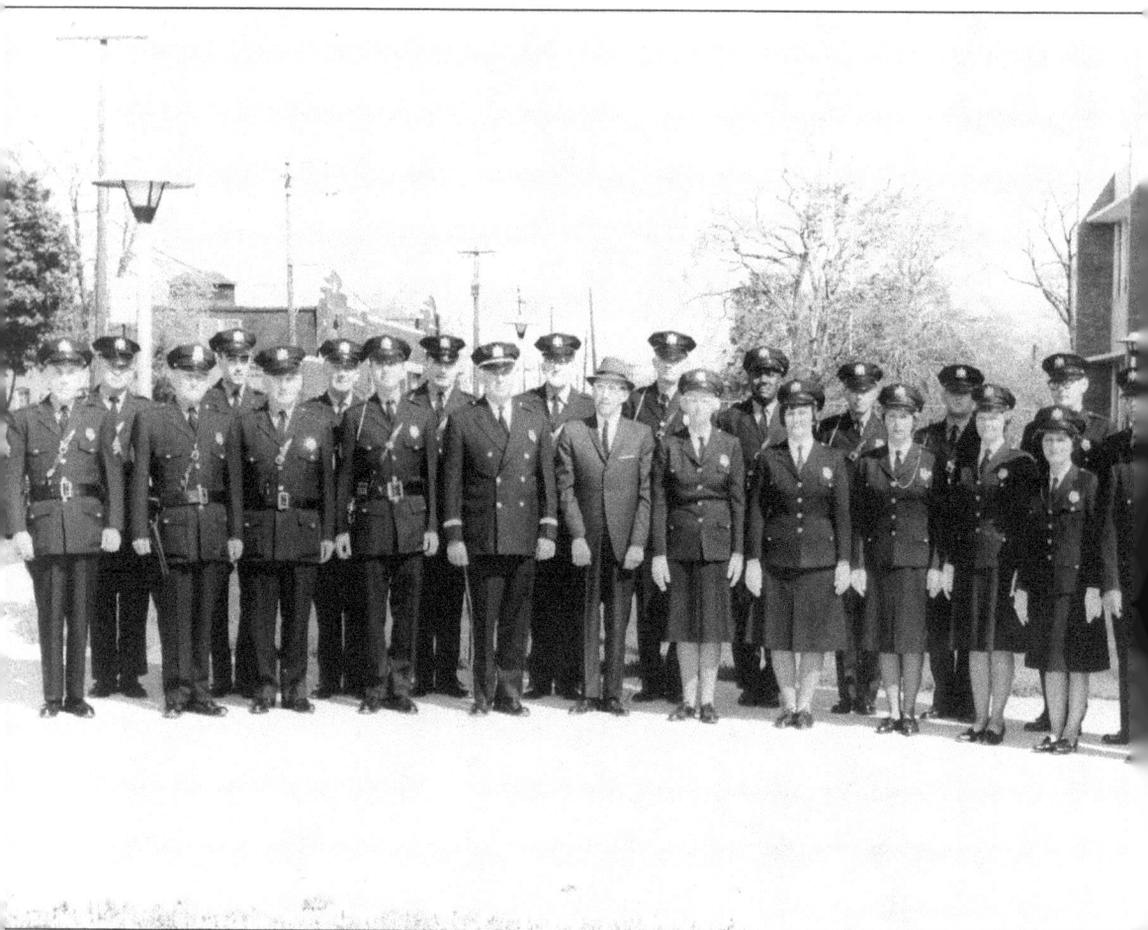

This picture of the police department was taken in 1966. Members stand about where the district court building is now.

Eight

SANDLOT HEROES, TOUCHDOWNS, AND MUMMERS

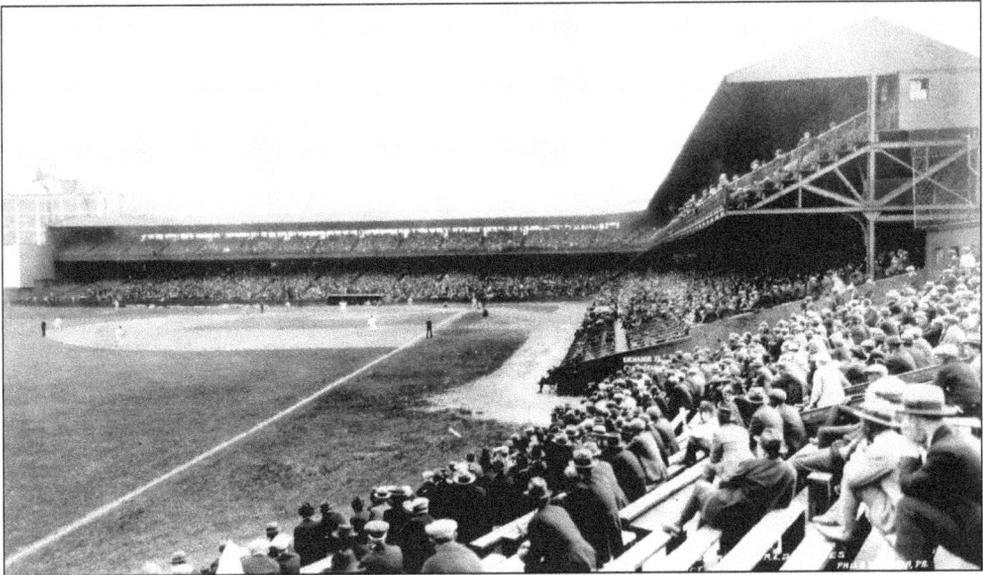

The Hilldales and the Kansas City Monarchs became the respective Negro League champions in the East and West in 1924. In this photograph, the Hilldales are playing in a Negro League World Series game in Philadelphia. The caliber of league players led Kenshaw Mountain Landis, the first commissioner of major-league baseball, to halt postseason brainstorming by major-league ballplayers. This kept ballplayers from earning after-season cash and stopped any comparisons between black American League teams and major-league teams. The Hilldale champs played in Cuba and in cities across the United States. (Courtesy the African American Museum in Philadelphia.)

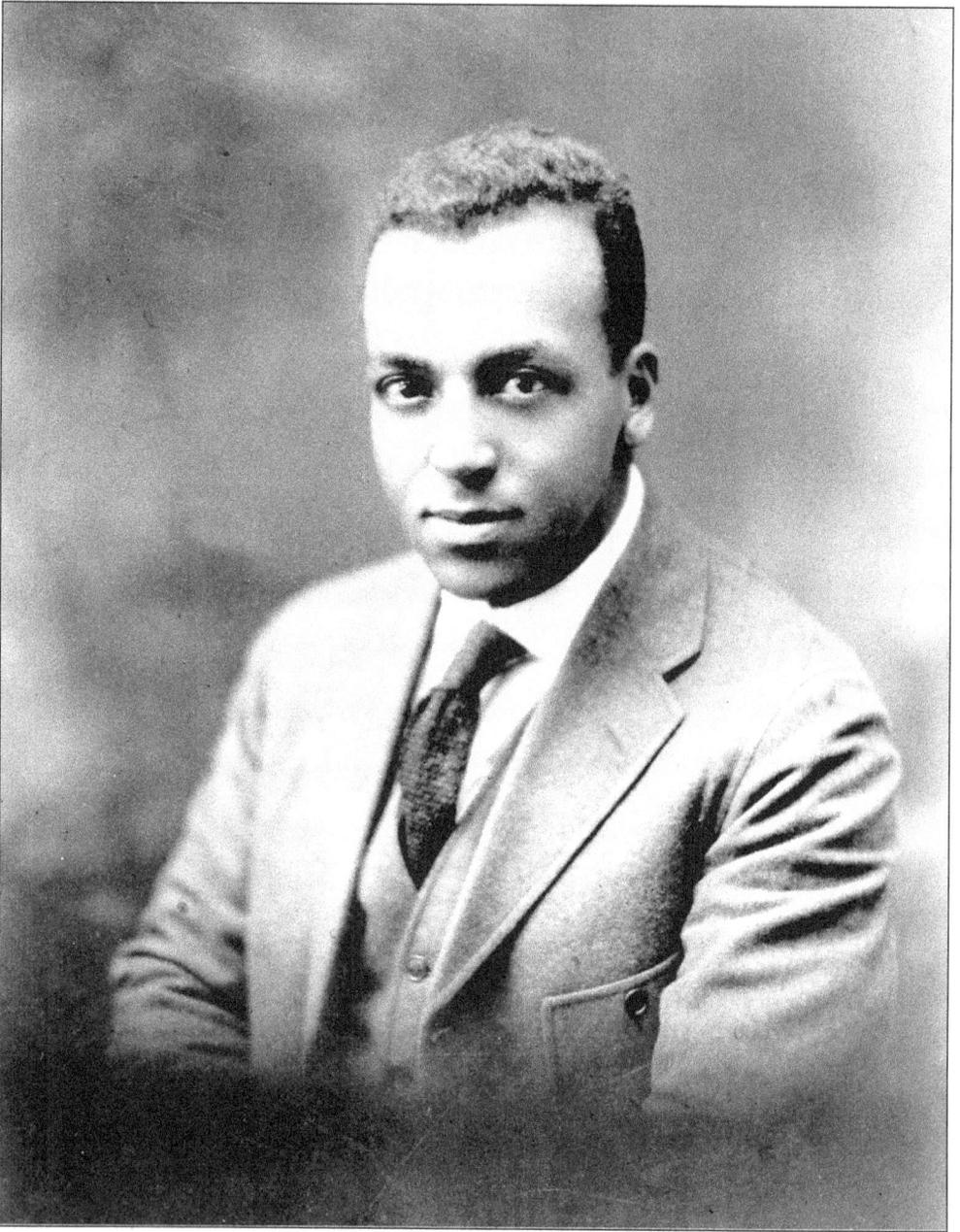

Ed Bolden was the founder of the Hilldale Baseball Association. He started with an athletic club of 15- and 16-year-olds, and within 13 years, he had built the team into the champions of the Negro Baseball League. He became one of the best baseball managers and business managers in the country. Lloyd Thompson played shortstop on the Hilldales and was a noted columnist. He wrote about the lives and times of Darby people and chronicled Darby Borough history for the *Suburban Weekly*, a Darby newspaper. The Lloyd Thompson-William Cash Collection at the African American Museum in Philadelphia preserves the history of the Hilldale Baseball Association. This remarkable association changed the face of major-league baseball. (Courtesy the African American Museum in Philadelphia.)

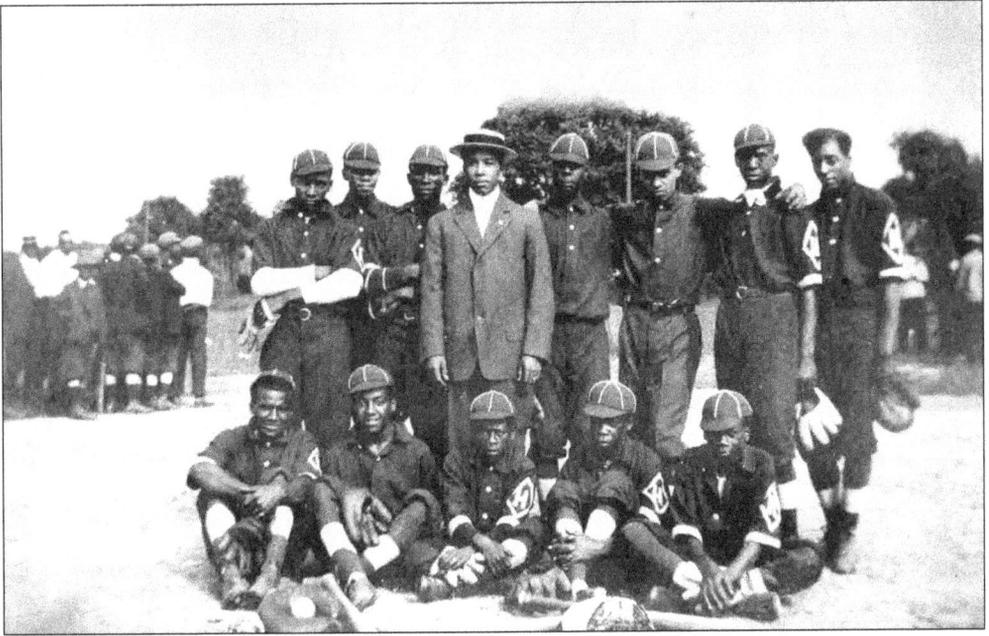

Ed Bolden and his Hilldale team are seen in this c. 1913 photograph. Bolden was always in the pictures with his team. Some famous baseball players came out of this league. Between 7,000 and 8,000 fans would fill the Hilldale Stadium near MacDade Boulevard and Cedar Avenue for the Saturday afternoon games. Other community teams used the stadium too. John Drew, a local African American entrepreneur, financed the stadium. He purchased the farmland, and the stadium was built where an Acme market now stands. When the stadium was demolished, workmen cemented a stake over home plate. It is still there. (Courtesy the African American Museum in Philadelphia.)

Baseball officials at Hilldale Stadium watch the major-league competition. (Courtesy the African American Museum in Philadelphia.)

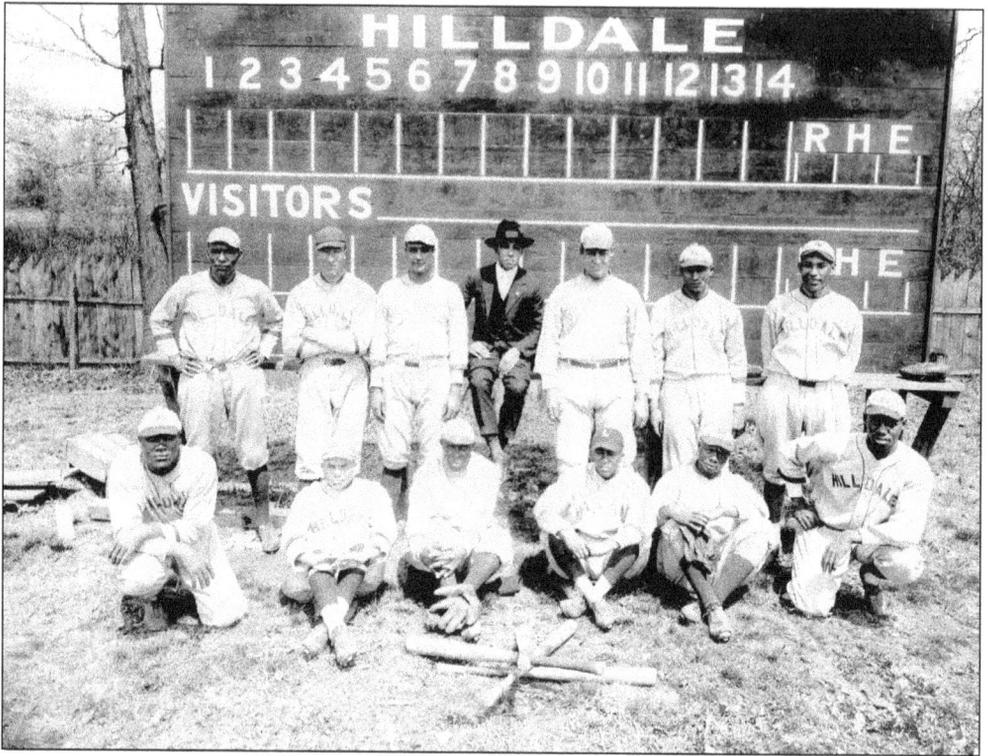

In uniform and ready to play, the Hilldales pose before a game c. 1919. (Courtesy the African American Museum in Philadelphia.)

This is the Darby Little League Yellow Jackets farm team of 1964. The team had 23 players and one manager. From left to right are the following: (front row) two unidentified players, ? McLeer, James Lawler, and four unidentified players; (middle row) two unidentified players, Phil Geiger, Pete Pashko, unidentified, Robert Rogers, unidentified, and Leon Pashko (manager); (back row) three unidentified players, Mike Winkis, Ray Winkis, two unidentified players, and ? Devine. (Courtesy Leon Pashko.)

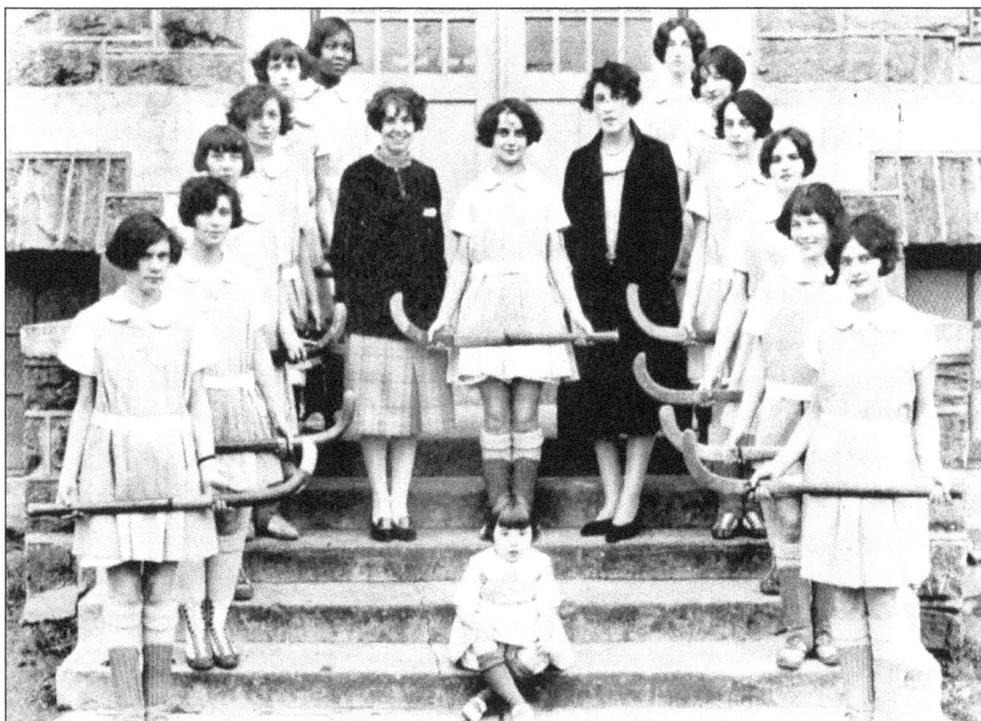

Members of the 1925 Darby High School girls' hockey team pose on the school steps, with the team mascot (front center). From left to right are D. Yates, T. Clark, B. Swope, M. Lynch, B. Magnin, R. Haines, K. Starrett (captain), F. Allen (manager), M. Ward (coach), F. Jack, D. Hauser, C. Pyle, C. Swope, E. McQuiston, and C. Shovlin.

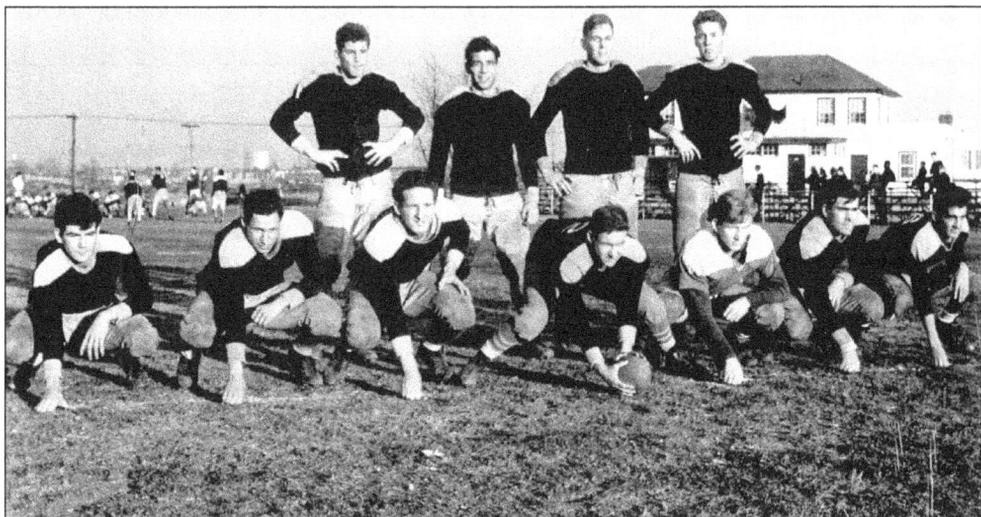

Darby High School games were well attended, and the teams were enthusiastic competitors. Dutch Winterle scored the winning touchdown that earned this team the Delaware County high-school championship in 1939. Lots of fun and antics resulted from the rivalry between Darby and other local teams in those years. The players, from left to right, are identified as follows: (front row) Sage, Colucci, Silver, Cox, Pavis, Parmer, and Cash; (back row) Pascalo, Sanute, Winterle, and Hardy. (Courtesy Dutch Winterle and Evelyn Cain.)

Father Gallagher of the Blessed Virgin Mary Church throws out the first ball for Darby Little League in 1955. (Courtesy the Blessed Virgin Mary Church.)

The Hilldales are escorted onto the field by the band. (Courtesy the African American Museum in Philadelphia.)

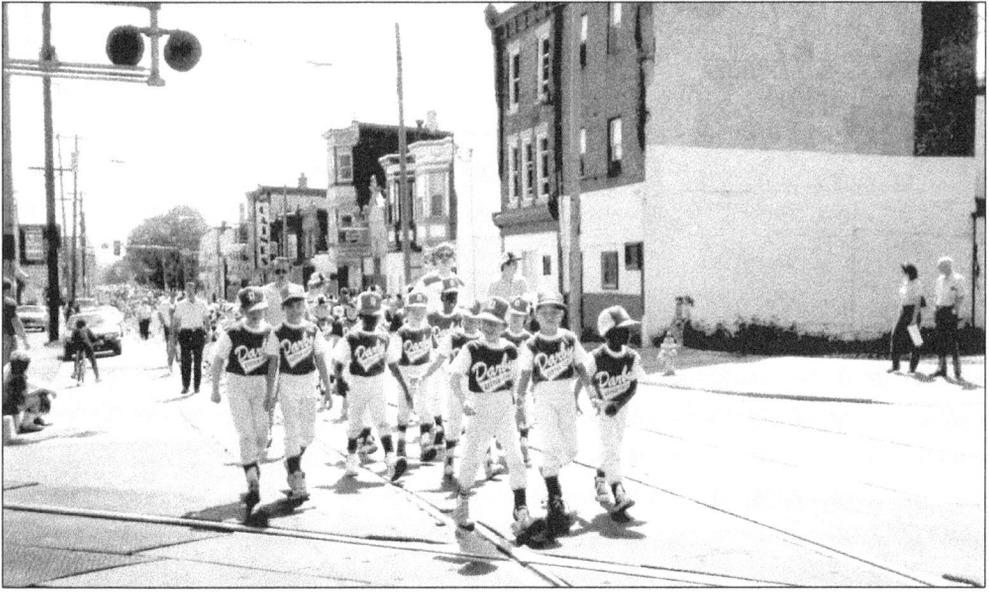

In the 1960s and early 1970s, Darby Little League was one of the most active community recreation groups for children. This photograph shows the teams on opening day parading on Main Street, ready to play ball for another season. (Courtesy Marion Pugh.)

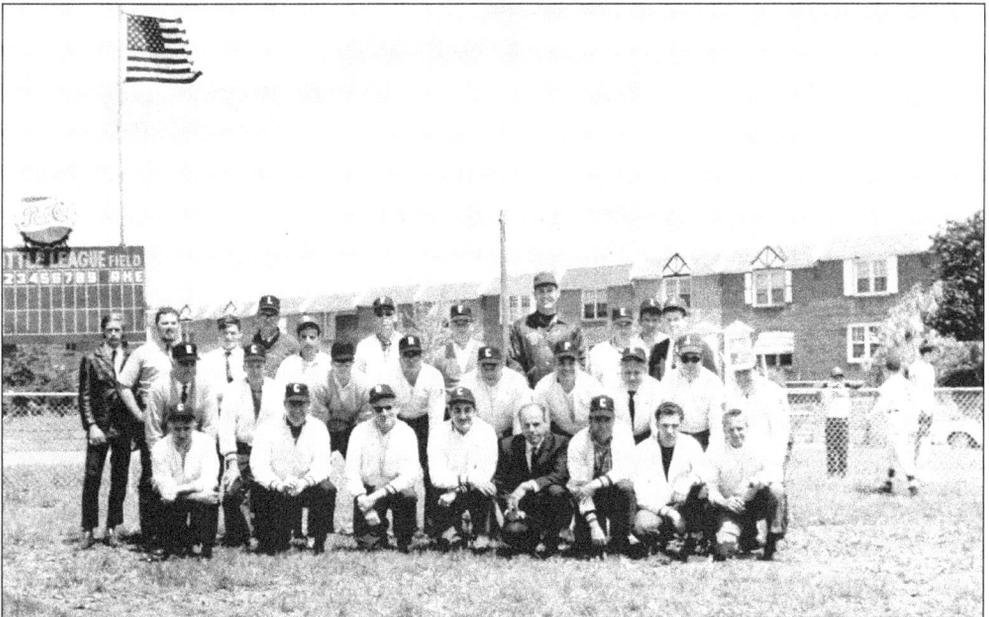

In 1971, Darby Little League had 66 coaches and managers, some of whom are shown in this photograph. From left to right are the following: (front row) unidentified, Phil Knoll, unidentified, Dick Dabagian, Leon Pashko (league president), Don Brennan, Walt Bittner, and Bill Stull; (middle row) two unidentified men, Jack Fitzgerald, Paul Murtagh, two unidentified men, Lou Fischer, Frank Marvel, and George Wetzel; (back row) three unidentified men, Charles Finlay, unidentified, George Tuson, unidentified, Bob Shanahan, Bob McFalls, unidentified, and John Murphy. The dedication of the parents and community to Darby's youth was evident by the large number of residents who participated in Little League. (Courtesy Leon Pashko.)

The Lansdowne Country Club in Darby was located on part of the land that is now Lansdowne Park. This 1905 photograph shows golfers returning to the old house that had been converted to the clubhouse. (Courtesy the Library Company of Philadelphia.)

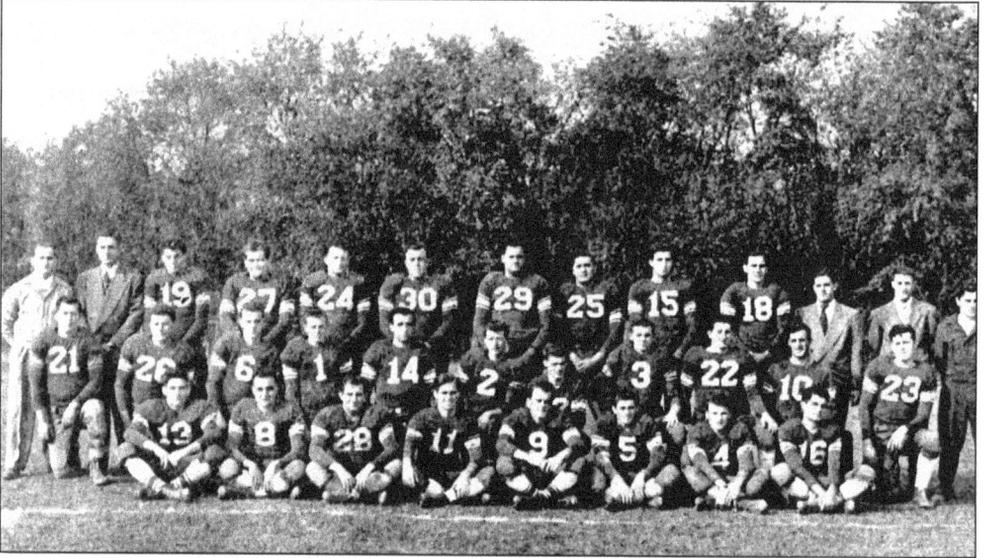

The Darby Rams Athletic Association began in 1946, at the end of World War II. It was a part of the Philadelphia Suburban Football Conference. The conference was composed of teams organized in Philadelphia and the suburban counties. In 1948, the Rams were the semiprofessional conference champions. From left to right are the following: (front row) Dom McGorry, Harry Gorman, Robert Furman, George Crain, Vince Pieseck, Adam Danesi, Jack King, and Ed Crain; (middle row) Joe McBreen, Irish Manning, Jack Shockley, Jerry Conway, unidentified, Tom Lydon, Joe Seefeldt, Bill Love, Roy Kerr, unidentified, and Bill Bassett; (back row) Tom Boyce, Ray Blythe (manager), Mike Grossi, Mickey McGee, Flicker Flynn, Rudy Pomanelli, Steppie Blythe, John Santoro, unidentified, Bill Deveraux, Charles Sanders (manager), Lou Bonder, and Len Danesi. (Courtesy Charles Sanders.)

116

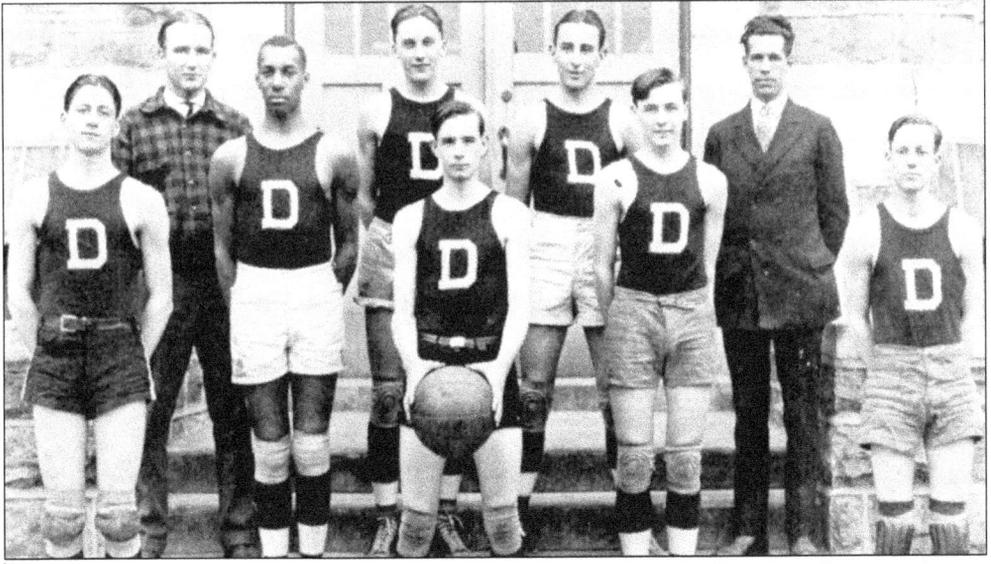

The Darby High School team won the Delaware County Basketball League championship in 1925 was. The team members are identified, from left to right, as follows: (front row) Gottliebb, Brice, R. Gamber (captain), Bob Gamber, and Beacher; (back row) Collison (manager), Cassel, Gotshall, and Doering (coach).

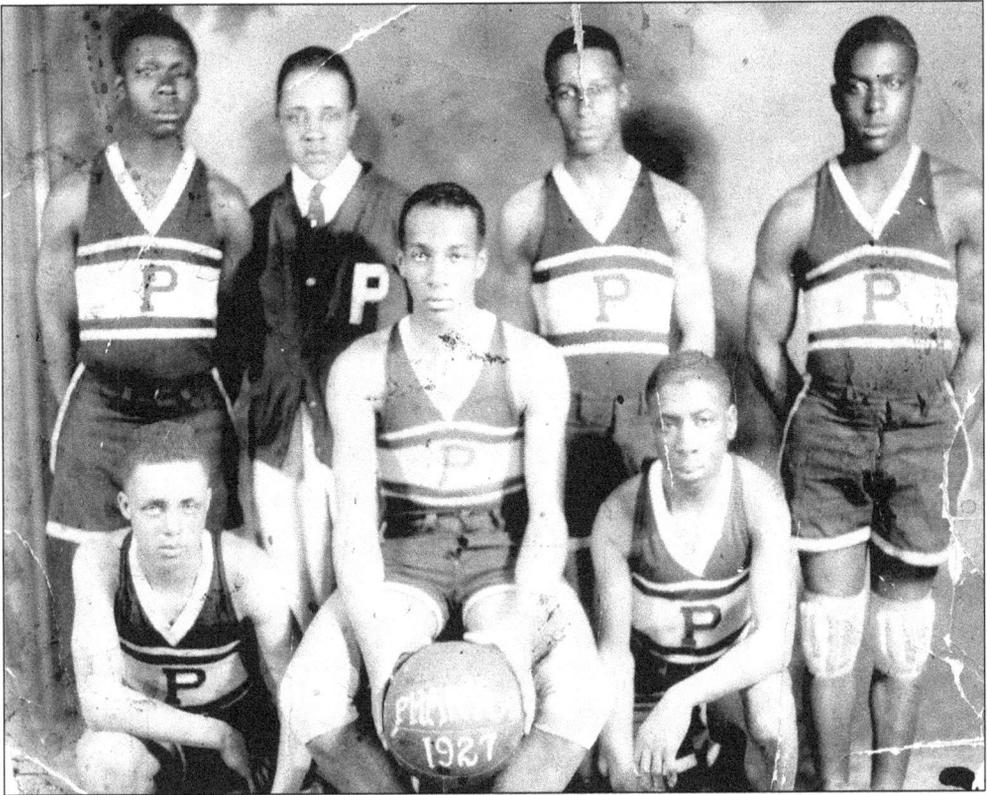

Darby never lacked for great teams to support. Shown is the Darby Phantoms semiprofessional basketball team in 1927. (Courtesy William R. Coleman.)

In 1905, the Lansdowne Country Club was a popular place for a few holes of golf—ladies included. Women were still dressing in long dresses for some sports *c.* 1900.

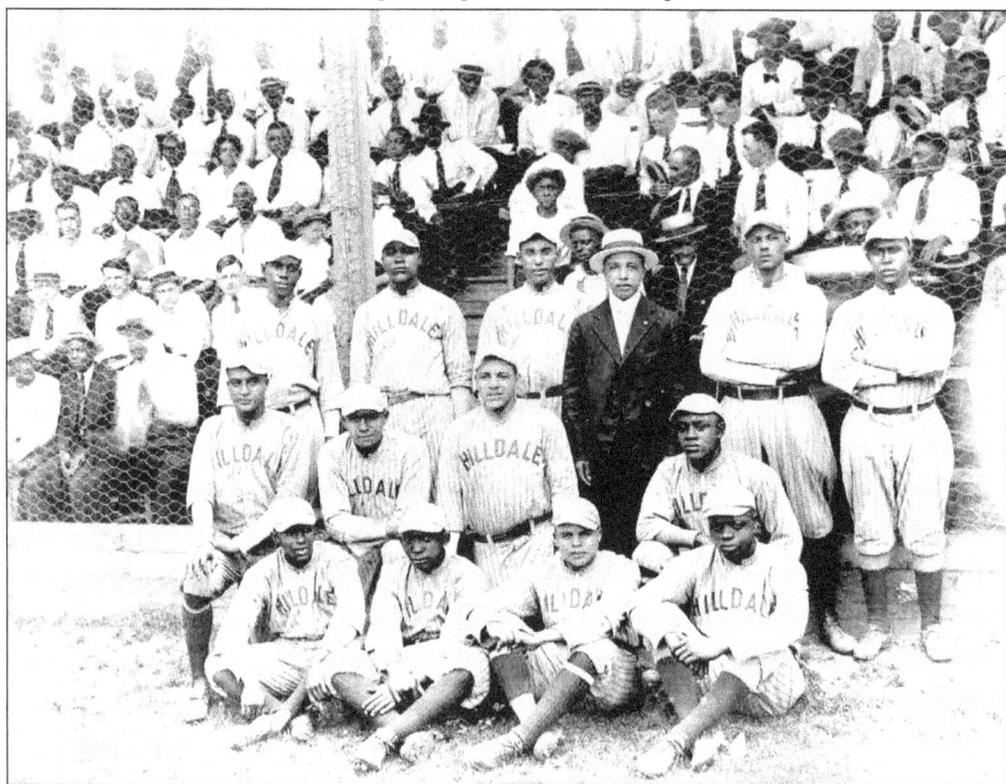

Ed Bolden and his team are ready for another game at Hilldale Stadium *c.* 1925. The stands were always filled, and Saturday afternoons were reserved by fans to watch the team play.

118

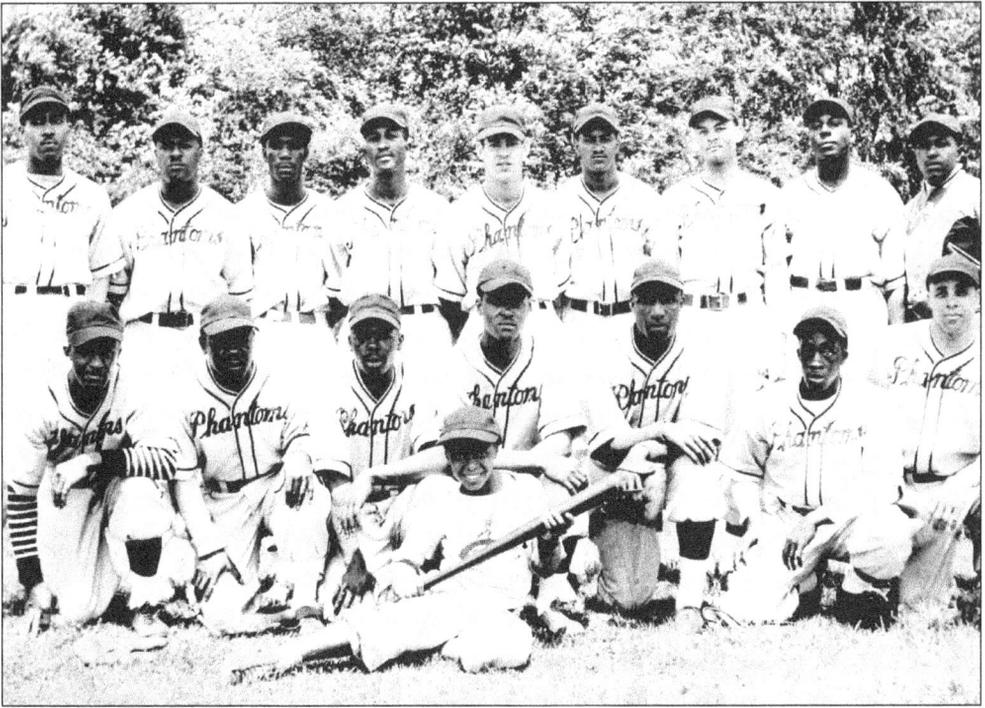

The Darby Phantoms baseball team was a semiprofessional team that played in the Philadelphia and Delaware County areas. It was a favorite of Darby fans. This picture is of the 1946–1947 team. Noted on photograph were the names of the bat boy, William R. Coleman, and 10 of the players: Tom Macey, Rabb Murray, Sock Walley, Tim Givens, Popeye Holland, Ed Bacon, Walter Carey, Ike Ford, Ray Garner, and Floyd Garvin. (Courtesy William R. Coleman.)

The crowd paid rapt attention to the players at this Darby High School football game in 1939, when the team was winning the championship.

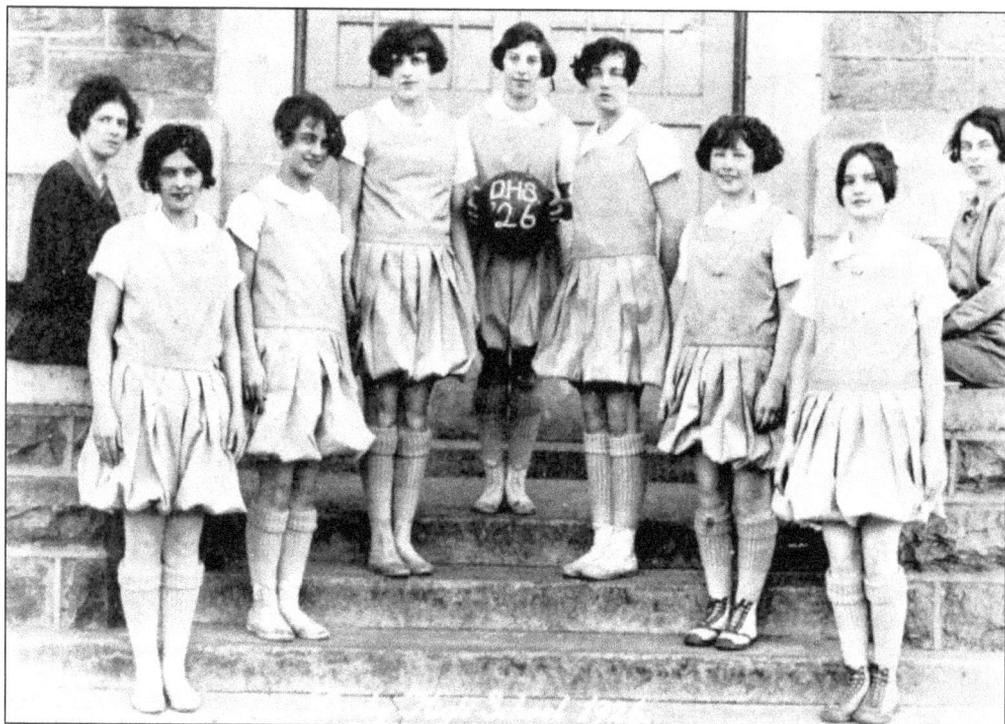

Members of the 1926 Darby High School girls' basketball team, from left to right, are Miss Falk (coach), R. Miller (captain), C. Swope (manager), F. Jack, K. Starrett, H. Magnin, C. Shovlin, D. Hauser, and C. Pyle.

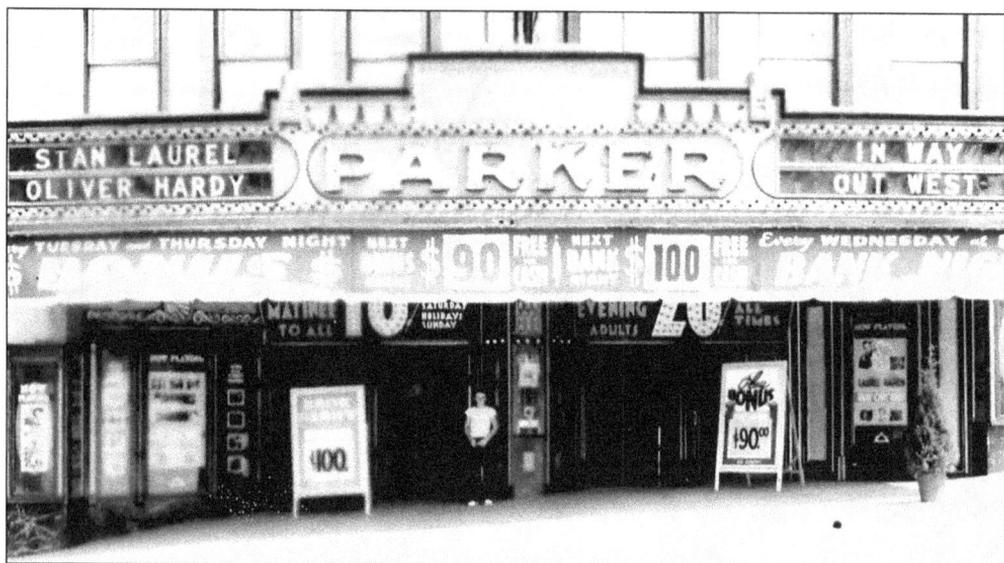

Shown is the Parker Theater in 1936. Standing in front of the door is teenager Charles Cain, who was employed as an usher for the theater. (Courtesy Evelyn Cain.)

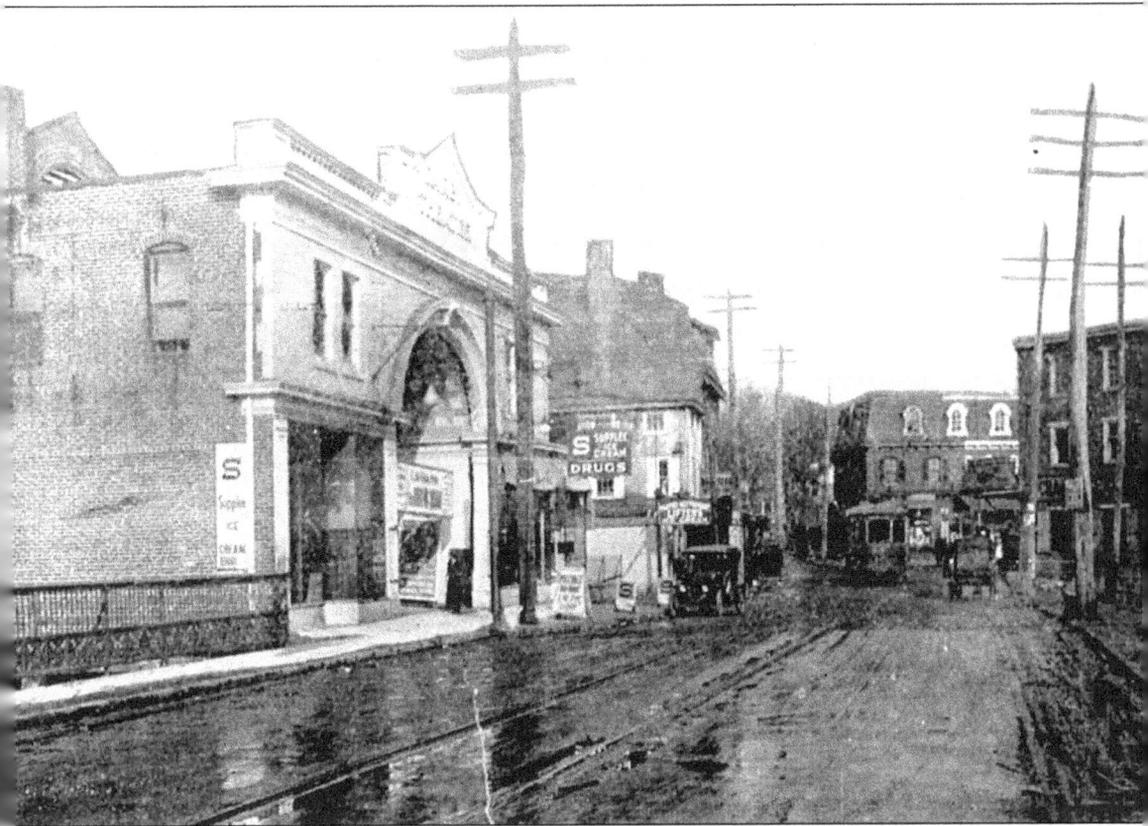

The Darby Theater was located on the corner of Chester Pike and Main Street. The Shin drugstore is next door, and the Buttonwood Hotel can be seen at the corner. This picture was taken before the partnership of Cloud and Shin.

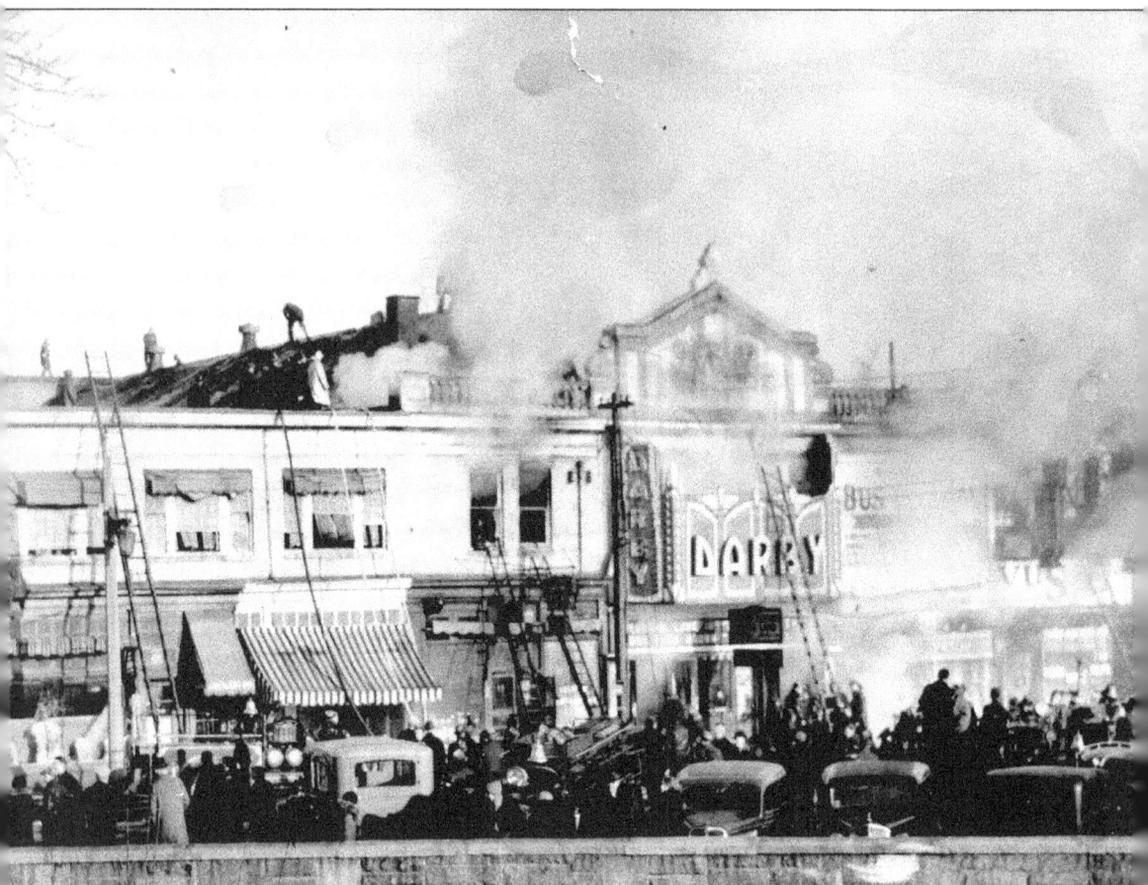

Shown is the fire at the Darby Theater in November 1936. (Courtesy the Temple University Urban Archives.)

Musical notes was the theme for the Trixie String Band in 1924. The band won fifth place in the Philadelphia New Year's Association parade on Broad Street. The band marched from 1922 to 1933. (Courtesy the Mummers Museum of Philadelphia.)

In 1925, the Trixies played at the Darby Theater. In 1931, they had a special melody composed by Walter Burgess of Darby to use for their march on Broad Street. They paraded in Collingdale and Darby and played and sang their version of the Ram song as a practice session. (Courtesy the Mummers Museum of Philadelphia.)

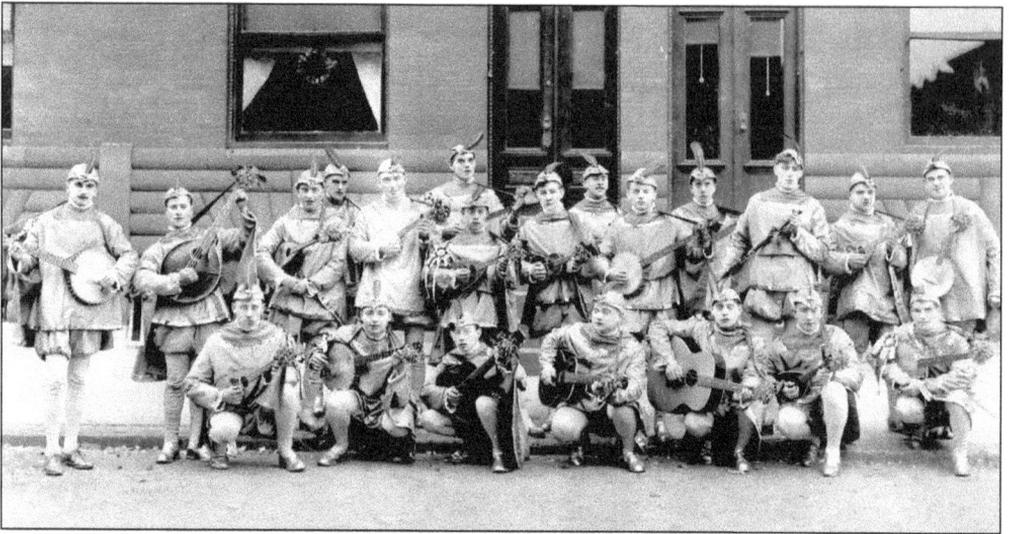

The Trixie String Band, with captain Tom Belk, is seen in front of the Collingdale Fire Company No. 2 after returning with the fifth-place prize for its Robin Hood theme. (Courtesy the Mummer's Museum of Philadelphia.)

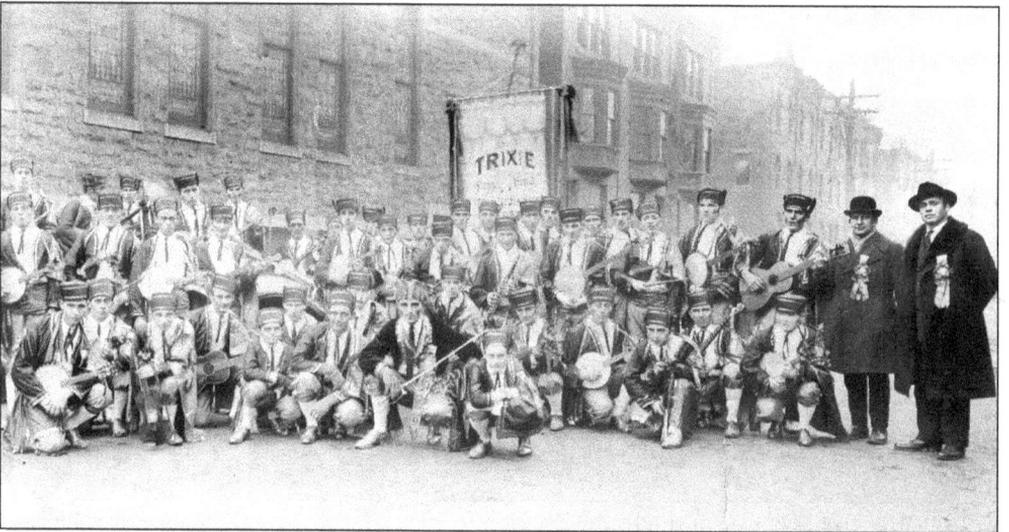

In 1923, the Trixie String Band's theme was toreadors. Band members are seen here in front of the Collingdale Fire Company No. 2 firehouse, where they practiced. (Courtesy the Mummers Museum of Philadelphia.)

Trixie String Band member Andrew Curtis stands in his costume in front of his house in Collingdale in 1925. The band placed third in the Philadelphia New Year's Association parade. (Courtesy the Mummers Museum of Philadelphia.)

With happy faces, the Darby Little Leaguers parade on opening day in the 1960s, expecting to win the championship.

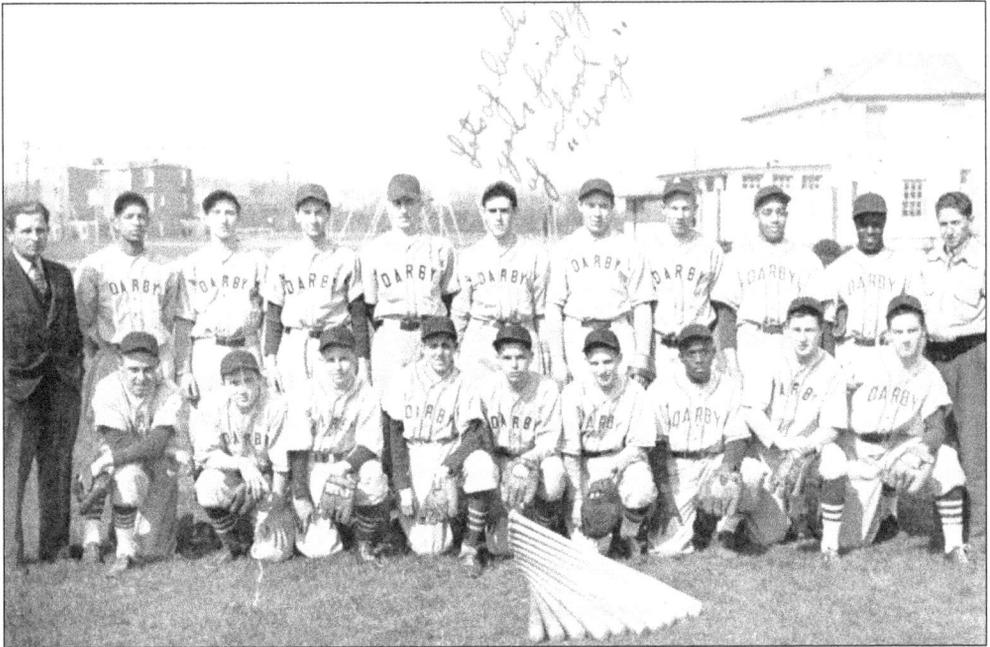

The 1943 Darby High School baseball team is ready to start the season. From left to right are the following: (front row) F. Parks, G. Kidd, J. Rogers, F. Schmitt, G. Richards, H. Anderson, E. Warfield, J. Boyd, and J. Bassett; (back row) ? Solar (coach), H. Talley, J. Columbo, A. Hopkins, J. Dickinson, F. Magee, A. Burrows, W. McIlhenny, C. Spain, J. Wilson, and F. Kelby (manager).

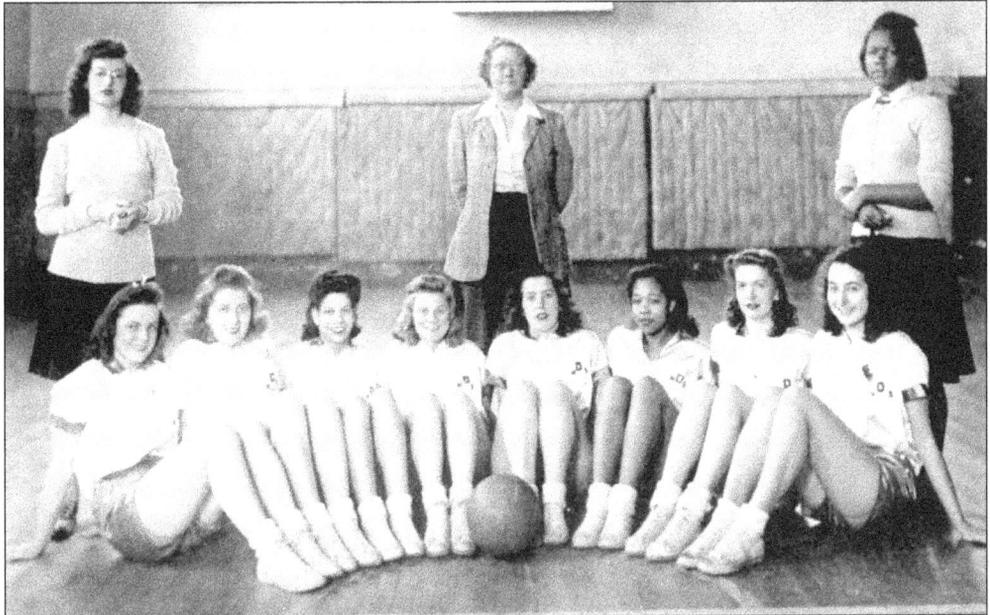

Girls' basketball was a favorite sport at Darby High School. Shown here is the 1943 team. From left to right are the following: (front row) D. Burns, A. Gamble, E. Dickey, J. Strockbine, B. Martin, M. Roye, V. Mosley, and E. Stephy; (back row) M. Rhinehart (manager), Esther Haun (coach), and E. Childs (manager).

This photograph was taken at the dam in Darby on Christmas Day 1887. (DBHPS, Harold S. Finigan Collection.)

www.ingramcontent.com/pod-product-compliance
Lightning Source LLC
Chambersburg PA
CBHW080617110426
42813CB00006B/1535